CW00665458

NEW ARCHITECTURE LONDON

NEW ARCHITECTURE LONDON

RICHARD SCHULMAN

AGNESE SANVITO

PRESTEL
MUNICH — LONDON — NEW YORK

CONTENTS

EDWIN HEATHCOTE

There are old cities. There are new cities. London's strange and seemingly eternal attraction lies in its ability to be simultaneously both.

London is a city with Roman foundations and a street plan that emerges as a chaotic hybrid of arrow-straight Roman roads, winding medieval alleys, and marketplaces; but also well-meaning, if often halfhearted, attempts to make it grander, more beautiful—or at least more rational. But it resists all attempts to overlay it with a sense of logic, just as it defies the efforts of successive generations to transform it, despoil it, or iron out the creases.

Through this chaos emerges one of the world's most persistently desirable, expensive, successful, and unpredictable cityscapes, a place that is constantly changing yet somehow always remains fundamentally London. The following intriguing, occasionally oblique photographs capture this chaotic, endlessly fascinating city. These are not the conventional glamour shots of a city of blue skies, grand vistas, and architecture as isolated object, but instead a city glimpsed around corners, of the extraordinary framed through the banal, and of the insistent sensation of restlessness and change.

Each century seems to bring its radical transformations, from the Great Fire in the seventeenth to the elegant city squares of the eighteenth, the explosion of the suburbs of the nineteenth and the scars of war and the neophilia of modernism in the twentieth. But the twenty-first century is arguably already bringing about the most radical shifts in scale and skyline that the city has seen since the medieval era. While the post–Great Fire skyline was defined by the spires of Sir Christopher Wren's churches, culminating in the great dome of St Paul's Cathedral, the new cityscape is marked by supertall towers articulating the city's real estate status as the reserve currency of the global elite. That transformation from a skyline that once combined commercial development with social housing into one that celebrates the victory of private wealth has been radical in its visual impact and eye-watering in its pace. And, as if to reimpose itself on a profile in which height in itself is no longer enough to make a statement, London has supercharged its architecture to make itself seen.

If the towers have been the most visible manifestation of the city's real estate as a safe deposit box for global wealth, what exactly has been happening at street level? Cities with porcupine skylines are almost a cliché; what actually makes a city buzz happens in its streets and squares, its shops and bars, the

chandelier-crowned restaurants and the subterranean dive bars. And that's been a different story, one expressed through a cocktail of the salvaged and the shiny, the particular and the generic. In one interpretation, the city's streets are being homogenized, the plate glass windows and the glazed facades reducing the interface between public and private, interior and exterior to a banal membrane. But in a parallel route, architects and clients are weaving their buildings back into the historic fabric, the city streets becoming intriguing palimpsests in which the high tech gleams next to artfully maintained dilapidation. Walls are being stripped of centuries of plaster and wallpaper and taken back to the bare bones of brick and steel; battered floors and ceilings are revealed as precious surfaces divulge their history through their degradation.

If there is one building that characterizes this crossover between the ravages of history, the changing nature of the center of the city, and the new world of global art and money, it is Tate Modern, perhaps the defining monument of the city's new era, designed by Swiss architects Herzog & de Meuron, and opened at the turn of the new millennium, seemingly to usher in a new era. Free of charge and defined by what has become London's greatest public space, the Turbine Hall, it rapidly became the world's most visited museum of contemporary art. Its cavernous central space expressed in monumental brick and concrete challenged artists to create work at the scale of the city rather than the gallery. In its blend of industrial language and material, and the visionary space of its Swiss architects in which unprecedented scale, gathering, experience, and event subsume the art, Tate Modern crystallizes the notion that installation and ideas are what the city manufactures now that the production of goods and power has been subcontracted elsewhere, an impression reinforced by a new brick ziggurat rising behind the building, a contemporary Tower of Babel for the museum's mission to educate, archive, and entertain.

The same adoption of the city's industrial infrastructure is visible from King's Cross to Battersea, a seeping valorization of brick, concrete, and steel absorbed as the new language of luxury. Even the late Zaha Hadid with her Serpentine Sackler Gallery, inserted into the shell of an old munitions depot, has found the patina of raw brick irresistible. And, of course, Damien Hirst's Newport Street Gallery in Vauxhall (designed by Caruso St John Architects) sites itself within a former scenery painting workshop. What more perfect metaphor than a place of manufacture for the stage— the industrial infrastructure of artifice—reimagined as a display space for the artist whose auction of his own works on the eve of the financial crisis was itself the symbolic moment of decadent collapse?

Back on the scale of the skyline: London—a traditionally low-rise city—became the surprising epicenter of a revival in the tower as a medium of informed architectural expression. Sure, there are the shimmering desert skylines of Dubai and Doha, and the glassy, selfie-friendly, harbor-reflected cityscapes of Shanghai, Sydney, or Hong Kong, but it was a British architect who reinvented the skyscraper as a thing of beauty. Norman Foster, whose HSBC headquarters in Hong Kong was once the most expensive building in the world, erected his Gherkin in 2003. Sprouting from the ruins of a building bombed by the Irish Republican Army, this was a new, sleek city architecture, an expression of a newly technologized financial center, a bullet emerging from a city that had been bombed three times in a century. The City of London, the city's historic core and its one–time undisputed financial center, had been threatened by the success of Canary Wharf to the east. A North American style development of global towers, Canary Wharf reveled in its newness and its detachment from the

hidebound tradition of historic London. The Gherkin, or 30 St Mary Axe, represented a reassertion of the city's status and a sign that its convoluted Roman and medieval streets could accommodate a streamlined object of originality and architectural elegance. When it was unveiled, the Gherkin completely transformed views of the city. It impinged on views from East London and began to define a new era in which the city was a sophisticated, contemporary space set on a global stage. It became a signifier, its striking presence a blend of the dome of St Paul's and the tower of Big Ben. Now it is barely visible. Its success has been such that it stands almost unseen at the center of a huddle of skyscrapers expressing the success of the city as both a financial hub and a capital of contemporary architecture.

Within the huddle of towers is one particularly intriguing rivalry inscribing itself onto the skyline—that between the two aristocrats of British architecture, Lords Norman Foster and Richard Rogers. Rogers' Lloyd's building became the youngest building to be listed, given statutory protection from change—a supreme irony for the work of an architect who prides himself on the facility of his buildings to adapt with use and time. The building, which blends the aesthetics of the oil rig with an idea of a building as a machine for making money set itself up next to the Victorian Leadenhall Market—an iron-and-steel confection that was perfectly engineered and spatially impressive in its time. Foster + Partners' Gherkin was a smooth riposte, while its Willis Faber & Dumas Headquarters wrapped itself around the ensemble in a big, not entirely friendly, bear hug. But Rogers' comeback in the form of his renamed firm, Rogers Stirk Harbour + Partners' Leadenhall Building leans into the cluster and now dominates the center of the city. But even that will soon be eclipsed by Eric Parry Architects' elegantly attenuated 1 Undershaft, destined to be the tallest building on this side of the river. OMA's headquarters for N. M. Rothschild & Sons pokes its head above the dense city fabric, emerging as a glazed box, a city boardroom in which its occupants are exposed, a rare glimpse of the inner workings.

Rafael Viñoly Architects' swell-headed Walkie Talkie stands on its own, away from the cluster, with no one talking to it. It's not only London's skyline that has seen radical changes; its streets and its public spaces are being transformed—even if they retain a memory of routes and lines of desire that have existed since the streets were lined with timber-framed housing. Ateliers Jean Nouvel's One New Change introduced a strange, reflective, and refractive series of surfaces, while Paternoster Square presents another side of the city's view of itself as a classical setting for St Paul's Cathedral.

If the most memorable twentieth-century image of the city was of the cathedral's great dome rising above the flames and smoke of the Blitz, in the twenty-first century the persistent rebuilding and vague sense of dissatisfaction with its surroundings has revealed the city to be a cipher for what contemporary architecture actually is. This commercial heteropolis has yo-yoed between serious modernism, theatrical postmodernism, global starchitecture, and underpowered classicism. There is a restlessness here, a sense that the place is never complete. Tower cranes are as much a component of the profile of the city as are its towers and the restlessness, the impatience that imposes itself as a sense of incessant change. It never seems possible to sum up the state of the city because it is never static, never satisfied. Towers need to be taller, basements need to be deeper, penthouses need to be more expensive.

Not all the action however has been on the north side of the river. The traditional imbalance between north and south has been slowly resolving itself and nowhere is

this more visible than in the piercing glass obelisk of the Shard. Designed by Renzo Piano Building Workshop, the tallest building in Western Europe has radically shifted the perspective. Visible from across the city—and from the most surprising places— its thousand-foot-tall (310 m) crown glows at night and sparkles in the sun. But it remains an object rather than a building. Poorly integrated into the ancient fabric of the Southwark streetscape in which it sits, the Shard seems to have little to do with the everyday life of the city or its citizens. It looms above the streets but never quite connects. It isn't alone. Foster + Partners' City Hall, a building intended to represent the city's administration—its idea of itself—is a lopsided glass ball, an object sitting in a poorly defined morass of generic development not far from the Shard on the south side. What was meant to be a symbol of transparency and accessibility has become a symbol instead of the isolation of the political classes in their glass dome— all set in a privatized pseudo-public landscape in which everything is surveilled.

These buildings also represent a city suddenly enthralled by starchitecture. The Shard and City Hall are attempts to create a place using the brands and global recognition that come from commissioning Pritzker Prize winners. These are buildings that would not have been built were it not for the names behind them. A generation ago, London had barely any buildings by architects of international repute who were not themselves British. Now it has suddenly become a magnet for starchitects, each developer outdoing his or her neighbor. It might make for a more dynamic skyline but it does not create a coherent city.

Those global stars are being brought in to replace existing buildings, often barely a generation old themselves. The pace of development is itself a problem. It precludes an intelligent analysis of the outcome—it is left to individual buildings to make their mark with astonishingly little idea of how each structure might affect the city surrounding it. But that speed of replacement has also led to the loss of almost an entire layer of history—the now surprisingly fleeting and fragile flowering of British modernism itself. The fruits of postwar redevelopment have been flattened beneath these new towers. Social housing, commercial office slabs, and elevated pedways have been demolished, and now even postmodernism, once the populist darling of the architecture scene, is under threat. Can a city be too successful? How much of its immediate past should we try to save?

Most remarkable of all has been the wholesale rebuilding of entire districts of the city center. No other major city in the Western world has so completely rebuilt itself over the last two decades. The results are varied—and many of the effects are still to be seen—but they are certainly unmissable. The 2012 Olympics cleared a huge swath of industrial East London and, although its sporting legacy is questionable, Zaha Hadid Architects' London Aquatics Centre has become perhaps the most eye-opening municipal pool in the world, a seductively sculptural and fluid structure that begins to compensate for almost all of her best buildings being abroad. Then there's King's Cross, the former railway lands that have been rebuilt as a landscape of leisure and luxury accommodation—a cocktail of salvaged industrial shells and shiny new towers. And at its heart the reimagining of the city's two great stations of the railway age, St Pancras, revived as an elegant transcontinental hub, and King's Cross, a high-tech hub. To the south is Vauxhall, an area that once accommodated the city's pleasure gardens, a picturesque park of dubious morality that is now being rebuilt as a suburb of towers in which the MI6 Building mingles on the skyline with poorly designed penthouses, visually illiterate skyscrapers, and ultimately the new United States Embassy, a piece of seemingly generic commercial architecture surrounded by, of all

things, a moat. The vista terminates in the upended table of Battersea Power Station, its four chimneys poking into the sky. This late industrial behemoth that once powered the city is being smothered by bland blocks master planned by Rafael Viñoly Architects, and glass-fronted global superblocks designed by Gehry Partners, Foster + Partners, and others, which are slowly blotting out the great brick building.

You might argue that the incoherence of the siting of the city's new towers, the lack of connectivity between its emerging districts, and the generic nature of so much of its architecture points toward an underpowered, failed planning system in which corporate money always has the upper hand. Or you might also argue that this is the destiny of a city that has always resisted master planning and big ideas. London is driven by wealth and private interest rather than state-sponsored dogma or social thinking. The blip of postwar modernism and the architecture of the welfare state was, it turns out, a momentary aberration. And in the midst of the current orgy of development and change, there is, surprisingly and almost counterintuitively, the sense of a London architecture emerging. Expressed austerely, occasionally even severely, in the extruded minerals of the earth—brick, stone, ceramic, iron—it seems to take its cue from the power stations as much as the modernist blocks and the terraces its architects admire. In bits of King's Cross, Hackney, Victoria—indeed scattered all across the city—there is a slowly emerging, stripped-back sensibility that nods to the essence of a city of self-effacing row houses and Brutalist blocks.

Many of the best new works in the city appear not as monuments or towers, as museums, or malls, but as pieces of infill—considered, modest, occasional glimpses of a coherent, characterful architecture that has somehow emerged from this polyphony of voices, styles, and forms. Eric Parry Architects' faience facade at 50 New Bond Street and 6a Architects' cast-iron shop front for Paul Smith's store in nearby Albemarle Street seem to represent a new, but also rather traditional, idea of ornament as inherent to structure, a willingness to merge experiment and art with the historic texture and the subtle but intriguing decorative character of the city. Adjaye Associates' Rivington Place, meanwhile, introduces what appears to be a memory of soot-stained industrial architecture scaled at the level of the street, while Herzog & de Meuron adopt the cheap, polycarbonate, and concrete language of industrial construction for their shimmering Laban Building.

The complexity of London's streetscape, the incoherence—perhaps even absence—of an overarching plan, the layering of historic strata, and the way in which modern megastructures are allowed to burst through the filigree lace of medieval scale and grain, mean that buildings are never experienced in a straightforward way. Instead they are glimpsed poking above streets or reflected through shopwindows or rain puddles. The winding of the Thames means that towers appear in vistas where you least expect them as the city seems to wrap around itself and warp through time and space. It is this aspect of urbanity you will find here, architecture as background for the everyday life of the city, impinging rather than imposing. London is not a city of monuments but a metropolis of glances and slightly hidden surfaces. Once obscured by the fog, it now fades into the drizzle or creates the backdrop for the ebbs and flows of the crowd absorbed more in their phones than the streets they are walking through. The photographs here capture precisely—or perhaps impressionistically—that realm of glimpses and impressions, unexpected details and sudden surprises, a cityscape of infinite variety and constantly evolving aesthetics, which, no matter how well we think we know it, folds, collapses, and elides into new views and vistas even as we walk its endlessly intriguing streets.

=

CITY HALL

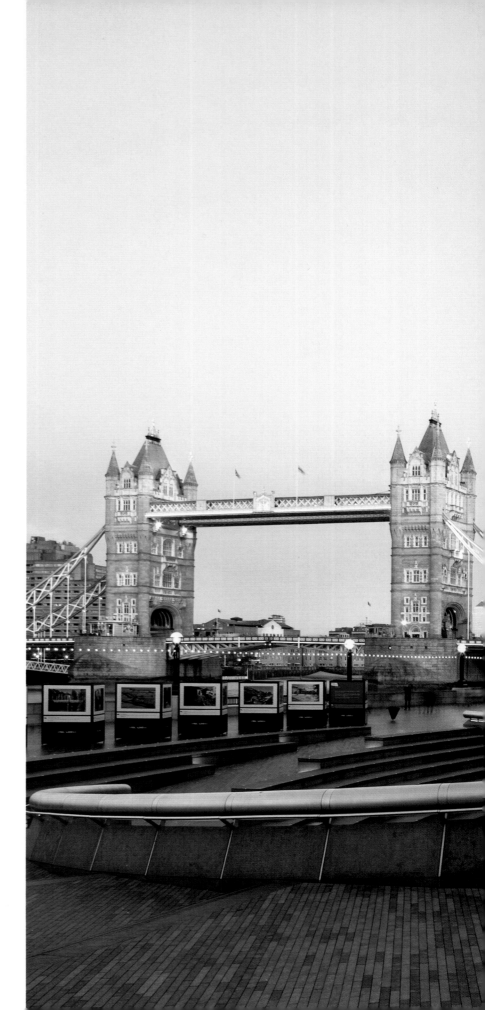

Foster + Partners
2002
The Queen's Walk

In 2000, almost fifteen years after Prime Minister Margaret Thatcher disbanded London's local government, the city formed the Greater London Authority, composed of a mayor's office and a twenty-five-member general assembly. In order to mark the occasion, and establish a home base, the administration appointed Foster + Partners to conceive an iconic City Hall in Southwark, within the shadow of the Tower Bridge. The result, a distorted glass orb of nine layered slabs, resembles an onion or a wedding cake slipping out of kilter. Aside from naturally ventilated offices and power largely derived from photovoltaic glass, City Hall's preeminent feature is a 1,640-foot (500 m) coiled central staircase that rises to its top floor, affording views of the Thames as well as the interior below.

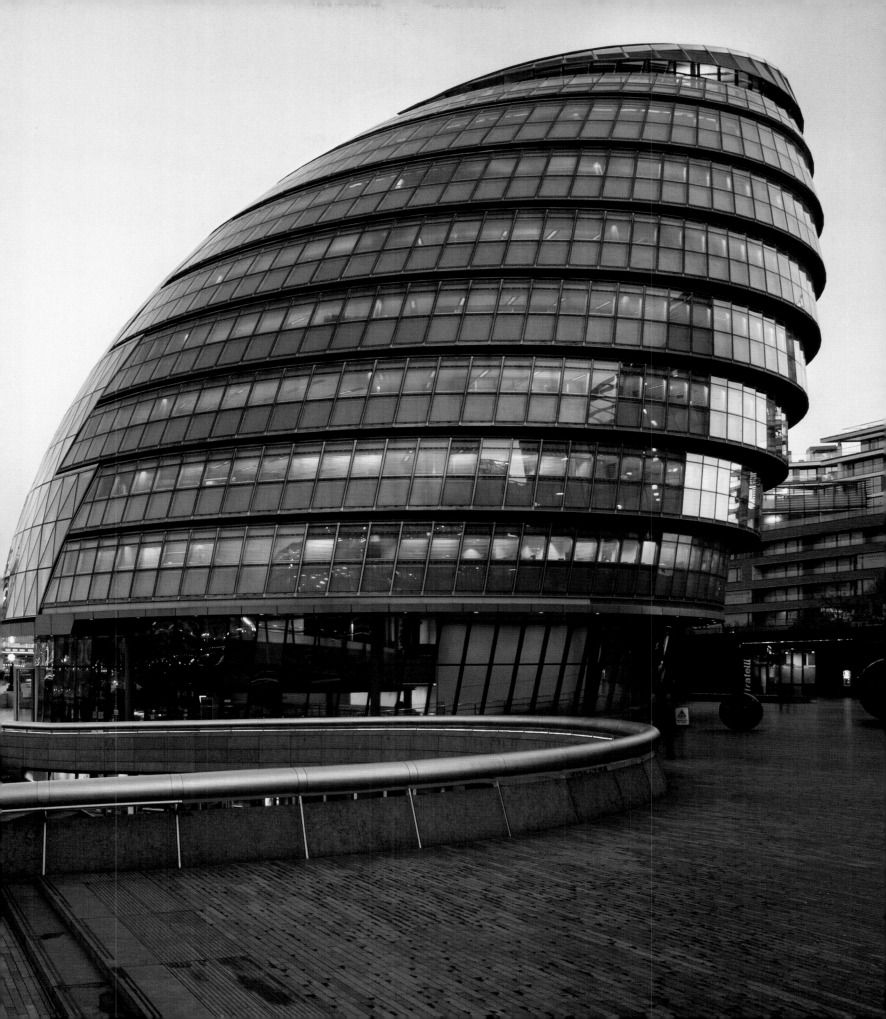

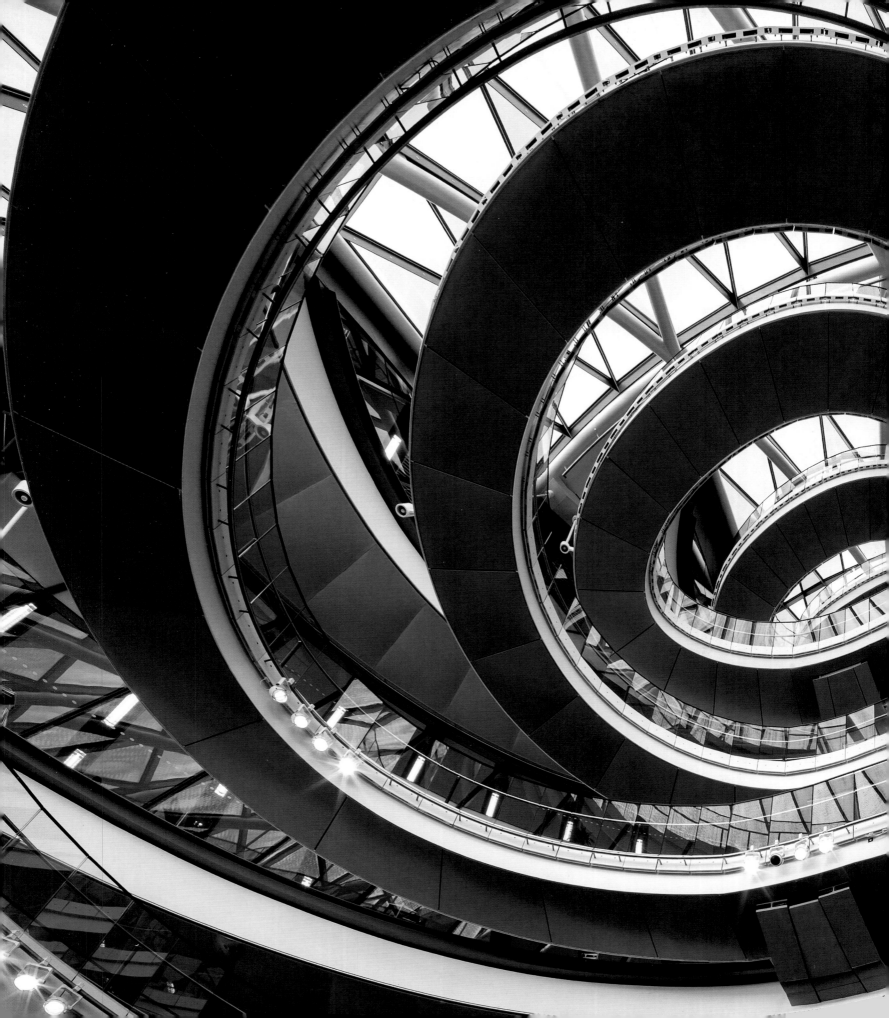

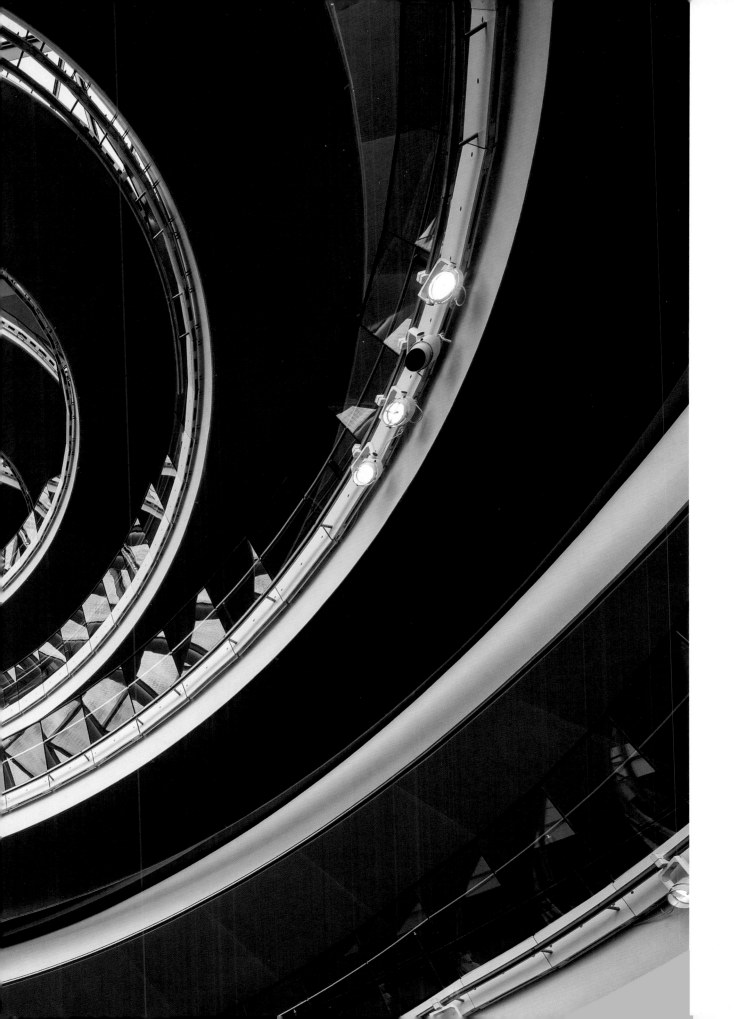

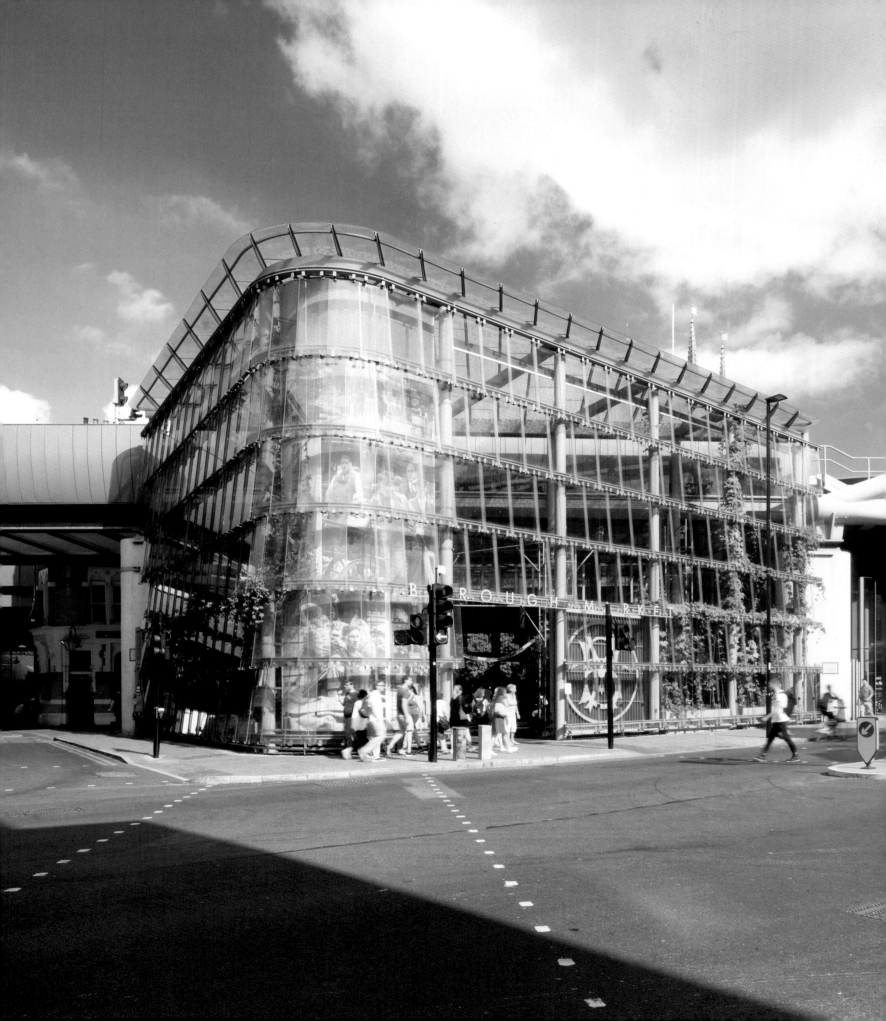

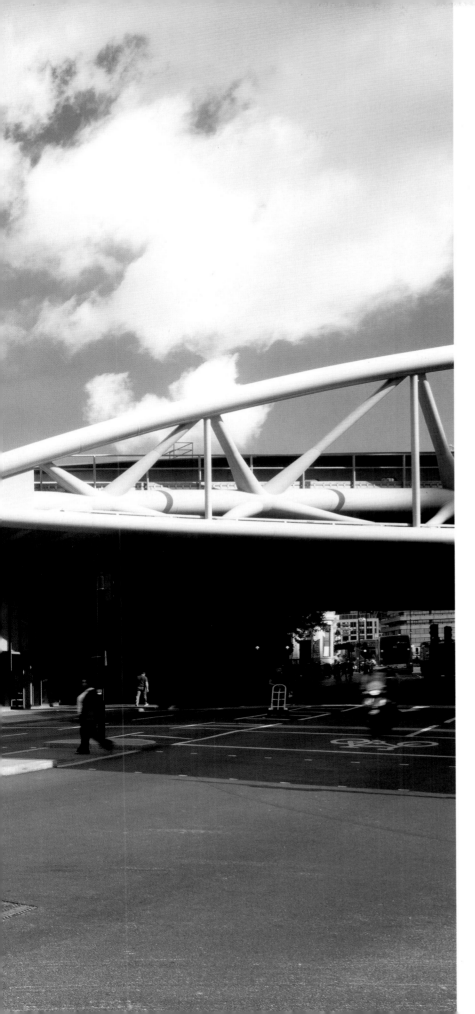

BOROUGH MARKET VIADUCT

Jestico + Whiles
2012
16–26 Borough High Street

As part of Network Rail's effort to improve railway infrastructure and increase the capacity of London Bridge Station, the organization selected Jestico + Whiles to redesign a bottlenecked track viaduct within the station and make additional improvements to the area. Because of the project's location in historic Southwark, constructing the 230-foot (70 m) zinc-clad bridge involved demolishing or altering several listed buildings, which prompted an initial pushback from local residents and merchants. The cast iron Victorian roof of Borough Market had to be temporarily removed, but was elaborately restored off-site; other inclusionary efforts included transforming an empty, derelict space into a beer garden. At the center of the project is Borough Market's new "shopwindow," a steel-framed cube encased in glass panels that overlap to create a central entryway to the expanded shopping center. Its sloping glazed roofs are embossed with a screen-printed leaf pattern that sends mottled shadows onto the entrance floor.

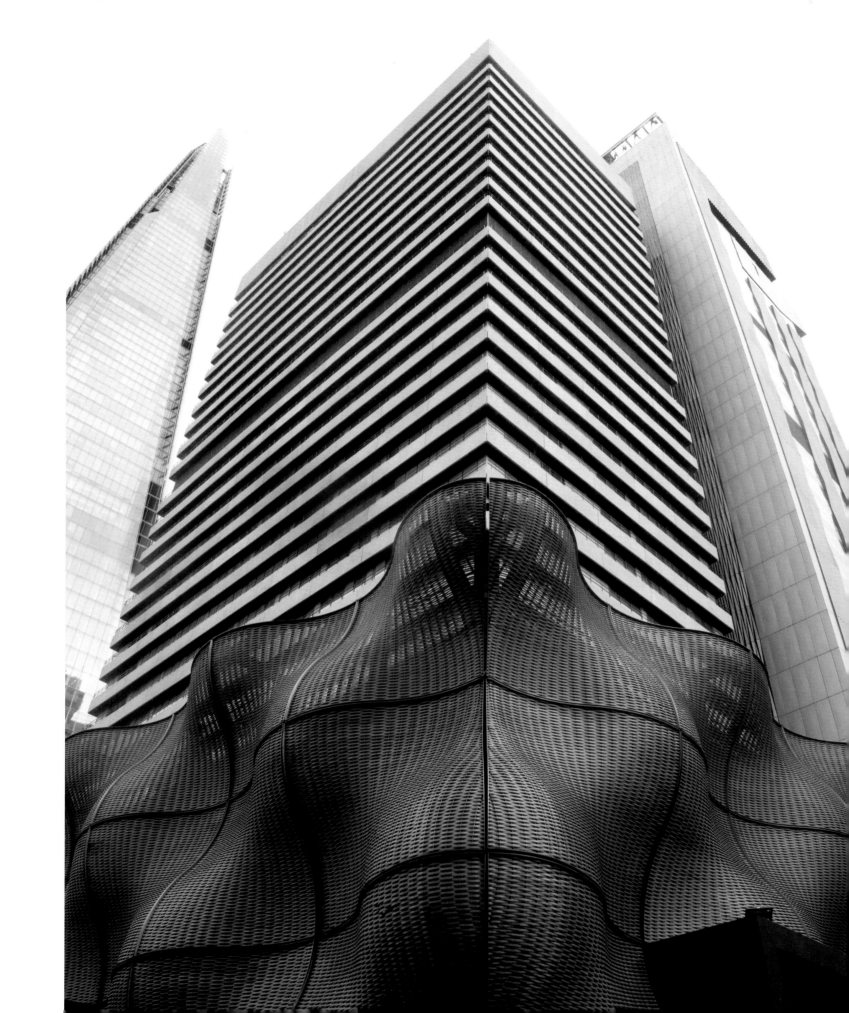

BOILER SUIT

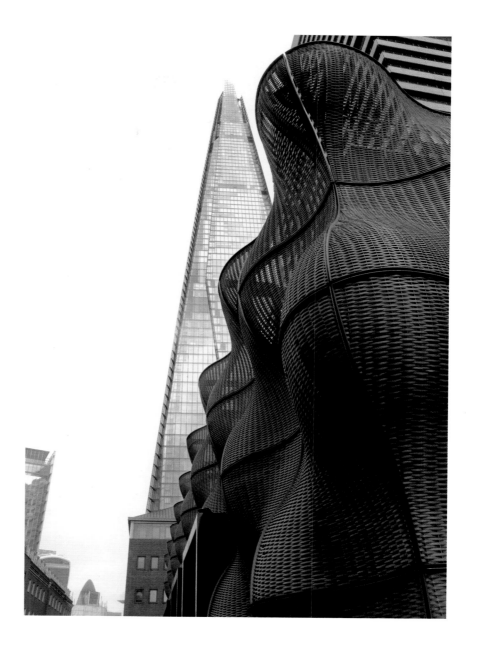

**Heatherwick Studio
2007
Guy's Hospital,
Great Maze Pond**

After years of putting up with
a convoluted exterior resulting
from inconsistent funding,
Guy's Hospital in Southwark
commissioned internationally
renowned designer Thomas
Heatherwick to provide a more
cohesive alternative. Heatherwick
quickly noticed that the building's
nearly imperceptible entryway
was located next to the boiler
room, which many had deemed
to be an eyesore. In covering the
boiler room with woven stainless
steel panels that swell and
collapse in rhythmic, sensuous
curves, Heatherwick was able
to provide an alluring access
point for both pedestrians and
vehicles. The cladding is malleable
and removable, making regular
maintenance easy, and is also
designed to afford glimpses of the
machinery inside.

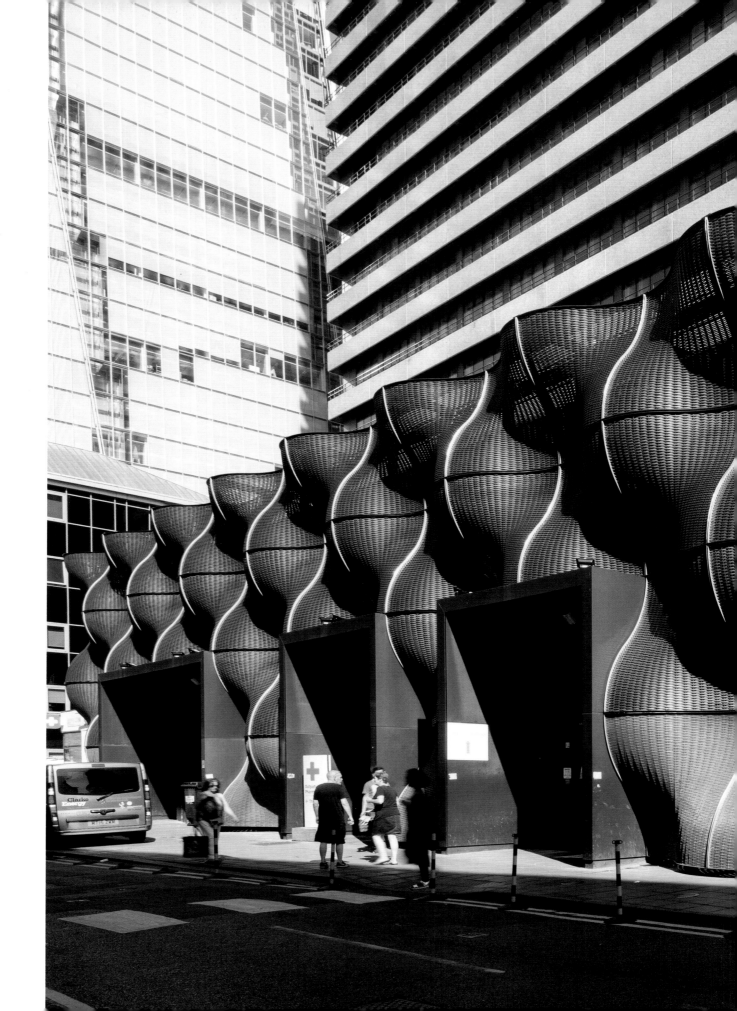

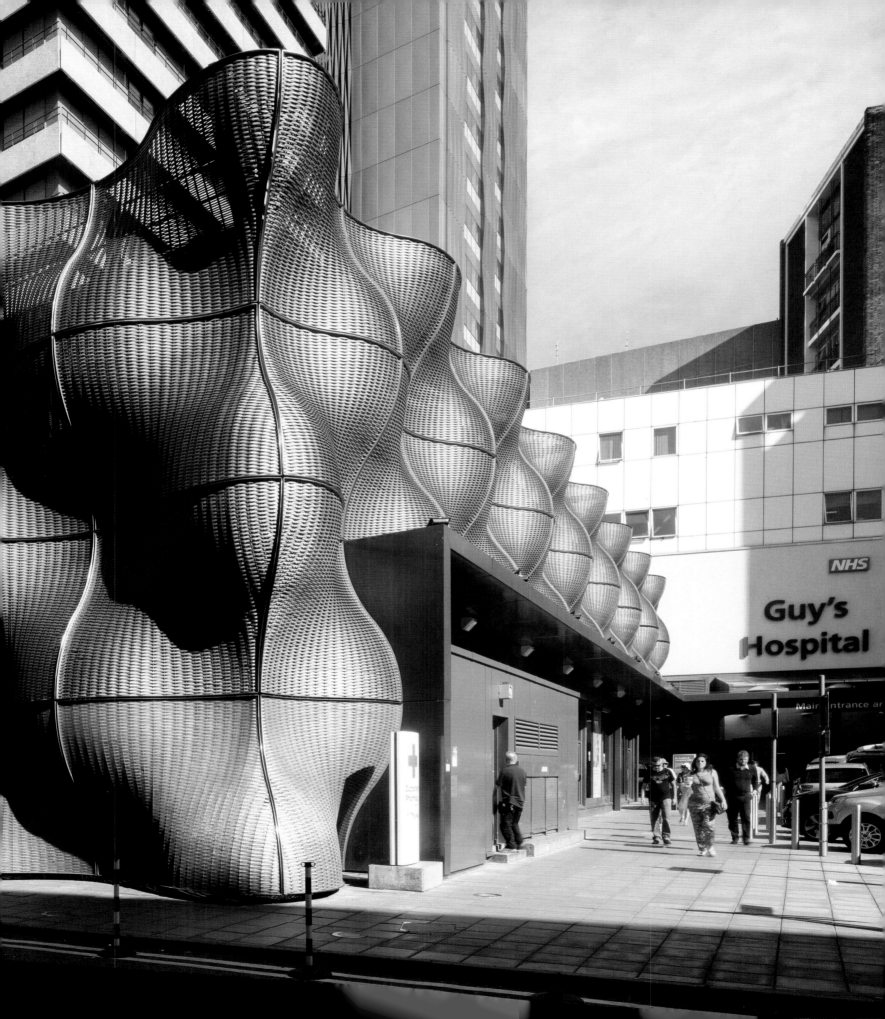

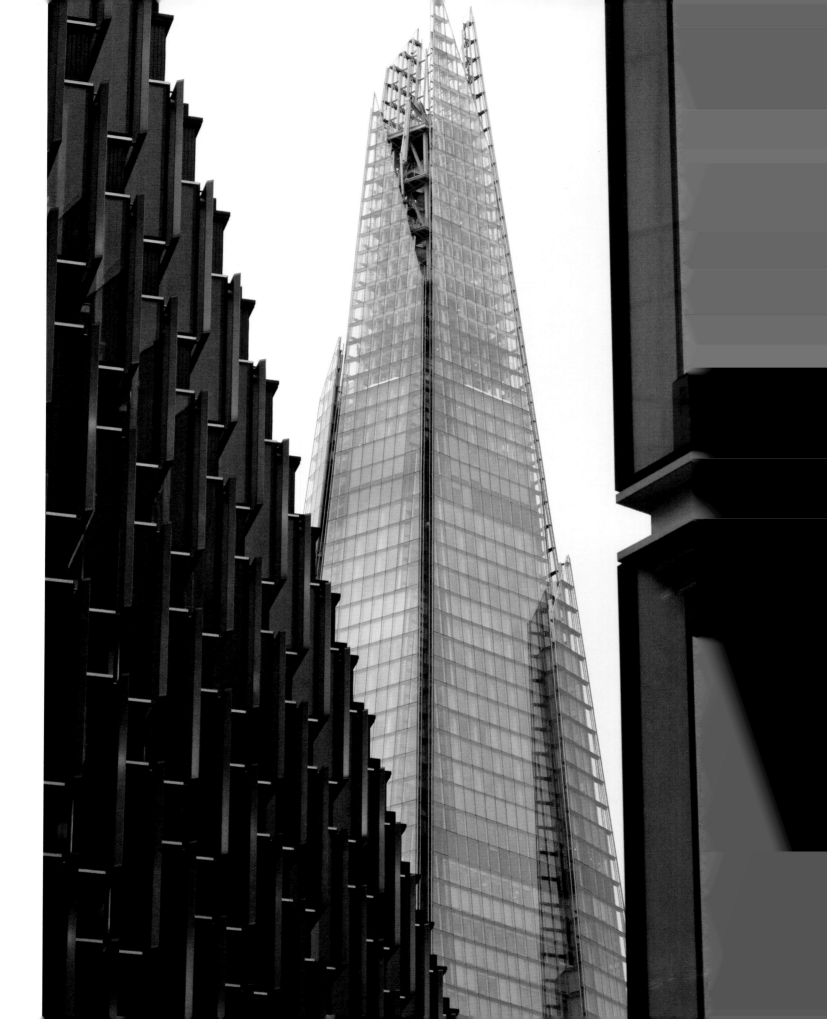

THE SHARD

**Renzo Piano
Building Workshop
2012
32 London Bridge Street**

A bright sliver soaring 1,016 feet (309 m) above the London skyline, Renzo Piano's Shard is a seventy-two-story mixed-use skyscraper that marks the city's movement toward high-density development. Eight jagged glass planes slope toward each other yet never meet, providing ventilation via open fissures and evoking the silhouette of a ship's mast. The complexion of the structure's exterior is in constant flux thanks to Piano's use of low-iron (also known as extra-white) glass that assumes an iridescent hue during peak daylight hours. One of the tallest buildings in Western Europe, the Shard contains a ground-level public piazza with rooms set aside for art installations. Its broadest lower floors are devoted to office spaces; overhead are restaurants, a hotel, and private apartments placed in ascending order. A viewing gallery takes up the building's uppermost floors, affording visitors a view of up to 40 miles (64 km) in every direction.

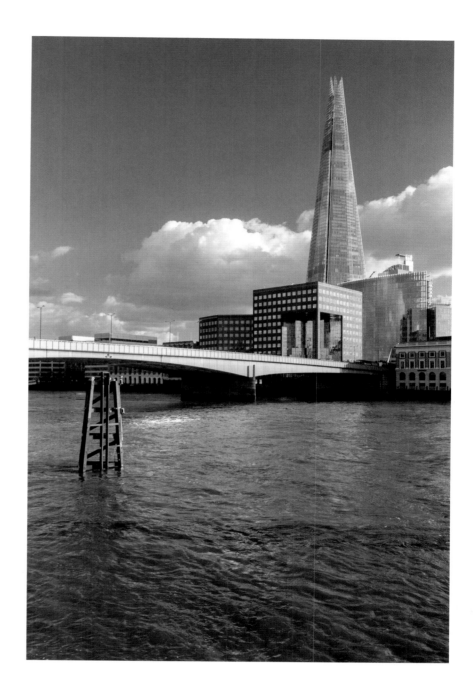

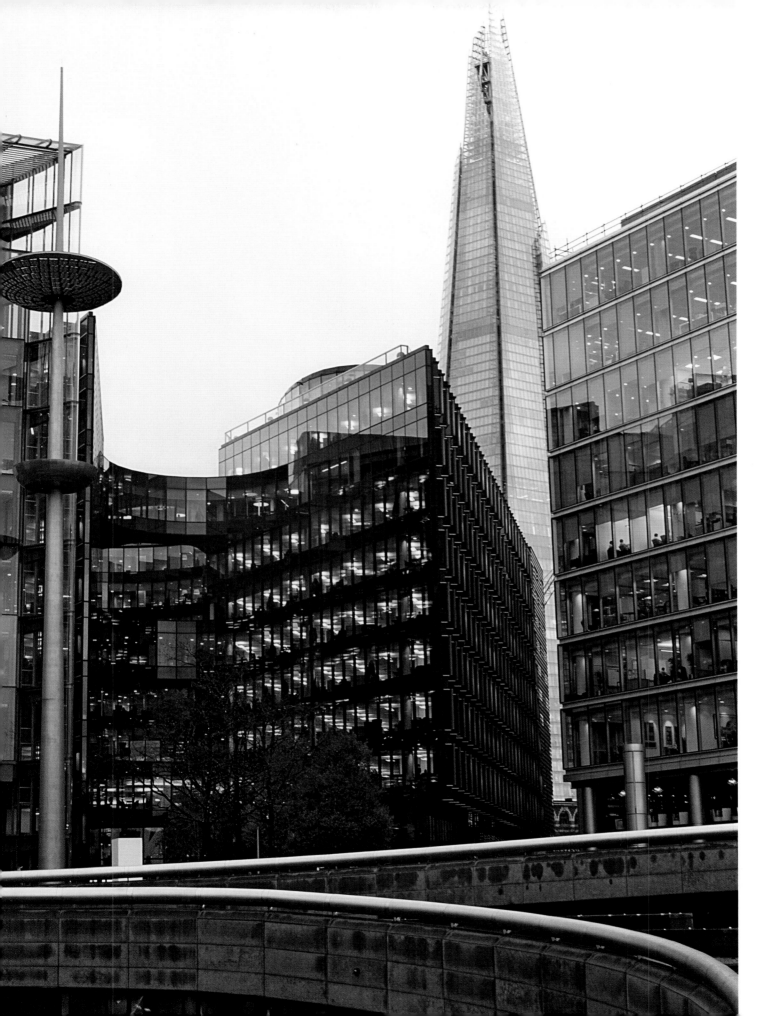

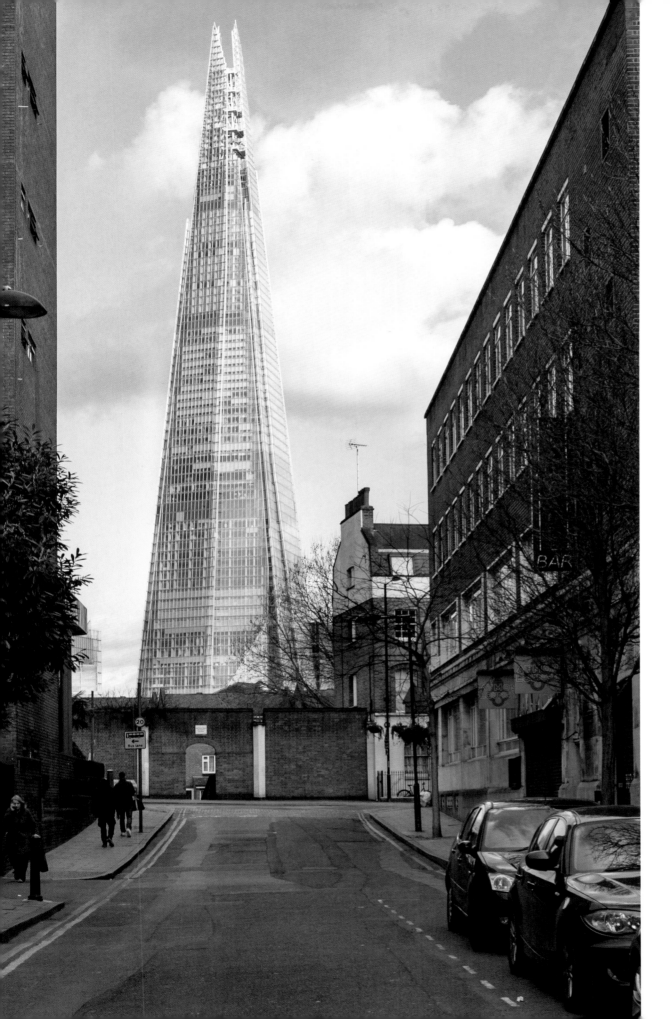

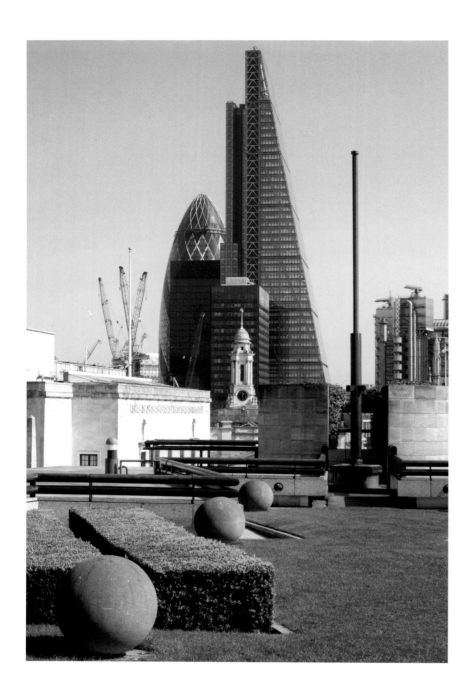

Rogers Stirk Harbour + Partners
2014
122 Leadenhall Street

A skinny, scalene triangle looming over the Square Mile like an enormous cheese grater, the Leadenhall Building teams up with the Gherkin and the Walkie-Talkie to make the neighborhood London's quirkiest architectural hotbed. Its vertical, tapered profile deferentially leans away from nearby St Paul's Cathedral and is facilitated by a ladder frame adorned with ascending arrows. The building's floor plans diminish in area as they extend upward. A massive half-acre public space takes up the bottom seven stories, containing a landscaped terrace and restaurant. The entire structure is wrapped in a double-glazed layer that regulates heat loss and solar gain; prominent, diagonal structural braces hold the glass envelope in place.

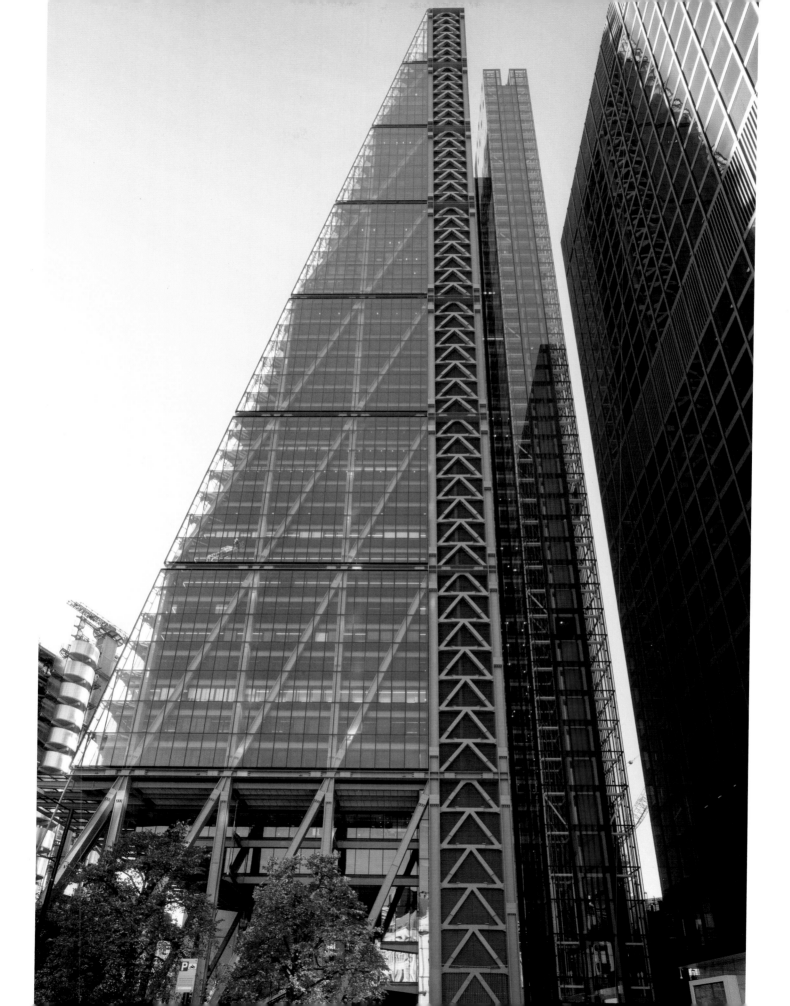

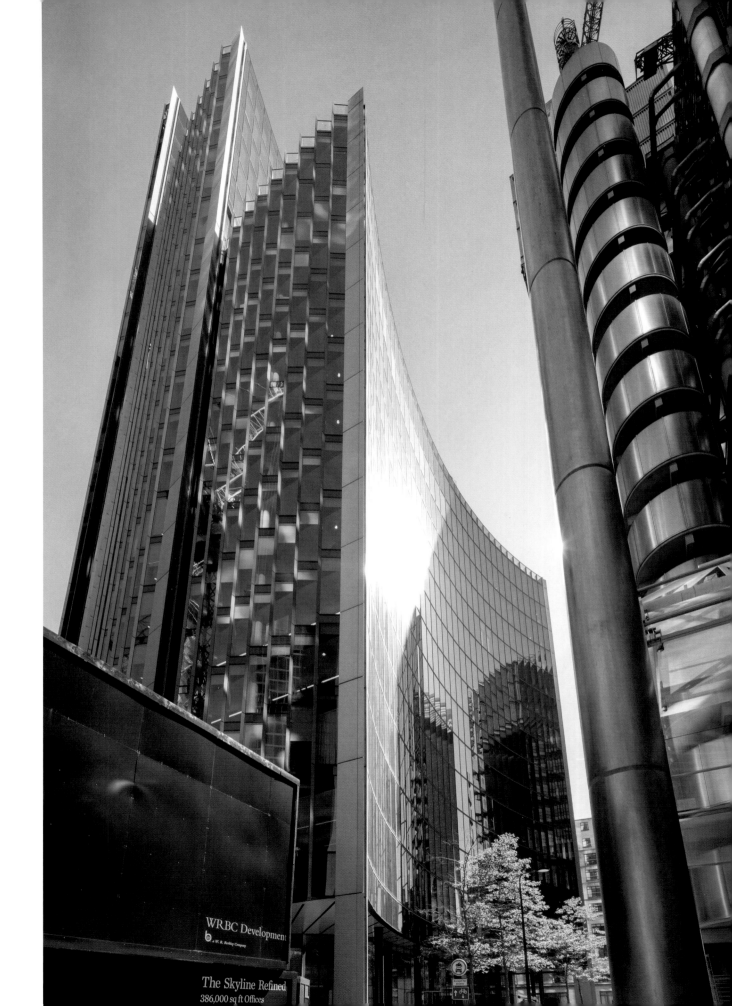

WRBC Development

The Skyline Refined
386,000 sq ft Offices

WILLIS HEADQUARTERS

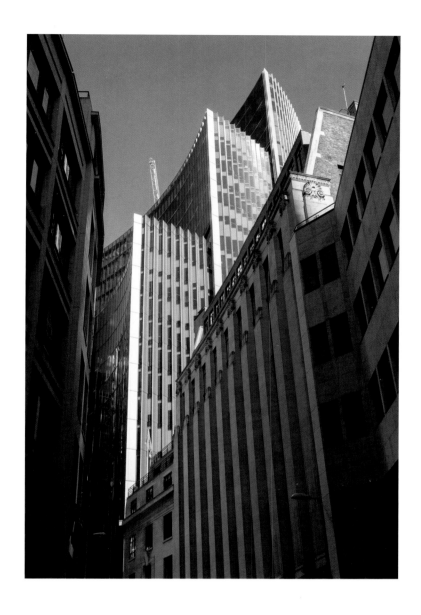

Foster + Partners
2008
51 Lime Street

Over thirty years after he designed Willis's famed offices in coastal Ipswich, Norman Foster and his firm generated a similarly revolutionary structure for the insurance company's new headquarters in Central London. Two attached buildings fan themselves outward in three arcing, stepped layers, edged by sawtoothed windows that recall a neo-futurist crustacean. The concave facade of the smaller ten-story building is bordered by ground-level shops and restaurants that draw customers from nearby Leadenhall Market; its glimmering outer coating envelops the rest of the structure, creating visual cohesion. Finished with mica, the reflective exterior minimizes solar gain, greatly contributing to 51 Lime Street's BREEAM Excellent rating.

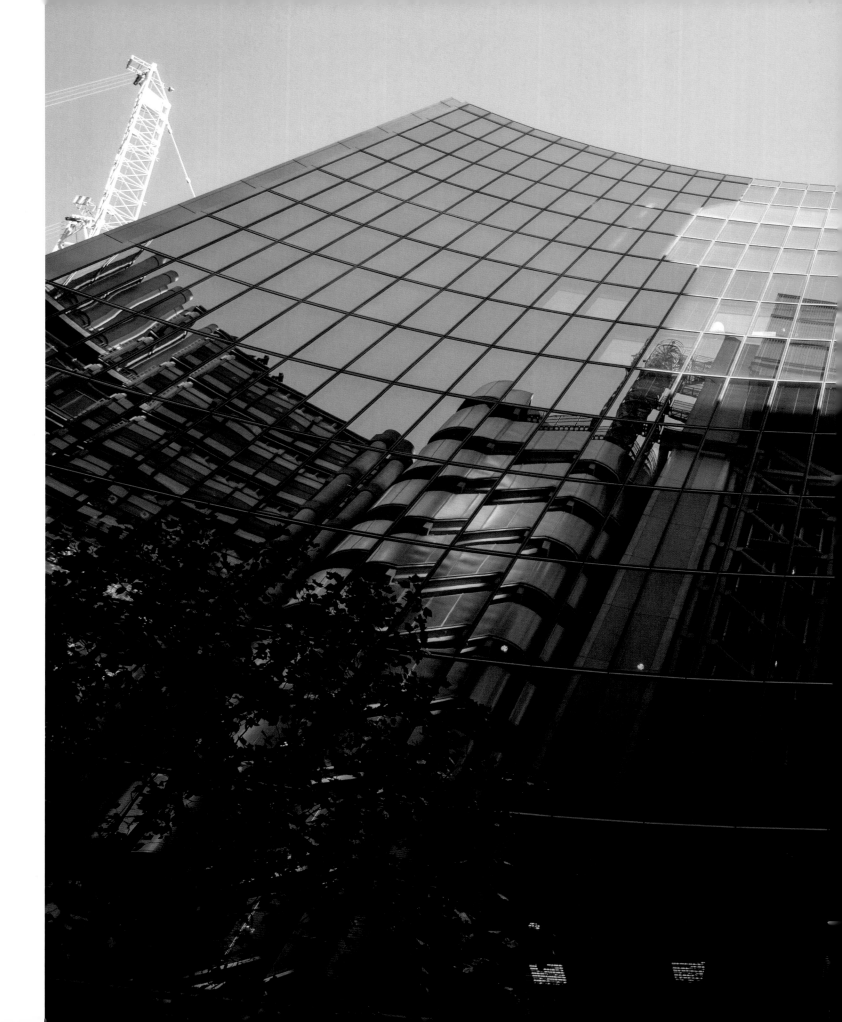

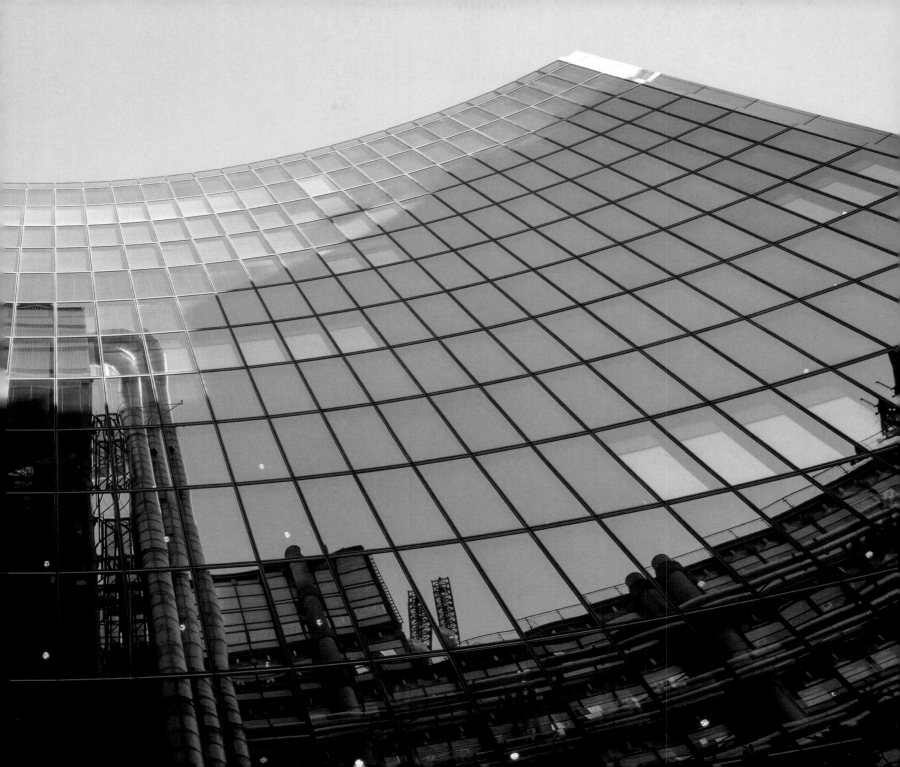

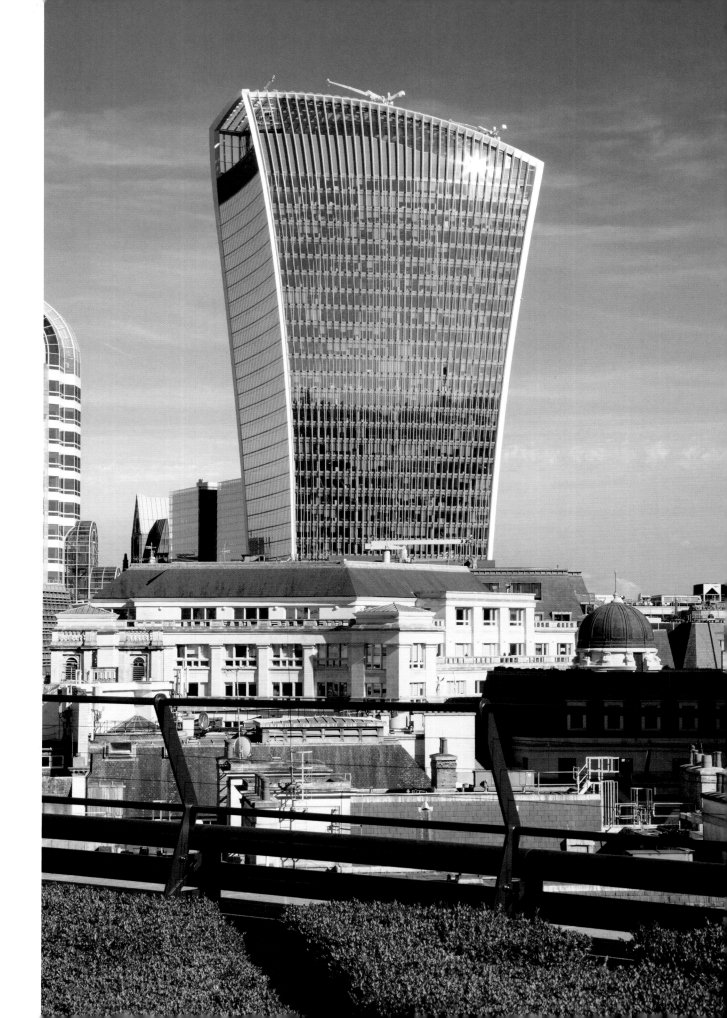

20 FENCHURCH STREET

Rafael Viñoly Architects
2014
20 Fenchurch Street

Thanks to its controversially bulbous form resulting from floor plates that widen as they reach higher over the Thames, Rafael Viñoly's eye-catching building was promptly dubbed the "Walkie-Talkie" upon its completion. The top-heavy design moves beyond the conventional boundaries of commercial architecture, creating additional floor space on the upper stories, which are the costliest and most coveted. Viñoly outfitted the northern and southern facades with extensive glazing, and gave the south side a concave shape that generates shade during peak sunlight hours. The building is topped by a three-story public "sky garden" that provides curated green space, a café, and a panoramic viewing deck.

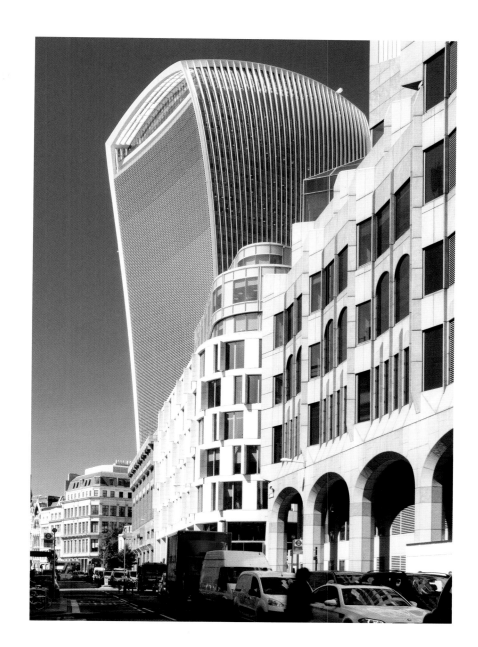

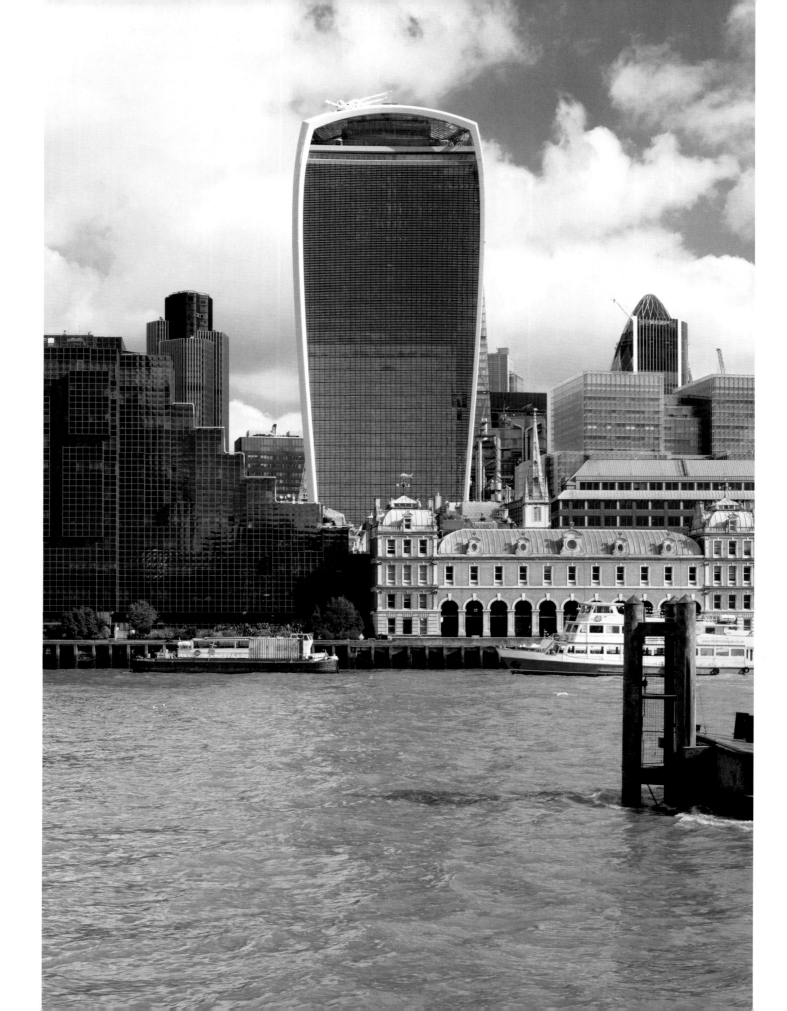

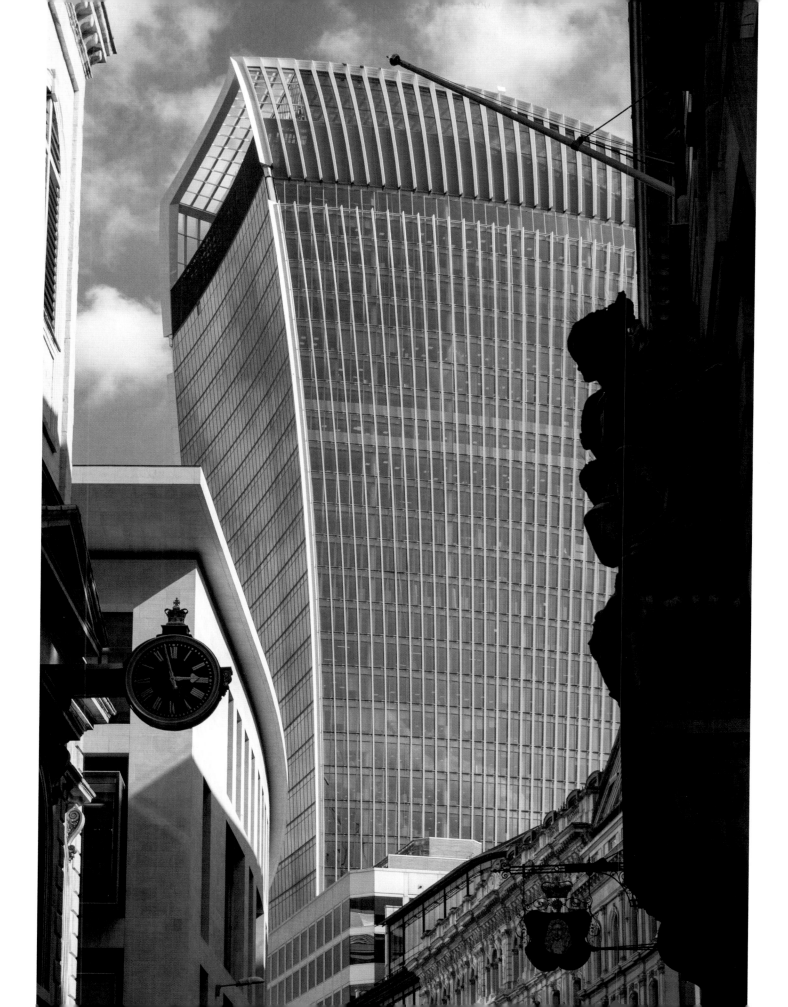

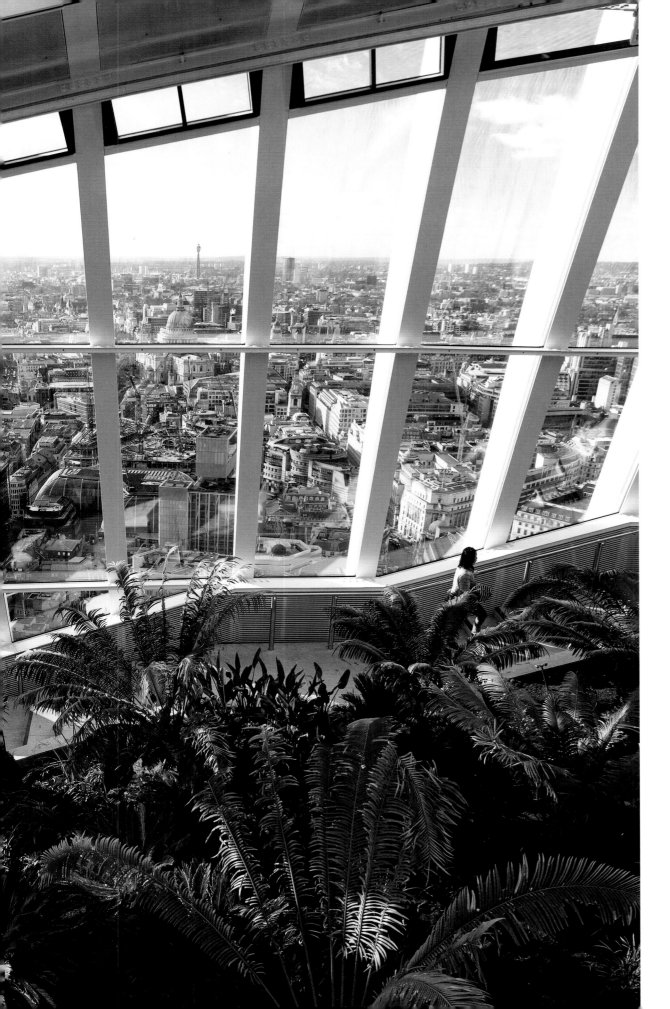

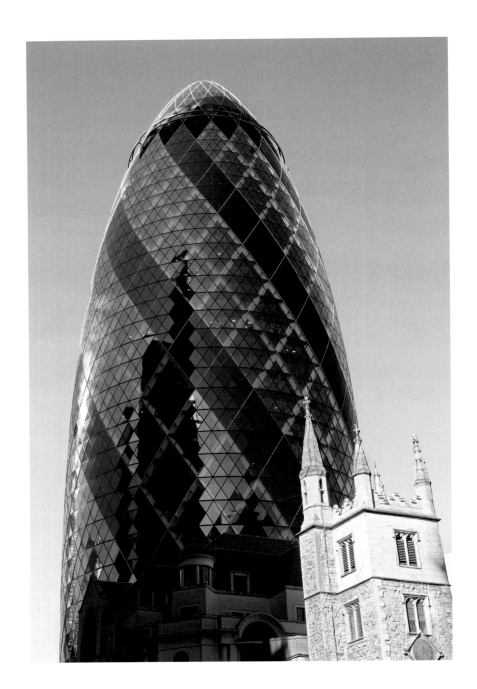

Foster + Partners
2003
30 St Mary Axe

With a soaring, organic silhouette that has elicited comparisons to a pinecone, egg, phallus, and, most commonly, a pickle, the Gherkin might best be imagined as a plump, glass-embossed cigar in the mouth of its principal architect Norman Foster. Officially known as 30 St Mary Axe, the forty-one-story, Stirling Prize–winning building became an icon immediately upon its completion in 2003, as well as an example of how environmentally sustainable tall office design can further economic growth rather than hinder it. The Gherkin's tapered cylindrical form is lined with the radial geometry of a helix, as diamond-shaped, double-glazed glass panels produce an exterior curtain that reduces solar gain. Beneath the building's patterned gray whorl, spiraling, conjoined atria provide recreational spaces for offices on each level; an arcade of shops and restaurants is situated in the lobby below. After more than a decade, the Gherkin's influence outweighs its individual success, as evidenced by the outcropping of futuristic high-rises now clustered around it.

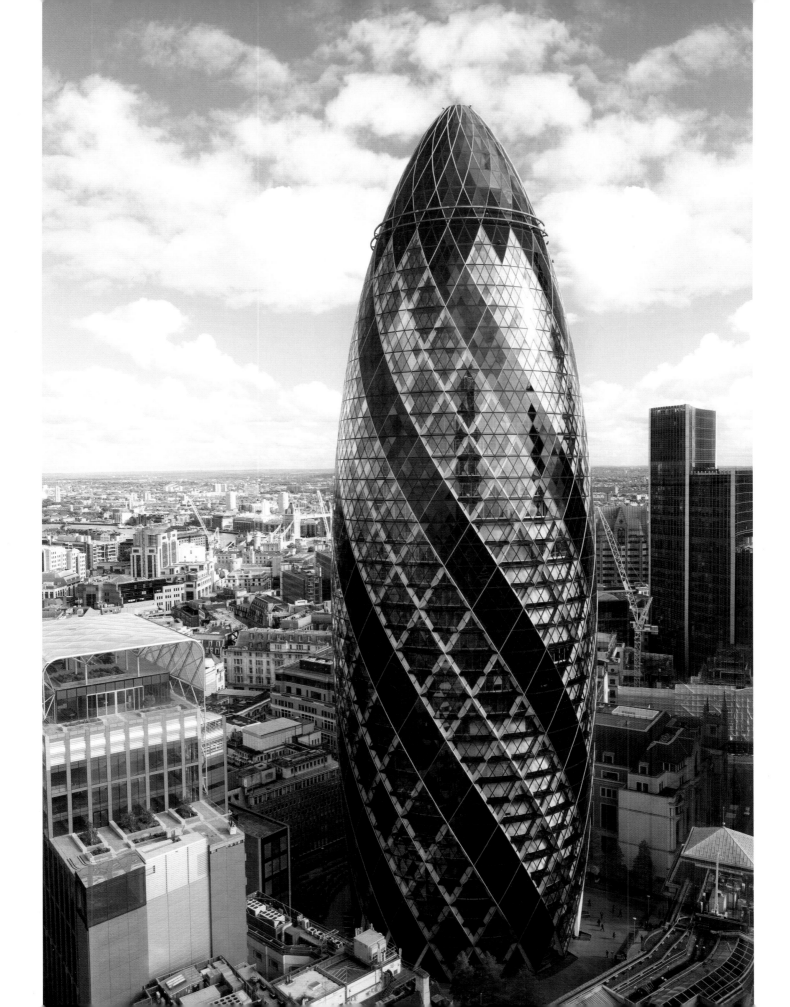

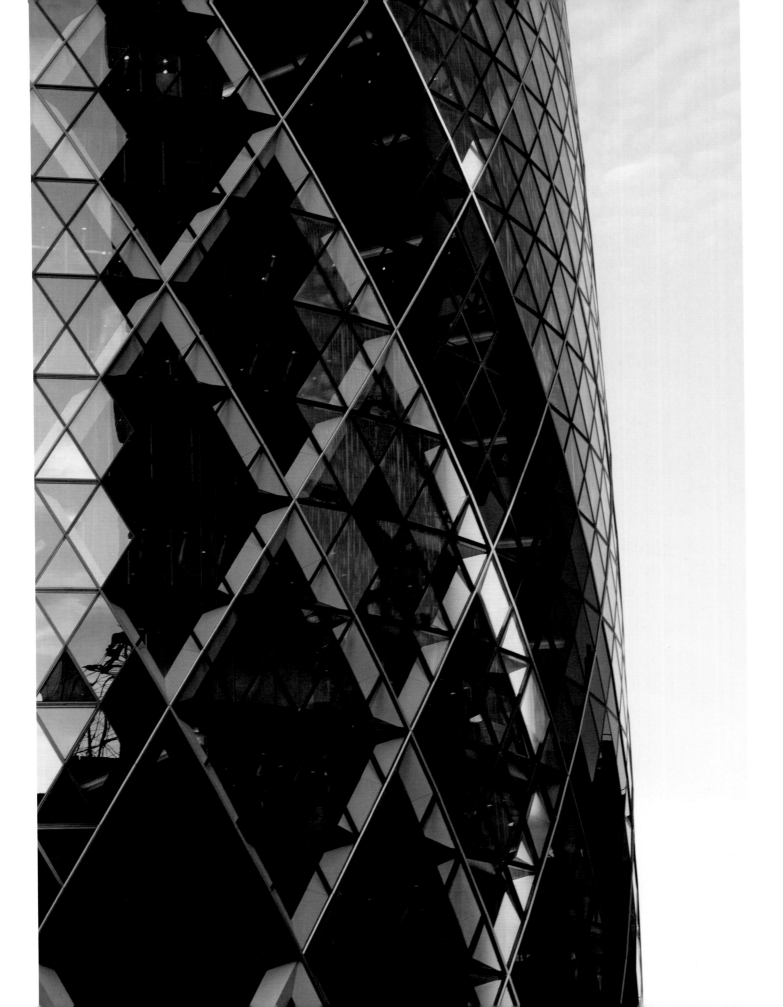

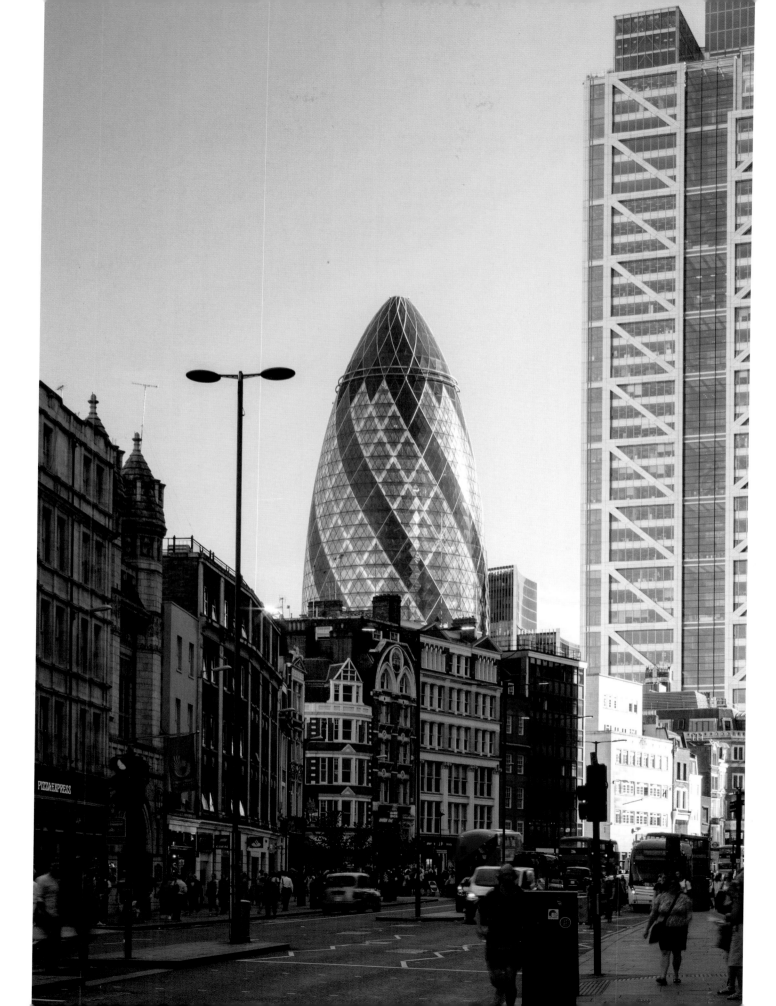

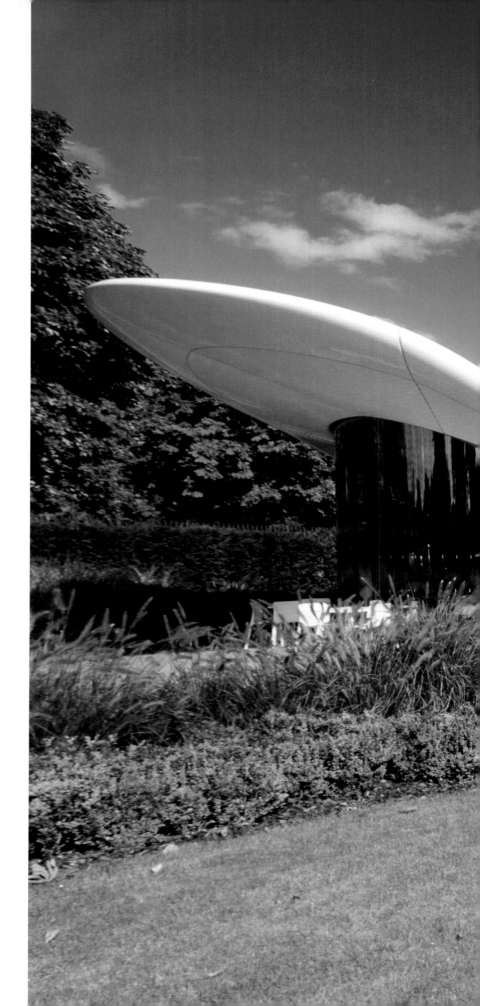

SERPENTINE SACKLER GALLERY

Zaha Hadid Architects
2013
West Carriage Drive

On the western edge of Hyde Park, in the green epicenter of the city, Zaha Hadid's 2013 Serpentine Sackler Gallery—across the lake from its forebearer, the Serpentine Gallery—initially appears as an exercise in architectural dichotomy. The Magazine, a colonnaded, nineteenth-century gunpowder store, holds the museum's primary gallery spaces, housed in two converted brick barrel vaults. A rippling, tensile extension with a glass-fiber, woven-textile membrane oozes from the Magazine, appearing to speak its own architectural language, like so many of Hadid's curved inventions. And yet, the pavilion, with its organic form that begs to be dubbed "serpentine," sinuously complements the staid dynamism of the museum's main building. Containing a ticket office and restaurant, it suggests a white sheet being removed from a sculpture, except that it is the sculpture.

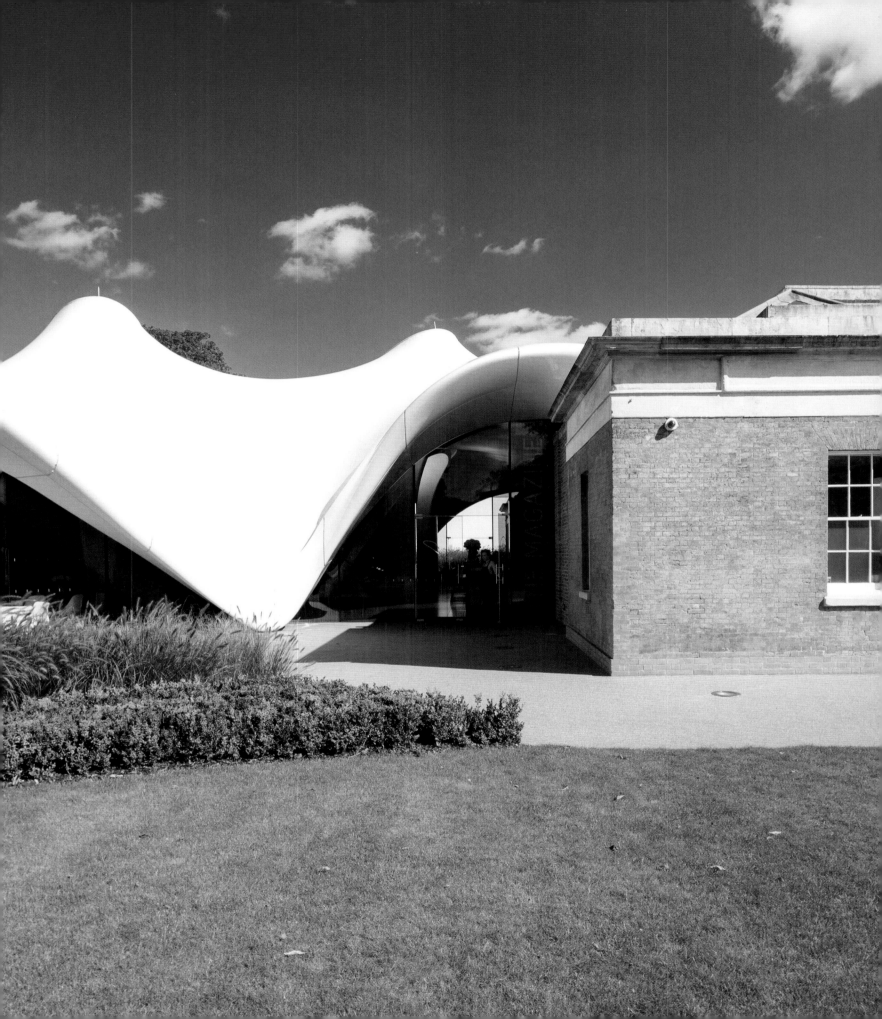

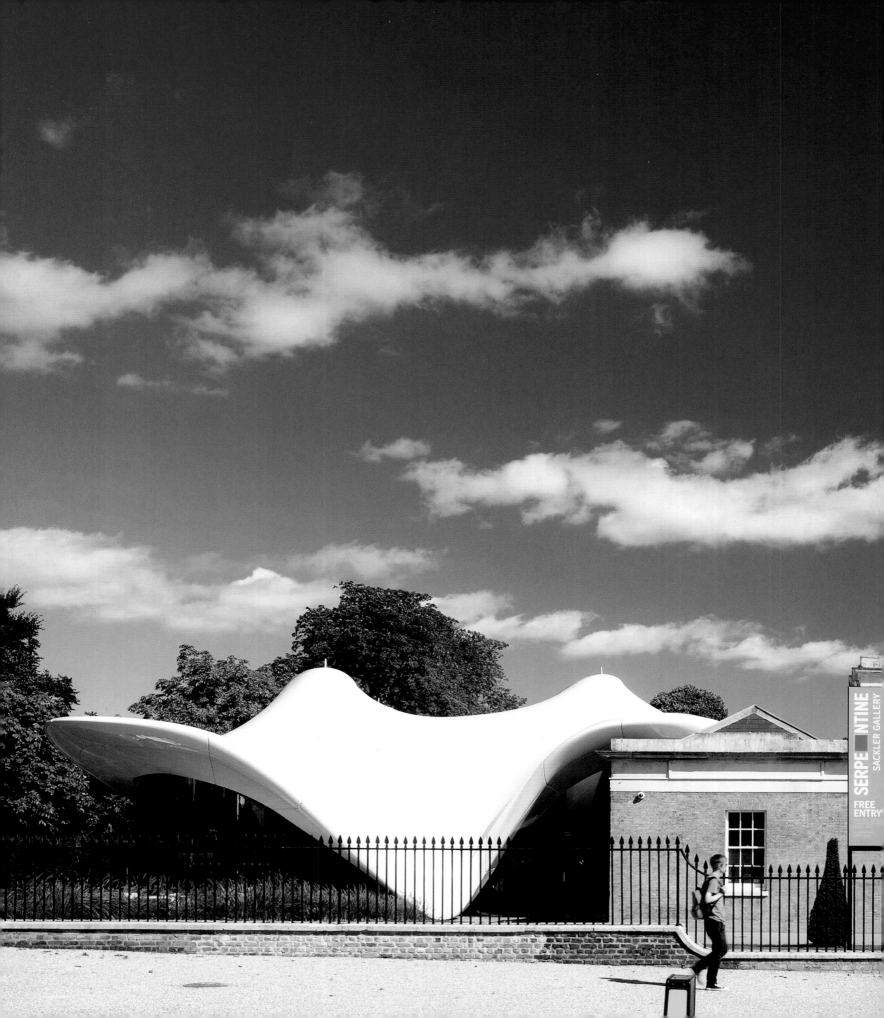

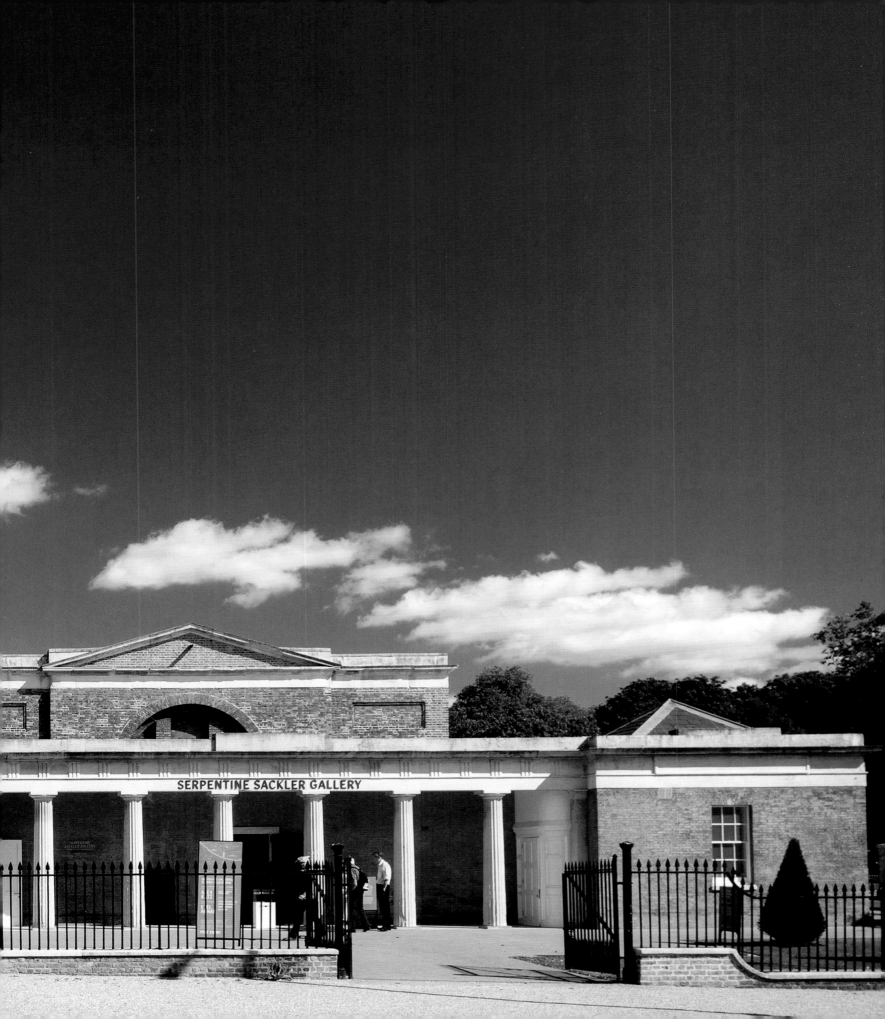

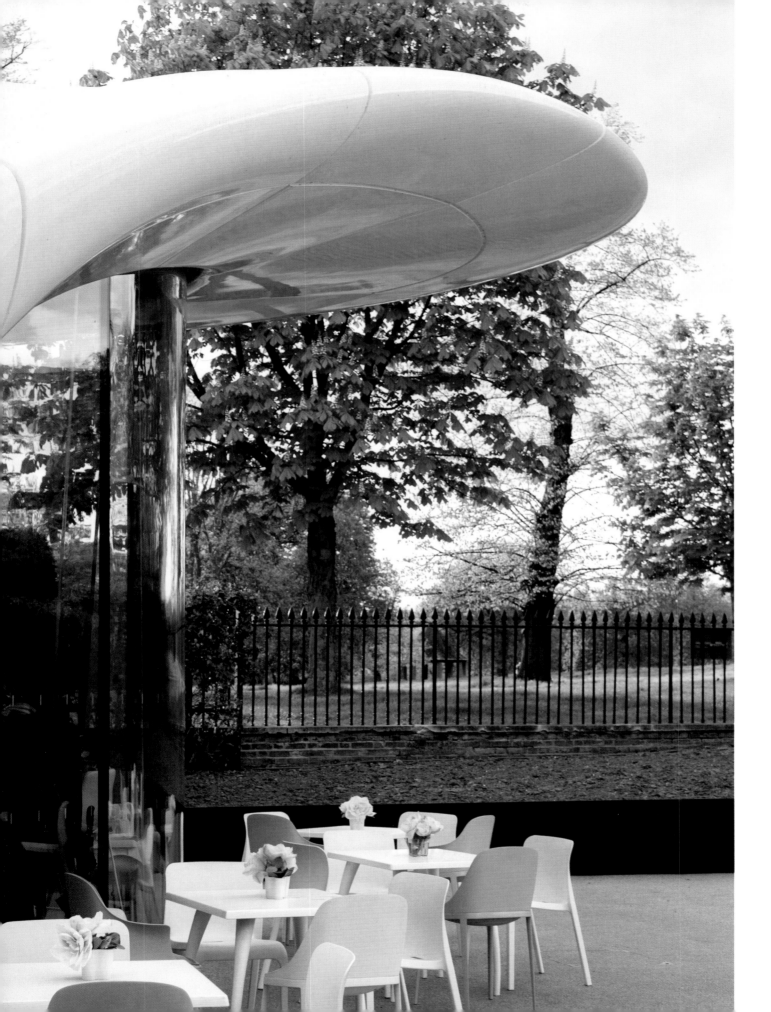

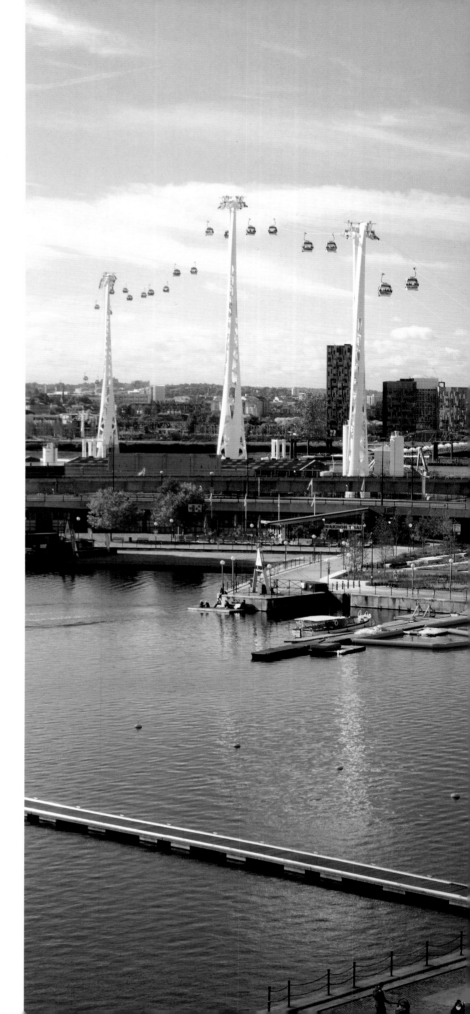

EMIRATES AIR LINE

WilkinsonEyre
2012
Emirates Greenwich Peninsula
and Emirates Royal Docks

Spanning the Thames, the
Emirates Air Line is London's
newest form of transportation,
and certainly its most aeronautic.
Two glazed pavilions, one
adjacent to the Royal Victoria
Dock, the other on Greenwich
Peninsula, transport customers
crosstown between two of the
city's most vibrant redeveloping
neighborhoods. Three twisting
spires sprout nearly 300 feet (90
m) above the river like inverted
icicles, strung together by wires
that send streams of cable cars
across the water in under ten
minutes. Opened just in time
for the 2012 Olympics, the Air
Line connects directly to the
London Underground while
granting passengers a much more
absorbing visual experience.

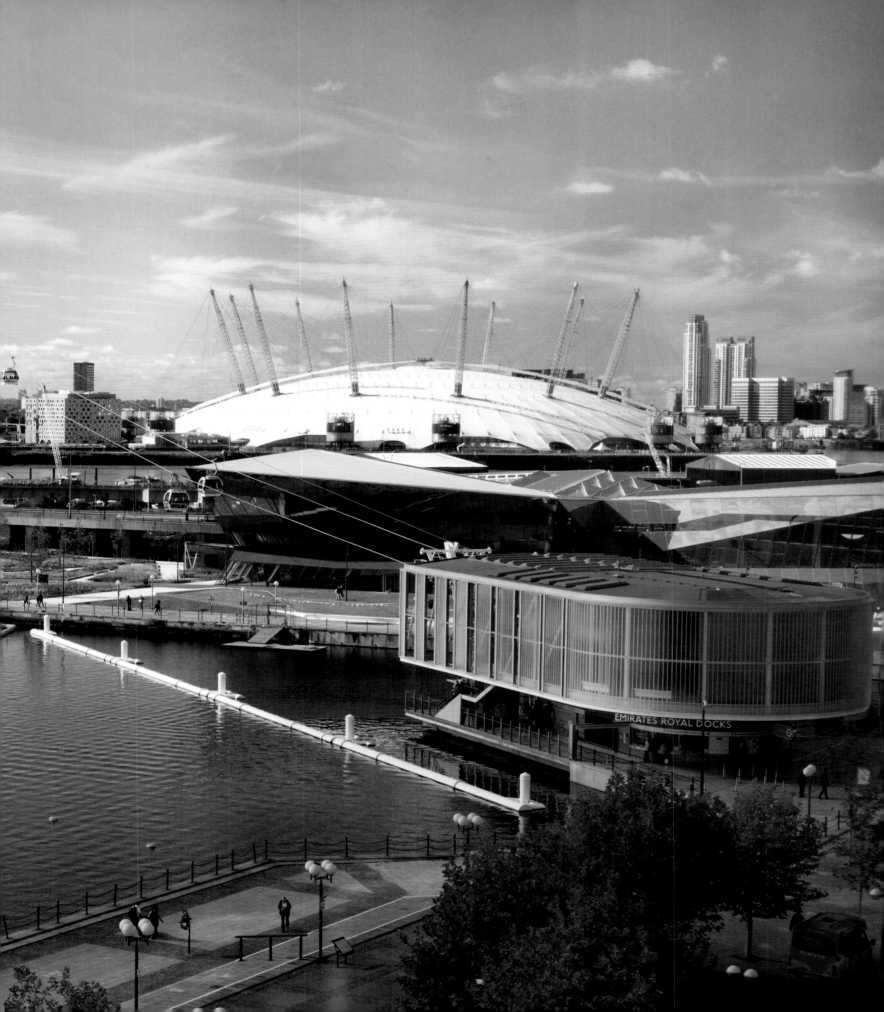

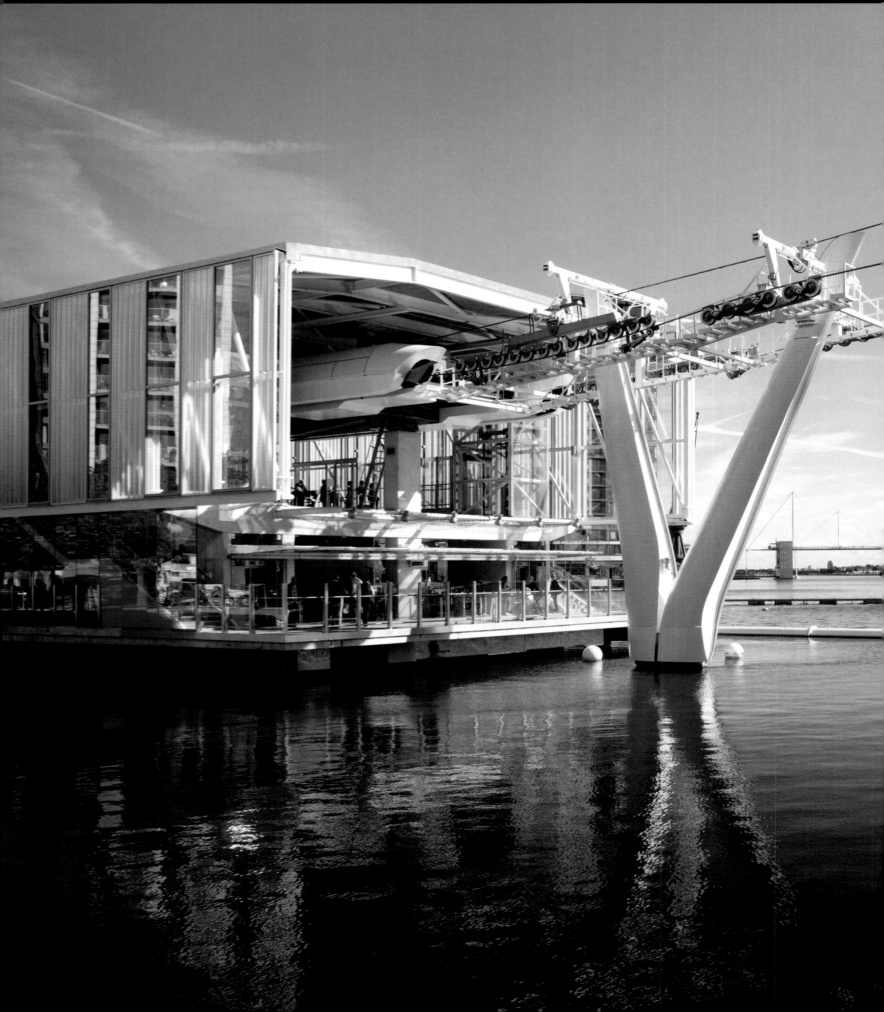

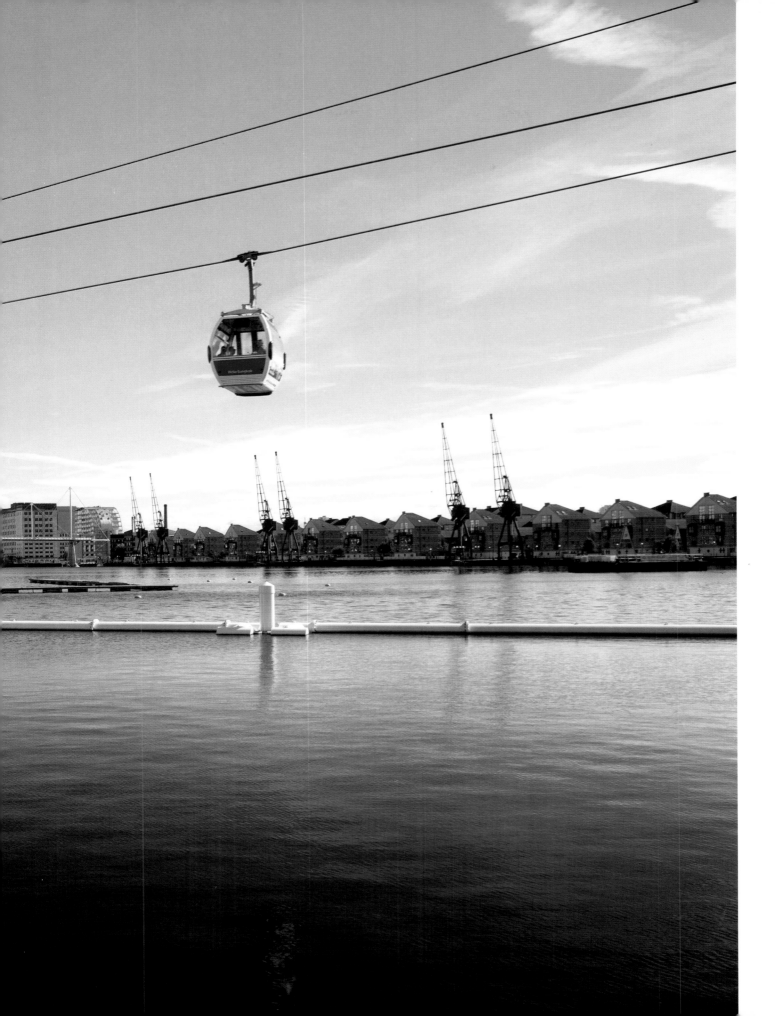

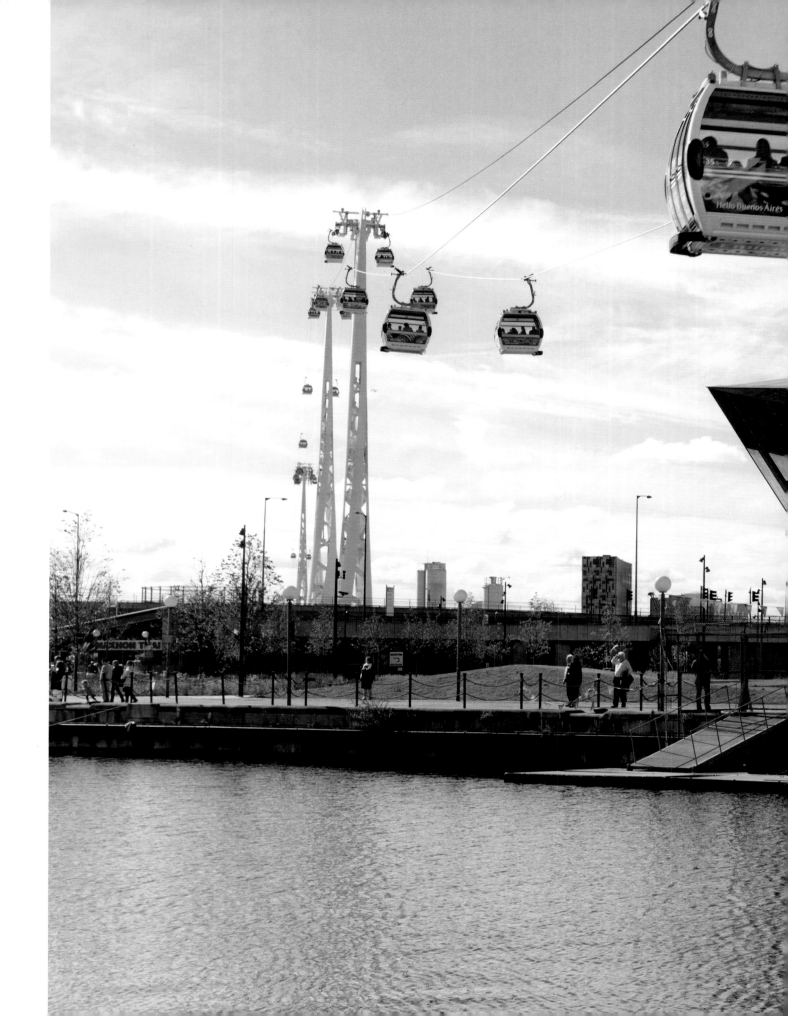

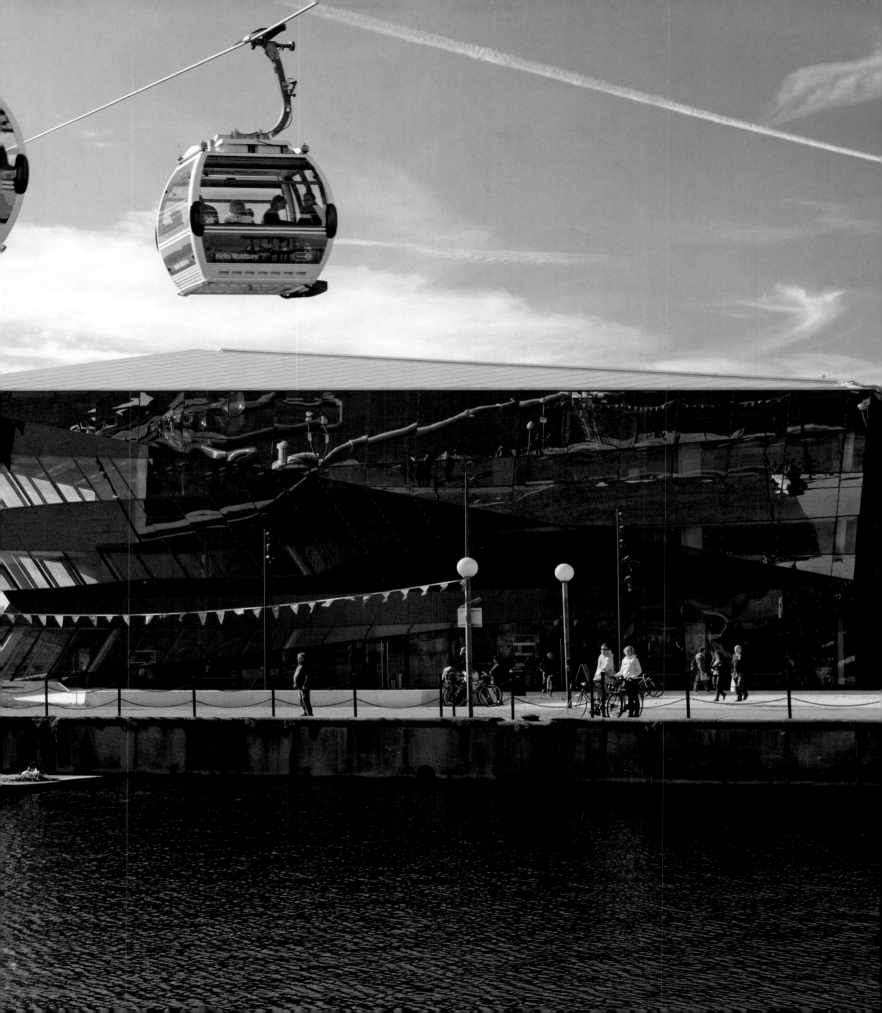

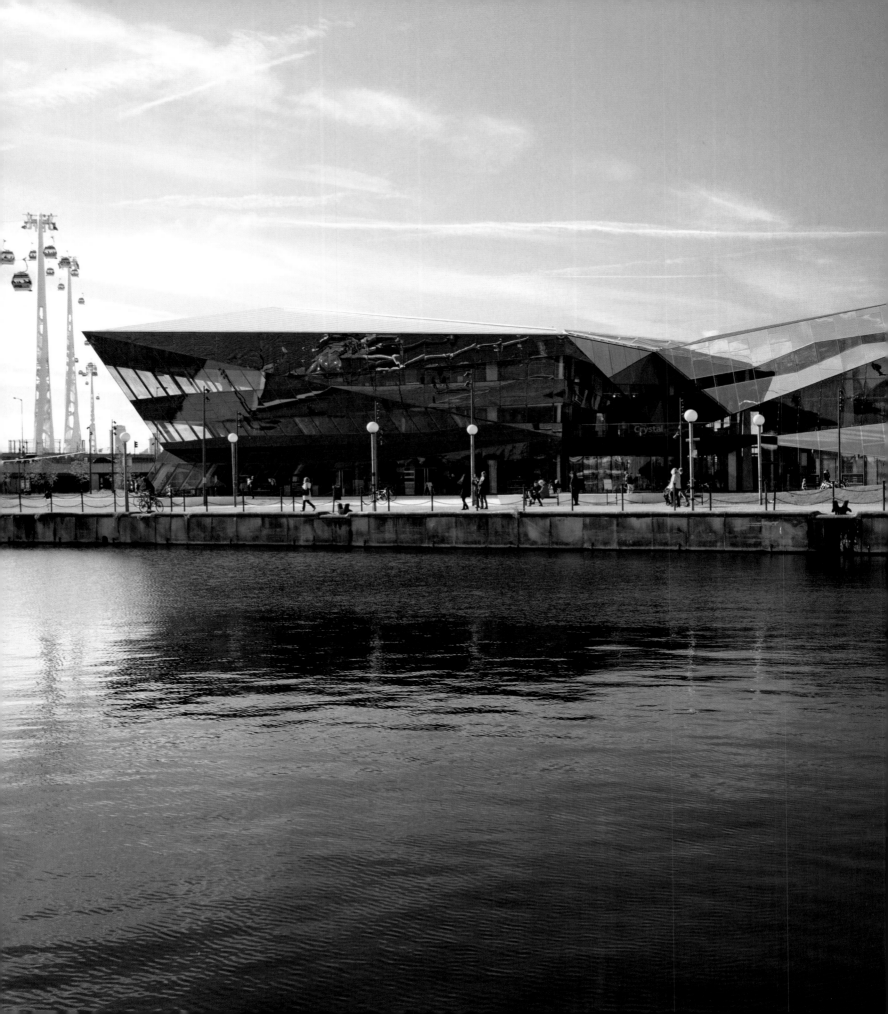

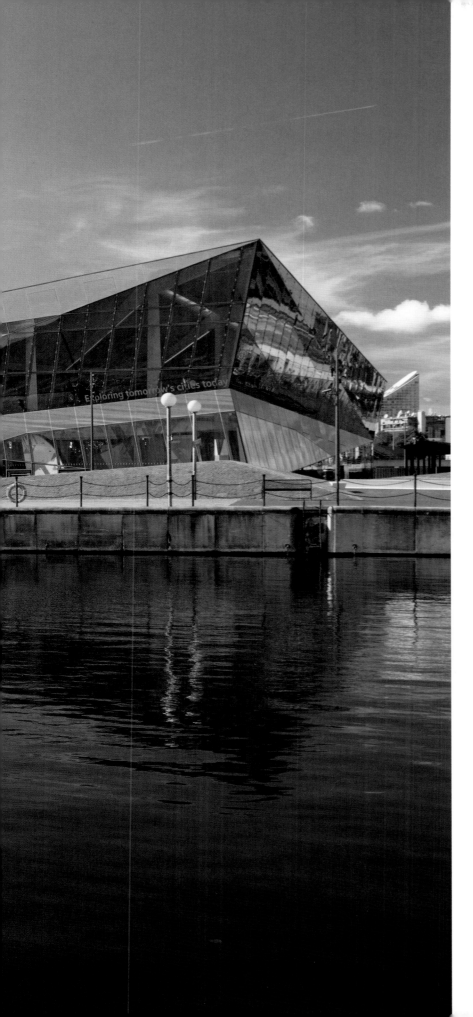

THE CRYSTAL

WilkinsonEyre
2012
1 Siemens Brothers Way

Commissioned by Siemens as an information center focusing on sustainable design, the Crystal rests on the edge of East London's Royal Docks like an angular, glistening butterfly. In addition to a permanent exhibition space that educates visitors on familiar issues such as renewable energy and efficient consumption, the Crystal acts as a physical exemplar in itself, reigning as the first building to earn both LEED Platinum and BREEAM Outstanding certifications. Triple-glazed windows admit natural light but filter solar energy in order to maintain consistent natural heating; runoff from rainwater is stored in a recessed storage tank, which can be warmed by ground source heat pumps; solar panels supply supplementary energy, eliminating the use of fossil fuels. Furthermore, the structure showcases Siemens's latest environmental innovations, as it is hardwired with over 2,500 interconnected sustainable technologies.

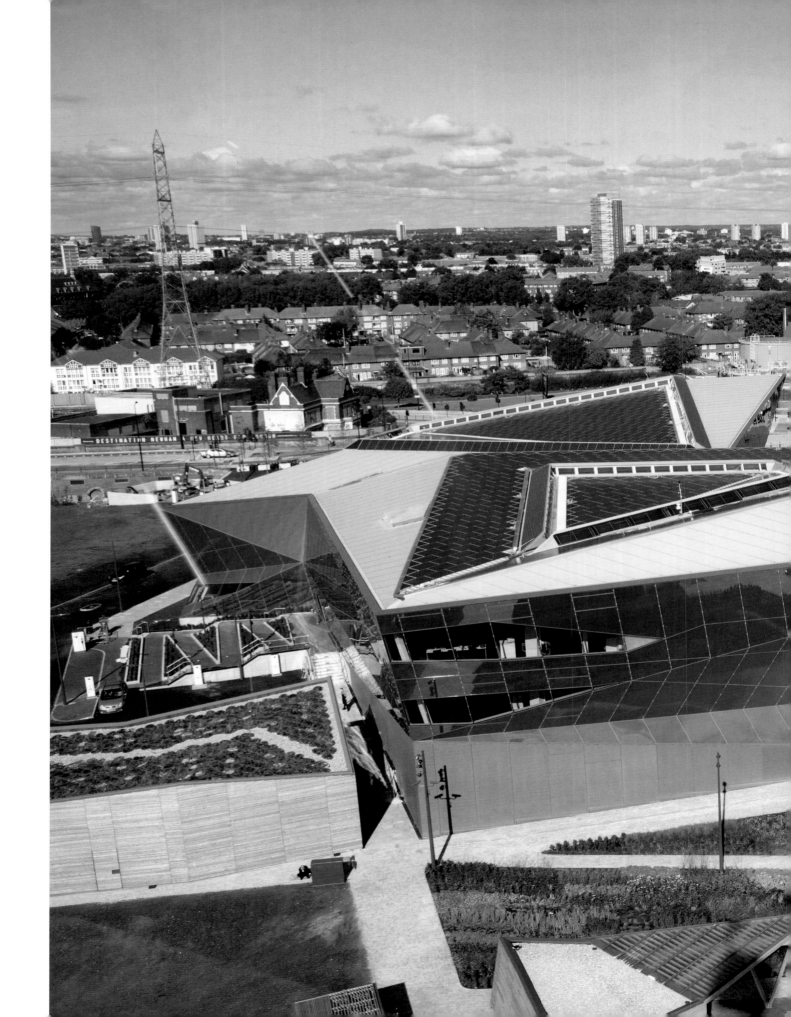

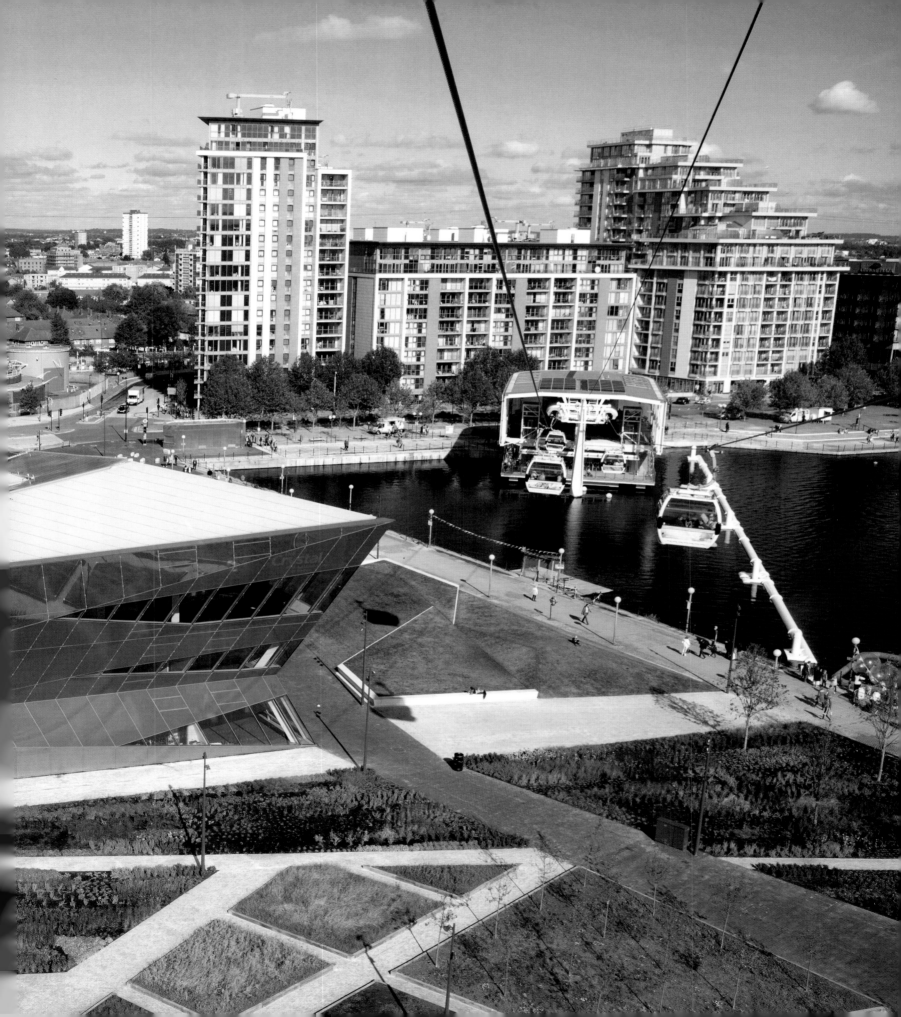

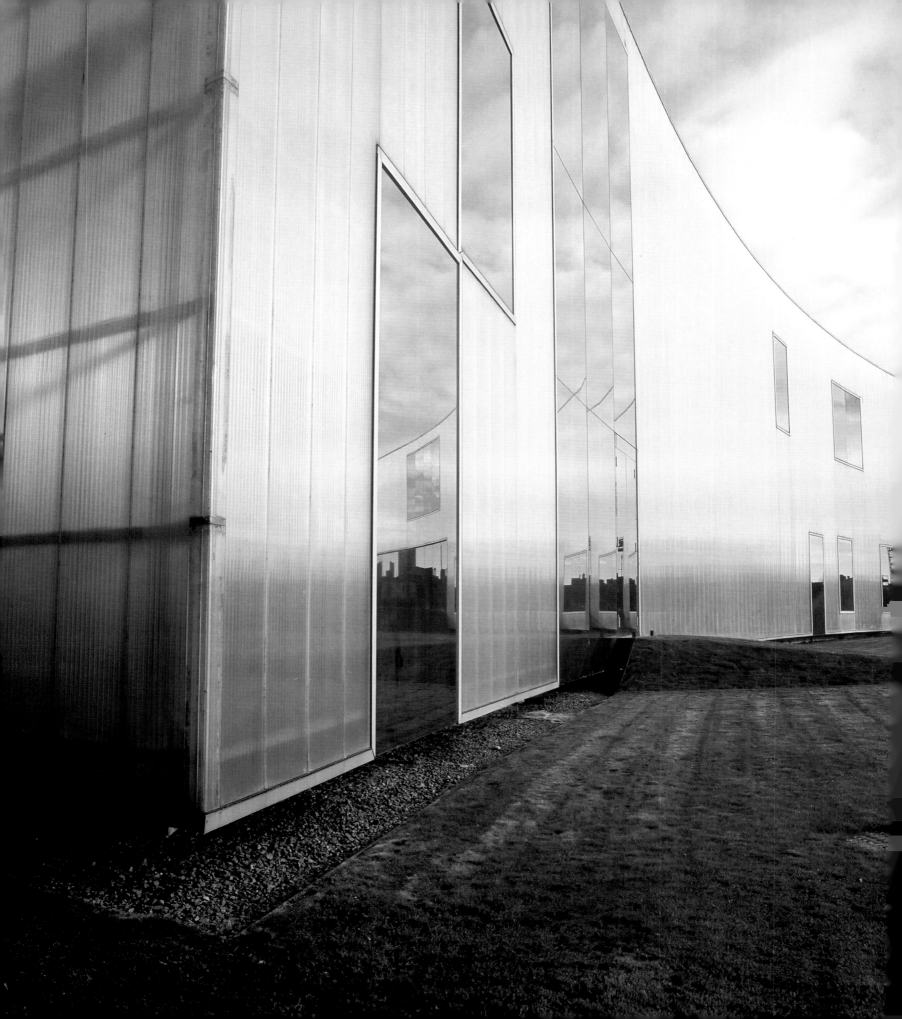

LABAN BUILDING

Herzog & de Meuron
2003
Creekside

Built for one of the world's largest contemporary dance institutions, Trinity Laban Conservatoire of Music and Dance, Herzog & de Meuron's Stirling Prize–winning Laban Building is imbued with movement. The structure's facade draws onlookers forward with its gentle curve, and features an ethereal "double-skin" exterior engineered in collaboration with visual artist Michael Craig-Martin. An inner layer of transparent glass is covered by translucent polycarbonate paneling that reveals the movement within the building's interior. At night, the building illuminates the surroundings with gentle colored light. Inside, all activities are distributed between two main levels in a manner that promotes communication and fluidity. Studio spaces, meeting areas, and winding pathways wrap around the main theater, the building's epicenter, and two concrete spiral staircases, placed at either end, are intended to facilitate spontaneous encounters.

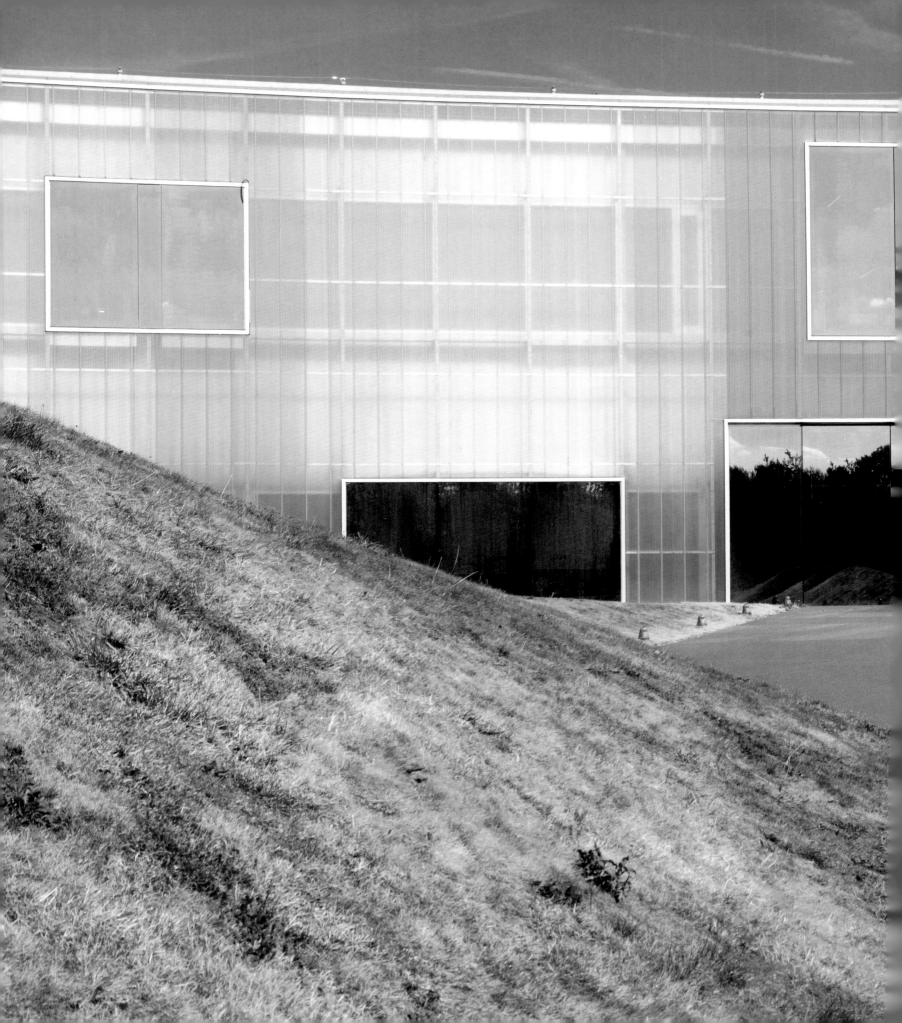

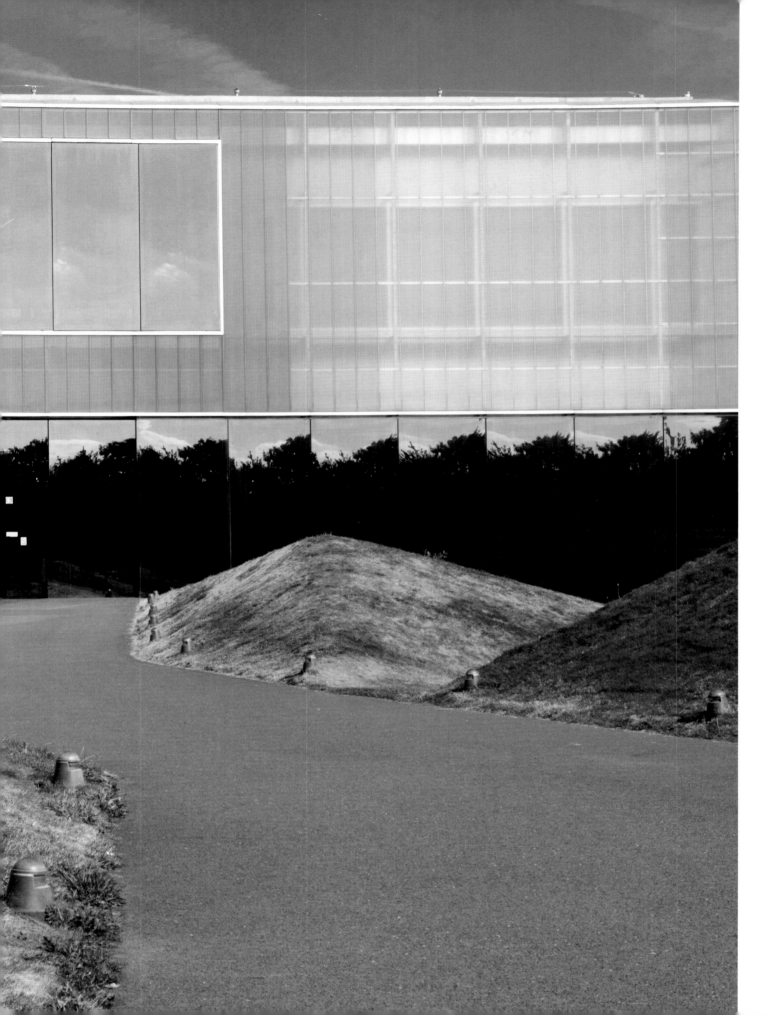

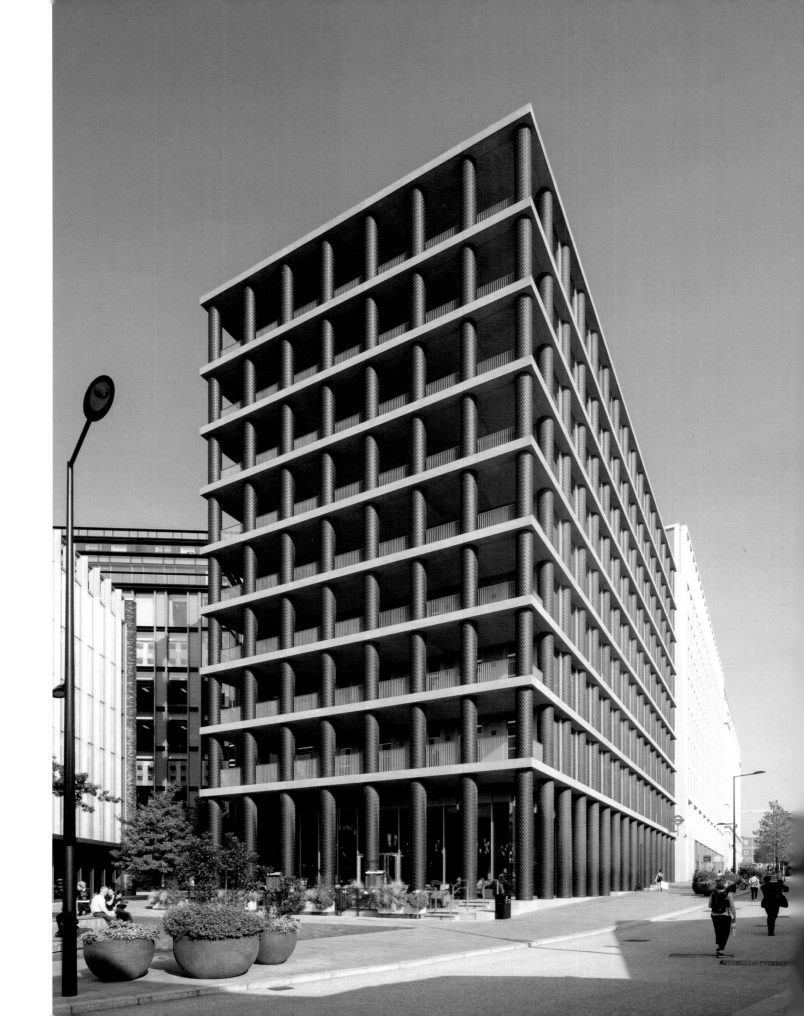

ONE PANCRAS SQUARE

David Chipperfield Architects
2013
1 Pancras Road

Occupying an important position within a mixed-use redevelopment in the up-and-coming King's Cross area, One Pancras Square announces its stylistic flexibility from the onset. With its narrow volume visible from all sides, the structure unfurls horizontally and vertically, containing nine colossal concrete floor plates propped up by 396 cast iron pillars that were constructed out of worn-out automobile brakes sourced from local scrap yards. Environmental efficiency influences the building's interior as well, as the floor plates are edged with office spaces along their perimeters, to ensure maximum natural lighting. This approach, feasible because of the building's relatively open-air location, had previously been considered impractical for urban office buildings. Downstairs, a double-height lobby lined with black Italian marble sits adjacent to two commercial units, which the developers feel will contribute to the area's general renewal.

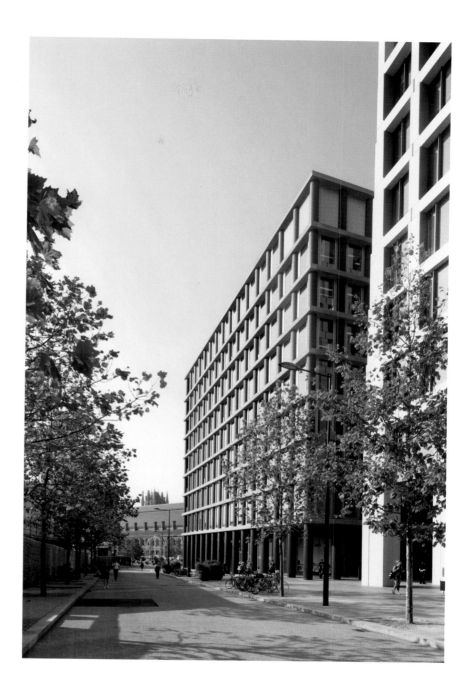

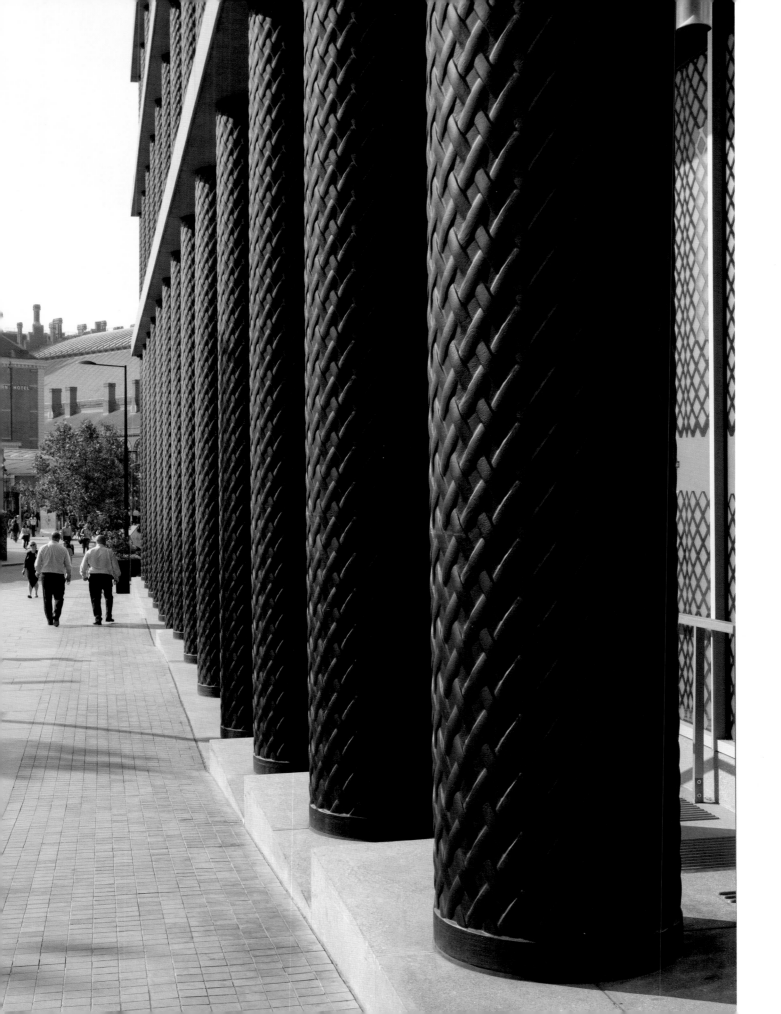

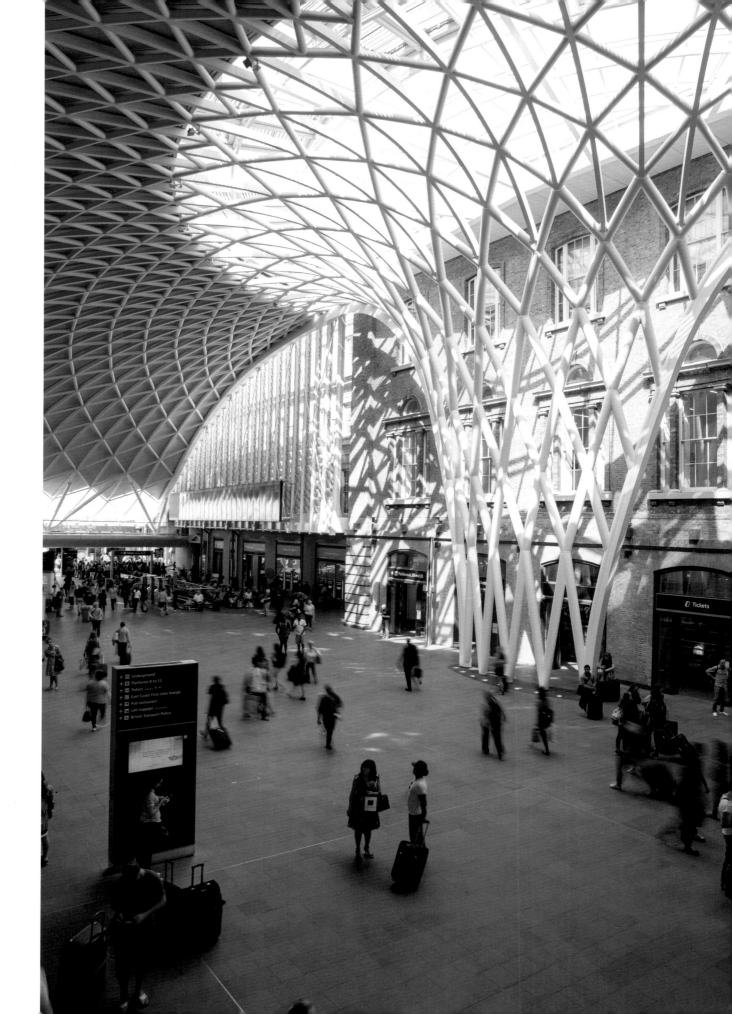

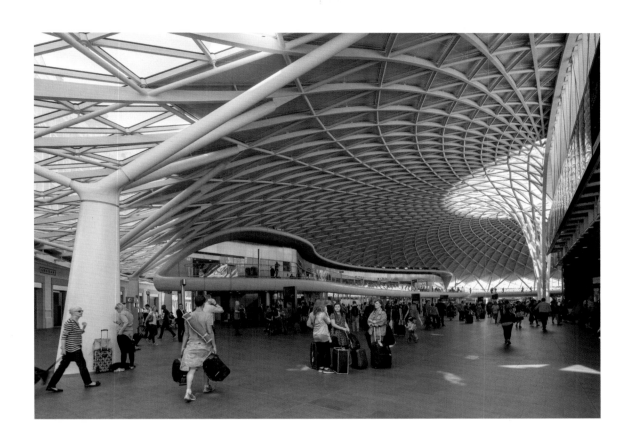

John McAslan + Partners
2012
Euston Road

Opening a few months before the London Olympics, John McAslan's transfigured King's Cross Station seamlessly blends restoration with innovation in order to produce a transport superhub. Along with cleaning the station's original tunnel-like glass roof and refurbishing its historic brick exterior, the project involved the addition of a vaulted, bow-shaped 81,000 square-foot (7,525 sq. m) Western Concourse that links King's Cross to St Pancras Station. Functioning solely as a departure space, the new concourse centers around a steel roof that narrowly sprouts from the ground before swooping outward in a massive crisscrossing canopy. Harking back to British architectural achievements like the Crystal Palace, this dramatic and fluid addition symbolizes the station's effortless accommodation of up to 150,000 passengers a day.

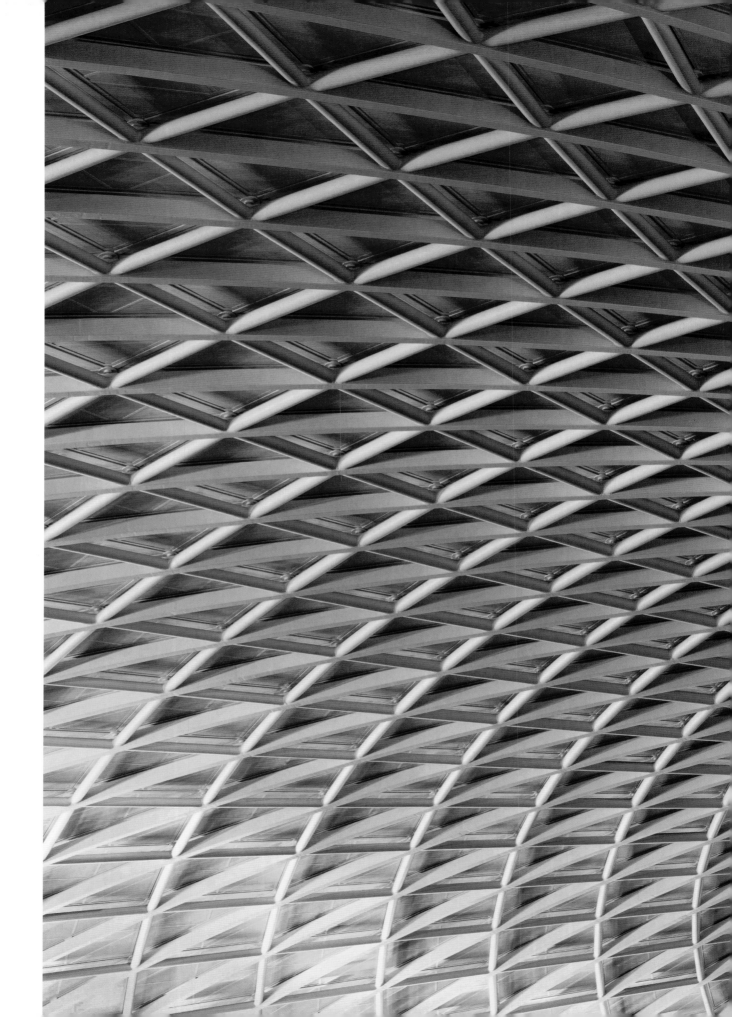

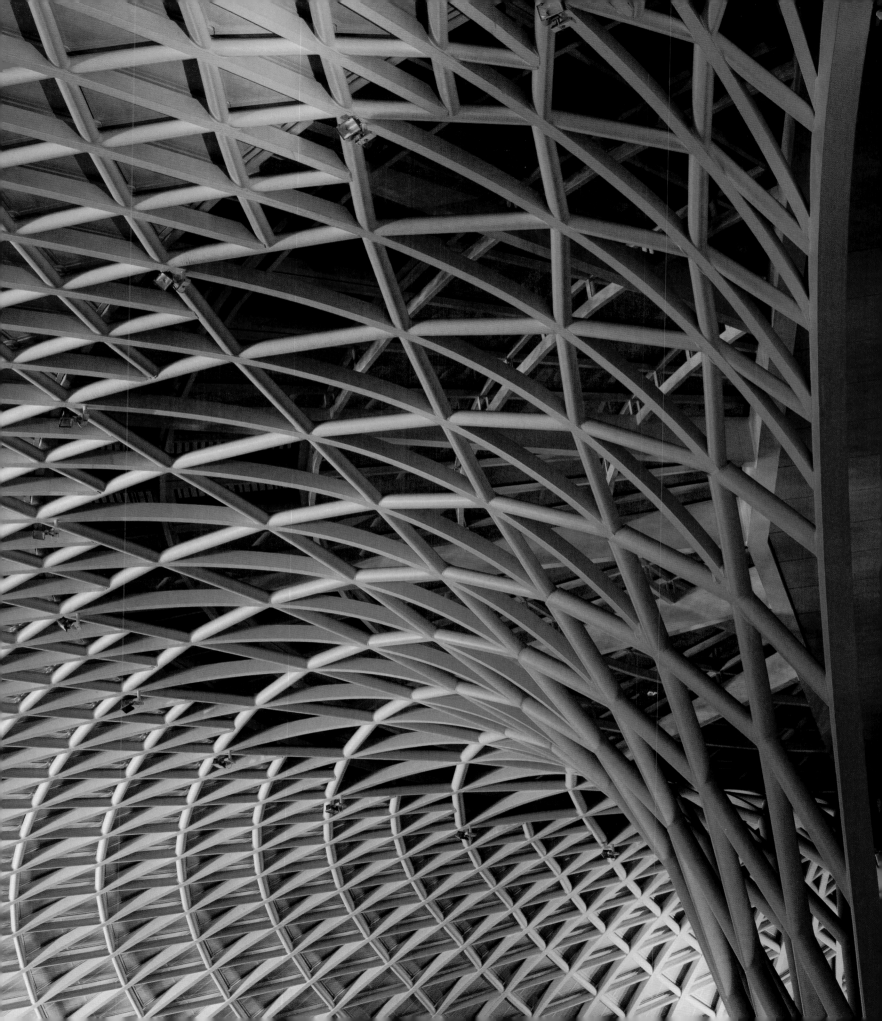

Alsop & Störmer
2000
122 Peckham Hill Street

Libraries are often, more or less by definition, structures characterized by solemnity. Alsop & Störmer's Peckham Library, which won the Stirling Prize in 2000, stands as a winning inversion to this approach. A bowled-over, upside-down letter L adorned with vivid, bluish-green, pre-patinated copper siding, the building introduces a vivacious good humor to an underserved portion of southeast London. This quirkiness and bravado quickly secured the affection of locals, making the library a vital example of thoroughly inclusive modern architecture. The front awning, held aloft by erratically angled steel pillars, creates an organic public space below, and contains elevated interior reading rooms far removed from the noisy street. A Frisbee-shaped orange tongue emerges from the roof, providing shade and passive ventilation, dramatically reducing operating costs. Three fantastical enclosed "pods" are placed throughout the interior, housing study spaces and activity centers for children.

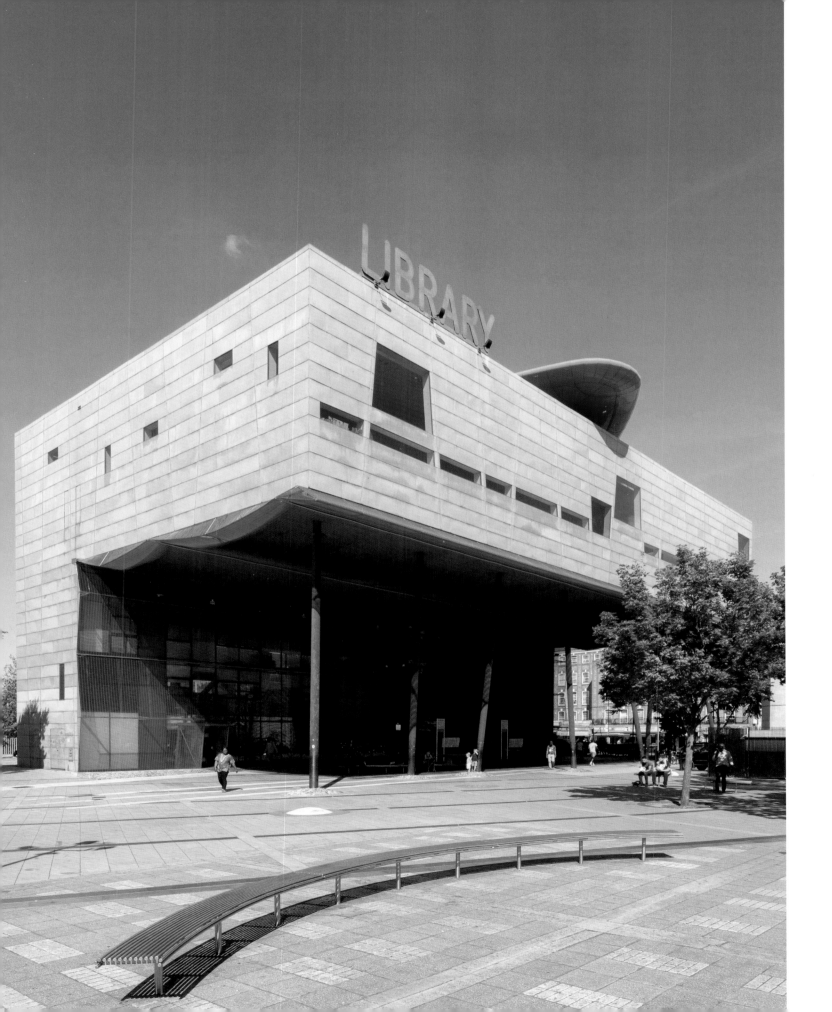

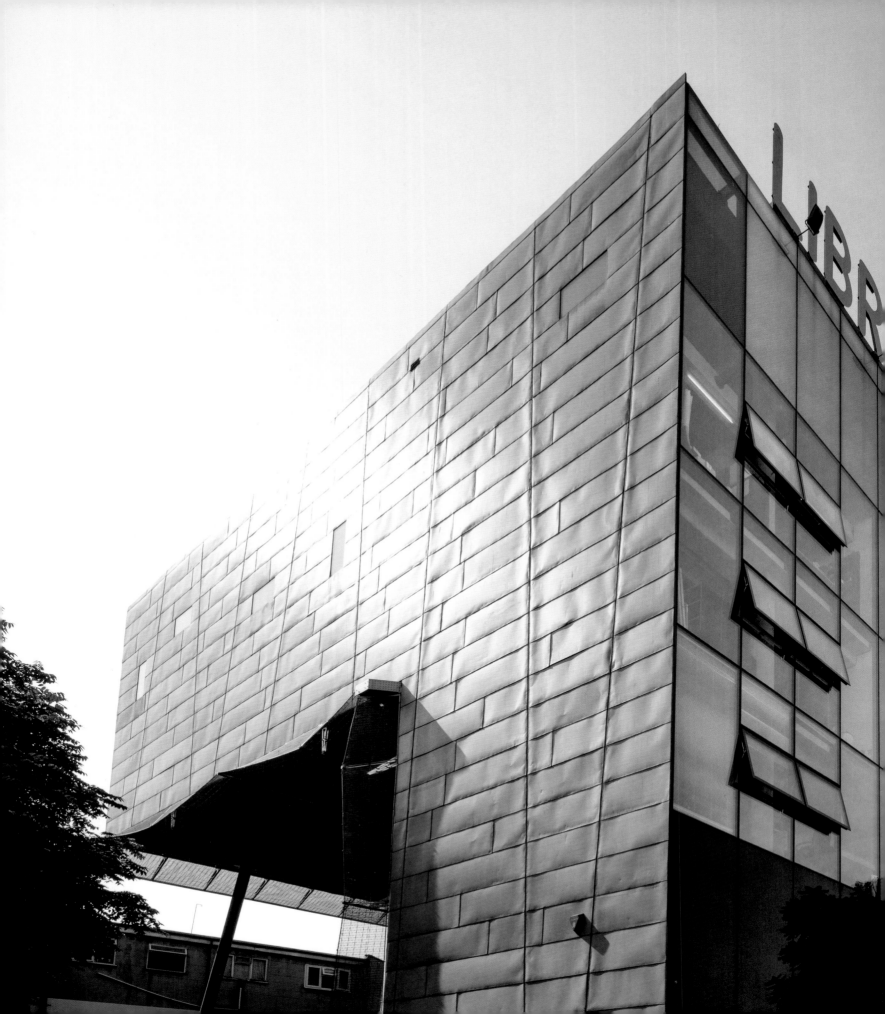

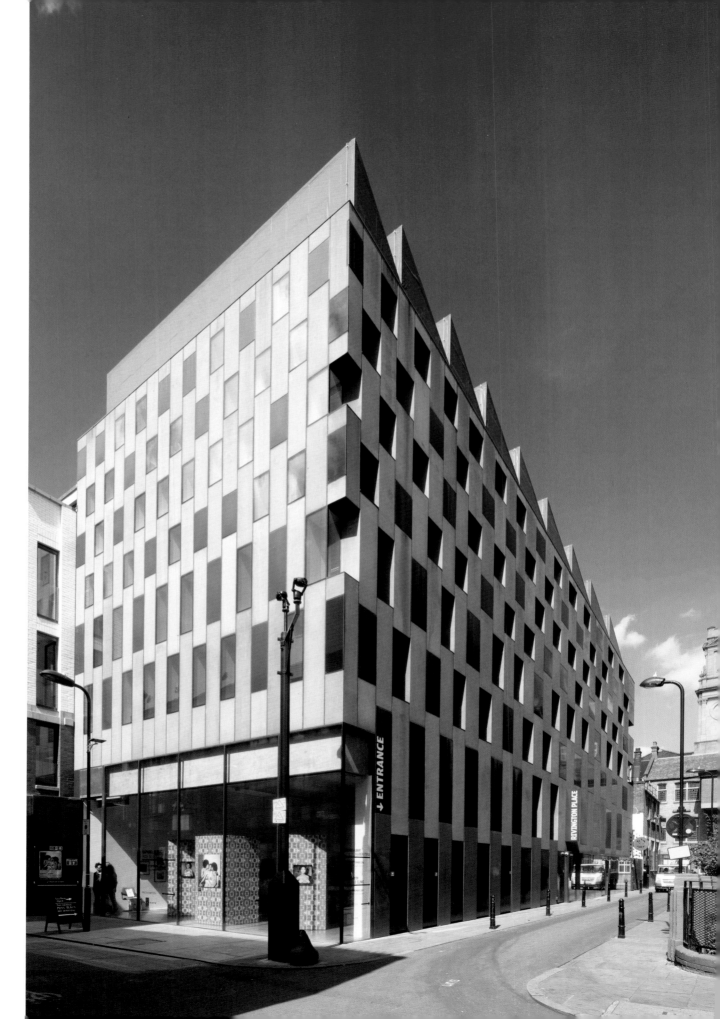

RIVINGTON PLACE

Adjaye Associates
2007
Rivington Place

London's first publicly funded art gallery in forty years, David Adjaye's Rivington Place bursts onto the city's art scene with a remarkably potent mission. The East London building serves as a home to both the Institute of International Visual Art and Autograph ABP, two organizations devoted to challenging the art world's status quo by promoting the work of artists from underrepresented, culturally diverse backgrounds. The space, which also contains two exhibition galleries, a research library, a digital media lab, and a lecture hall, affords the public access to alternate histories of art, and provides platforms for discussion and debate. Despite its constricted site along a narrow lane, Adjaye's structure takes on a monumental stature thanks to its concrete edifice layered with glossy black aluminum panels; many of the gallery's windows are deeply recessed, making it look like a stouter-than-average Jenga tower from certain angles.

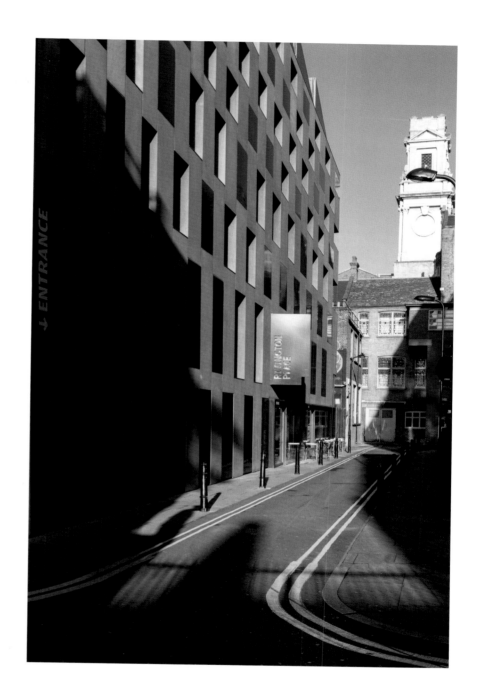

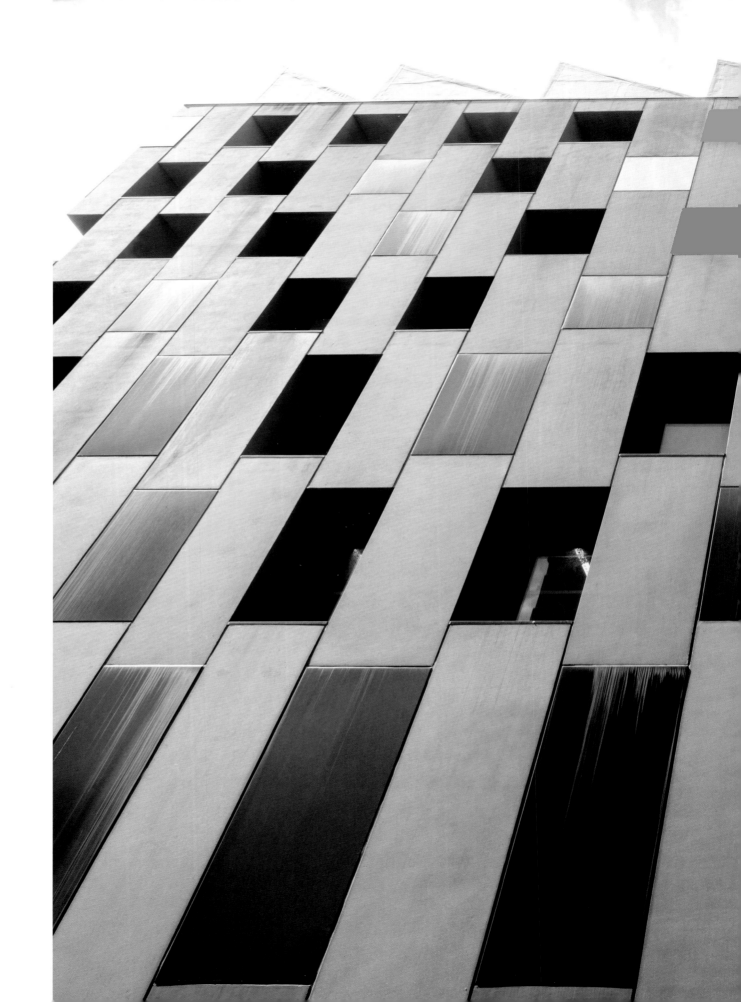

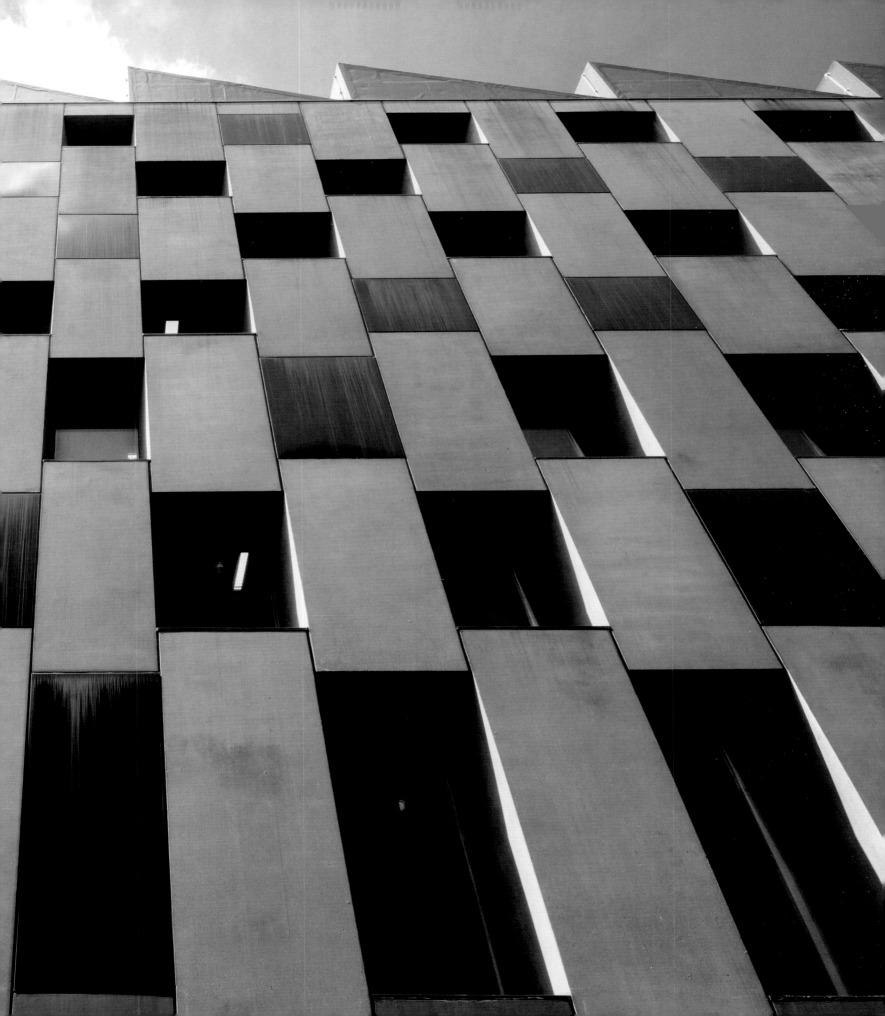

**Renzo Piano
Building Workshop
2010
1 St Giles High Street**

Depending on how you feel about Renzo Piano's cultivated palette of silvers and grays, the colorful riot of Central Saint Giles, his mixed-used development in Camden, came as either a gut check or a pleasant surprise. Composed of two separate fifteen-story buildings that encircle a central courtyard, the compound is edged by twenty-two planar facades coated in glazed tiles of yellow, orange, and lime green; from afar it resembles a child's horseshoed, Lego palace. One of the buildings is devoted to private apartments, while the other larger section contains office spaces. Below, the courtyard is surrounded by restaurants and shops, and features sculptural installations by artists Steven Gontarski and Rebecca Warren.

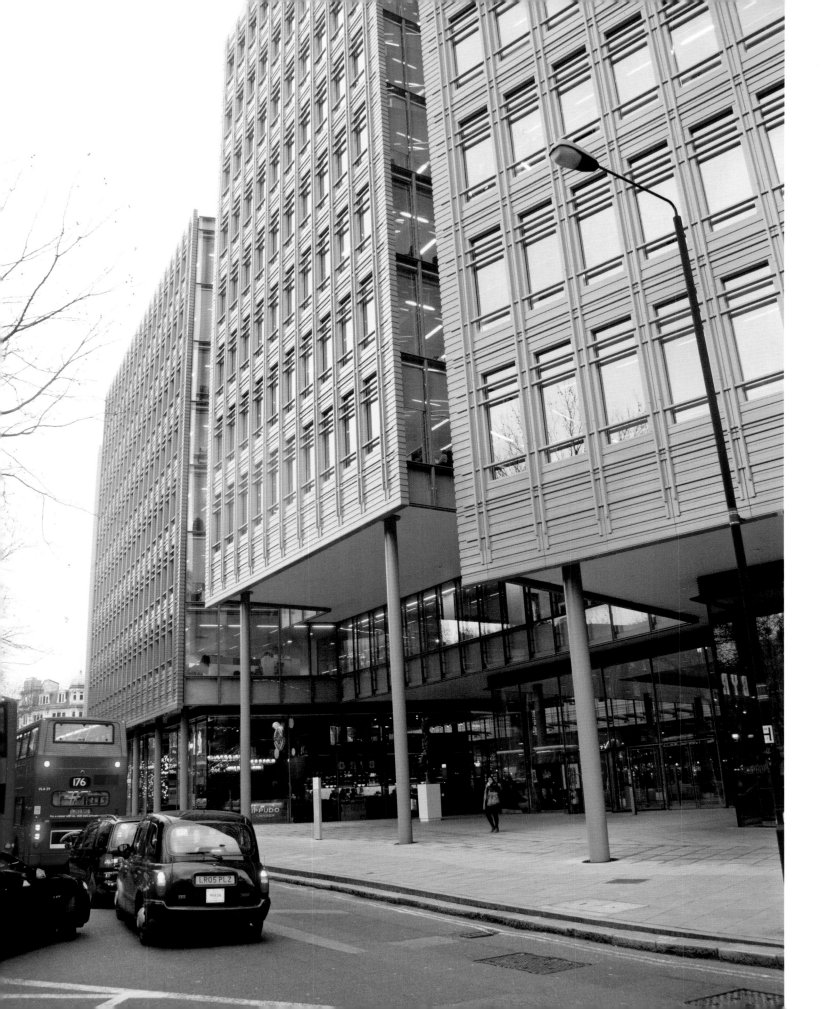

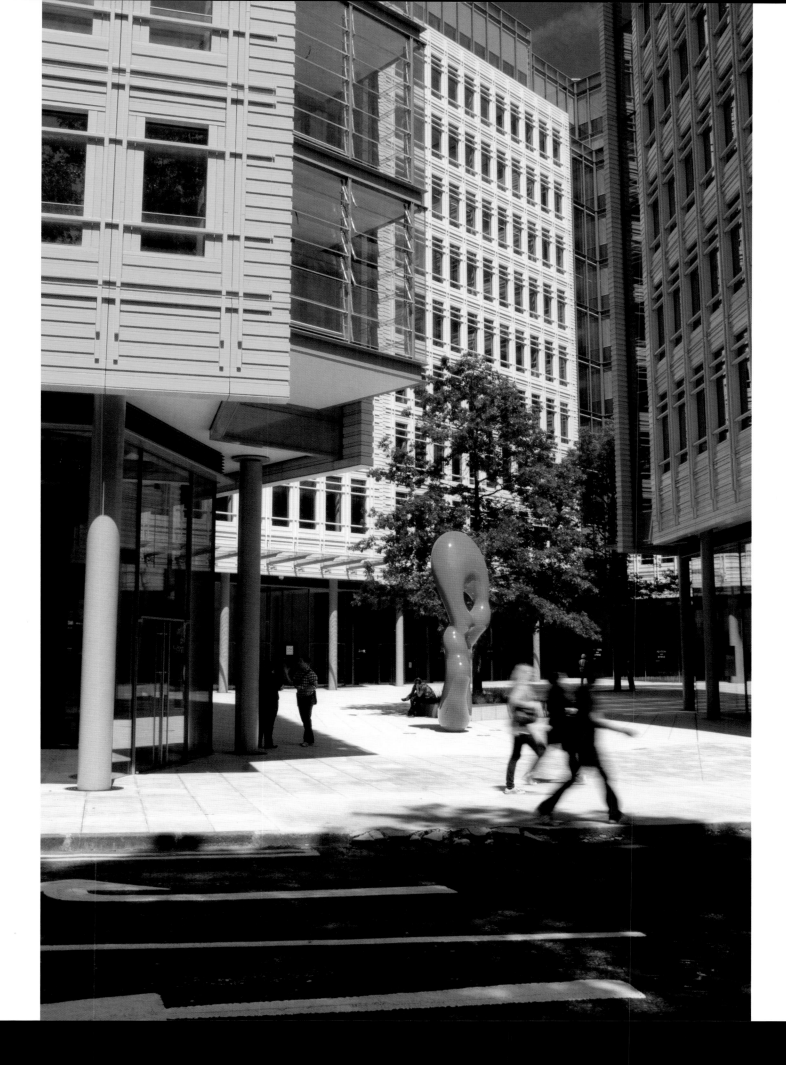

187–195 OXFORD STREET

Future Systems
2008
187–195 Oxford Street

Toward the less developed eastern end of Oxford Street, London's famed shopping thoroughfare, Future Systems was appointed to transform an unappealing brick-and-glass facade into something more enticing. The new frontage is covered in jewel-like, hexagonal bays, which project over the street like glinting glass honeycombs. The overhanging crystals grant the interior office spaces shattered views of the buildings across the street. On the ground level, a smooth sheet of glass provides a contrasting, unbroken view, and contains two inverted bays that passersby can step inside. At night, the facade is illuminated to give off a pale, multicolored glow.

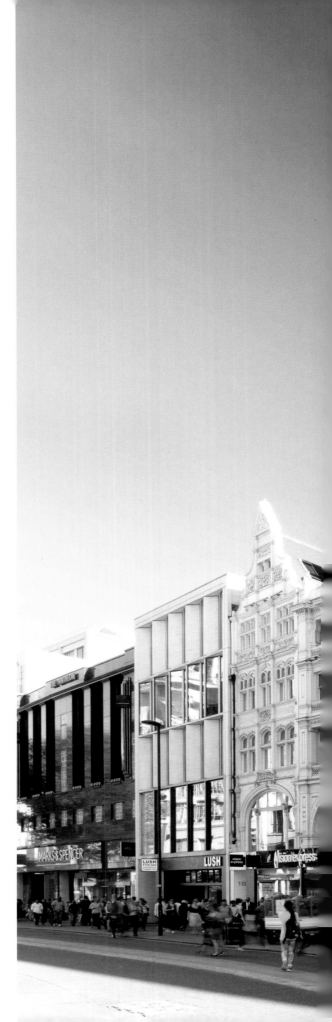

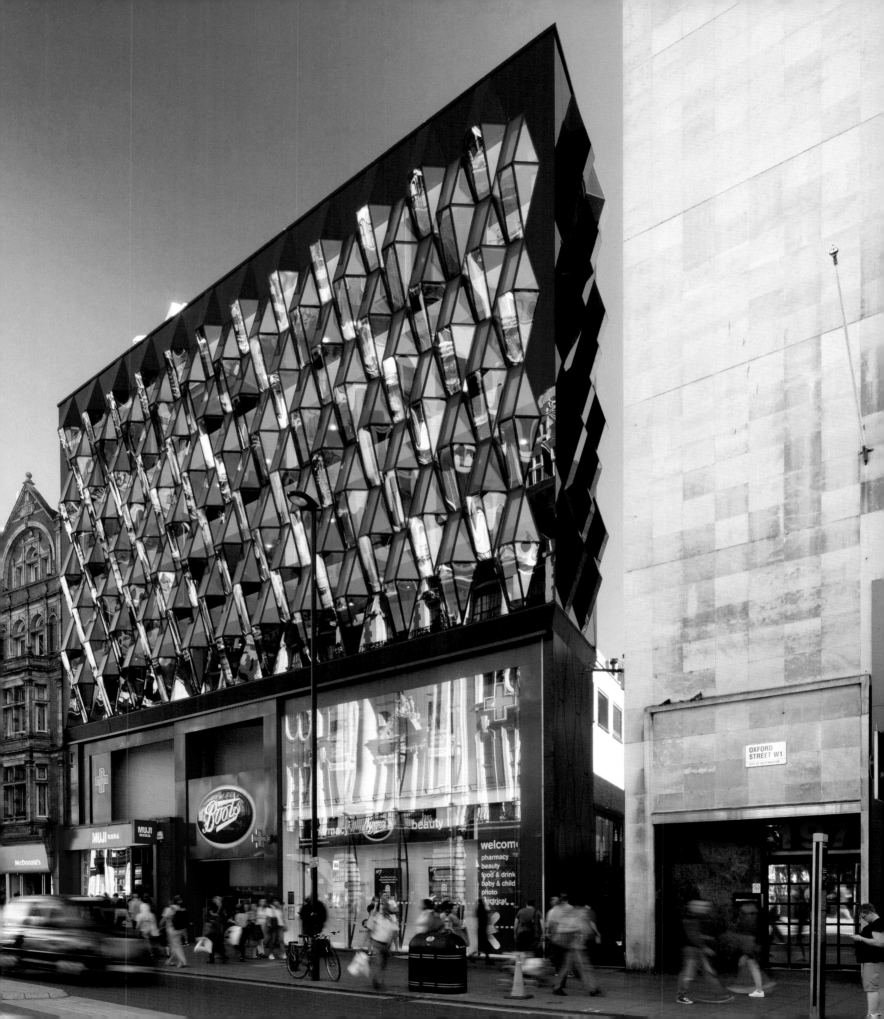

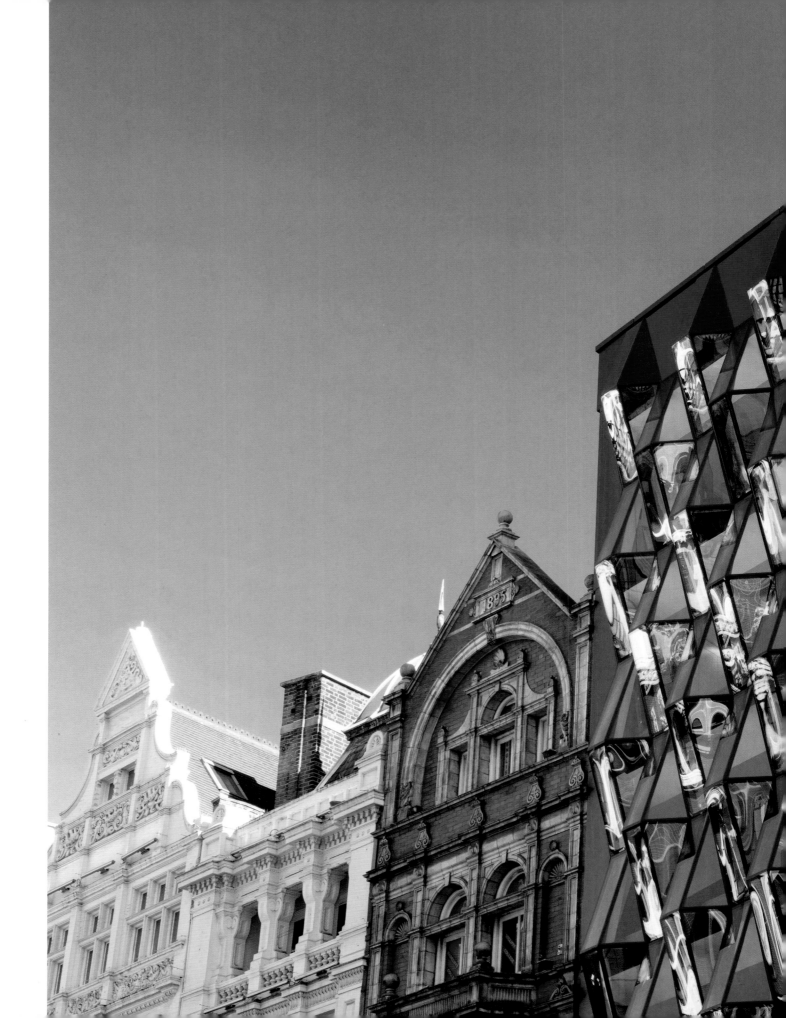

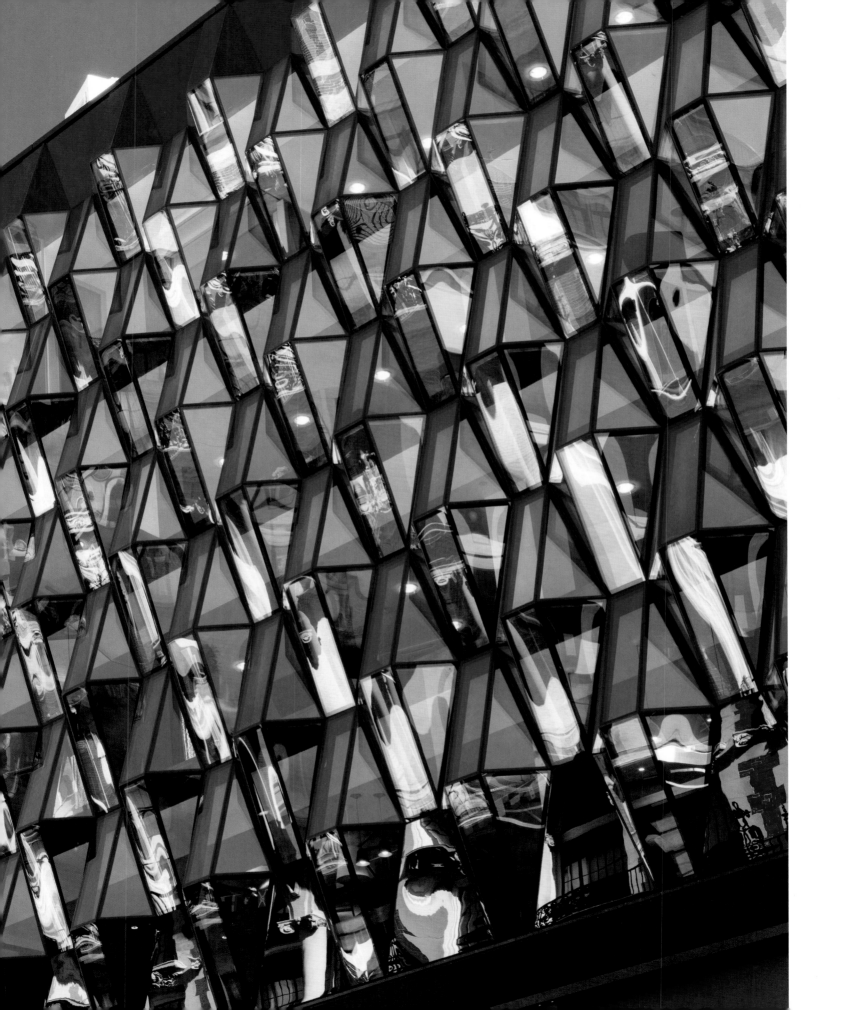

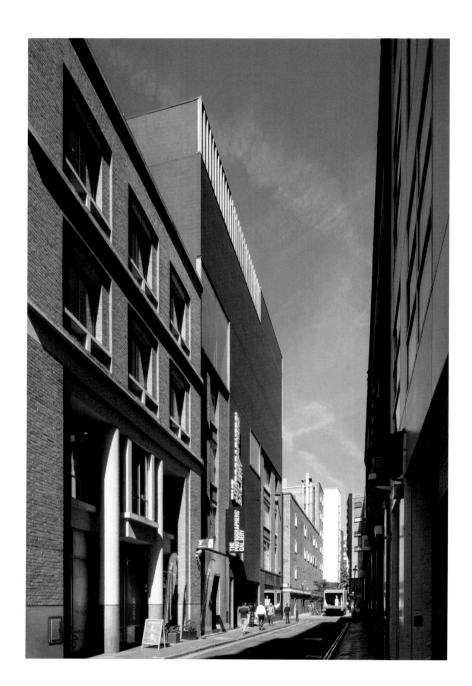

THE PHOTOGRAPHERS' GALLERY

O'Donnell + Tuomey
2012
16–18 Ramillies Street

After their preliminary redesign of the Photographers' Gallery was nixed, O'Donnell + Tuomey packed their initial aspirations into a smaller project that actively incorporates an abandoned twentieth-century warehouse. A mysterious matte-black box rests atop the original brick structure, evoking the enigmatic wonders of the darkroom and its inky emulsions. Rectangular tendrils reach down from the upper perch, disrupted by slots of opaque, hardwood-lined windows. Preparing the interior of the gallery involved carving out large exhibition spaces and replacing existing walls with glazing and slabs of untreated timber. After boring into the ground floor, the architects outfitted the basement café with a layer of black, polished terrazzo that mimics the texture and color of the external upper layer.

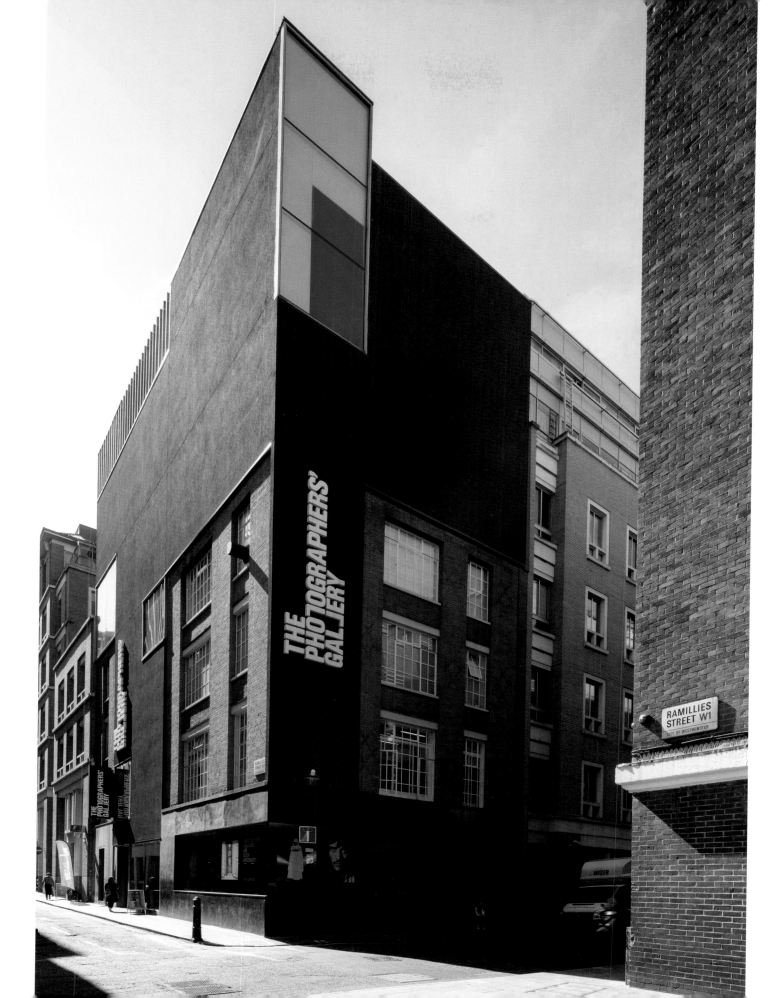

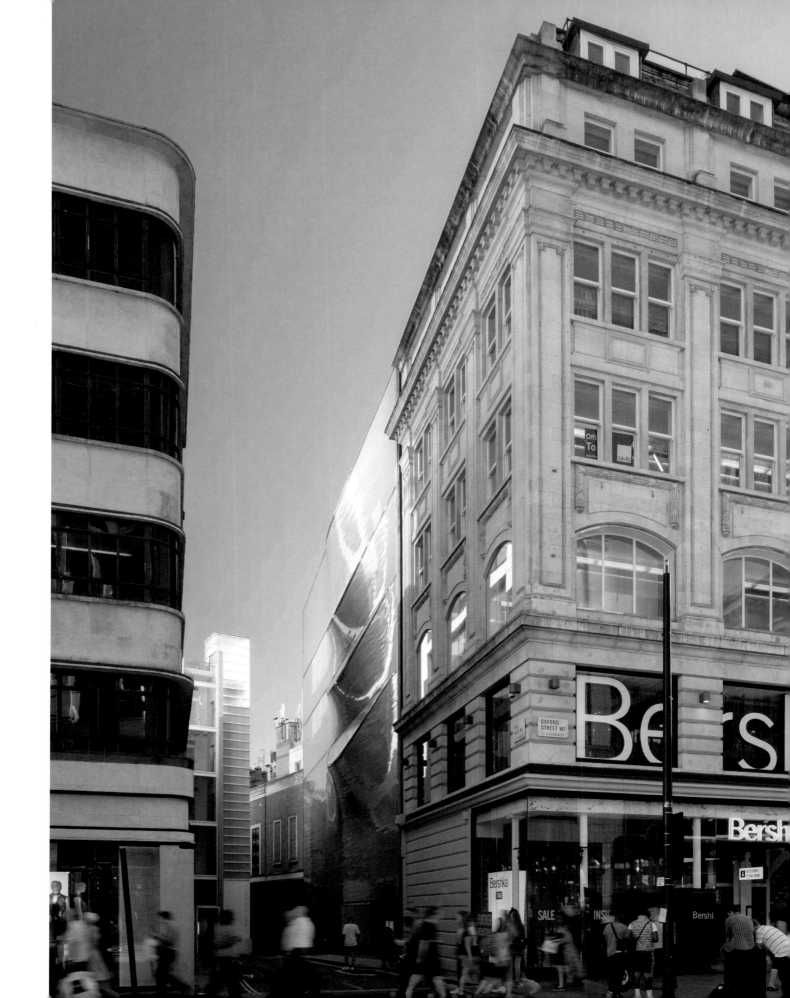

Amanda Levete Architects
2009
10 Hills Place

A sleek, shimmering facade
bursting from between two
traditional nineteenth-century
office buildings, Amanda
Levete's 10 Hills Place responds
to its storied environs even
as it appears to spurn them.
Commissioned by a Japanese
advertising company, the project
is located near Oxford Street
on a narrow lane where daylight
is often scarce. Drawing from
the slashed, monochromatic
paintings of Italian Spatialist
Lucio Fontana—and perhaps the
seductive curvature of Antoni
Gaudí's Casa Milà—Levete
outfitted the rippling aluminum
facade with upturned gashes
that funnel natural light deep
into the building's interior.
The sculpted aluminum was
constructed with technology
typically used to engineer ship
hulls, and each eyelid features
glazed self-cleaning glass that
ensures minimal maintenance.
Passing pedestrians are treated to
fragmented reflections of sky and
street, as well as illusory patterns
caused by a dichromatic strip on
the building's ground level.

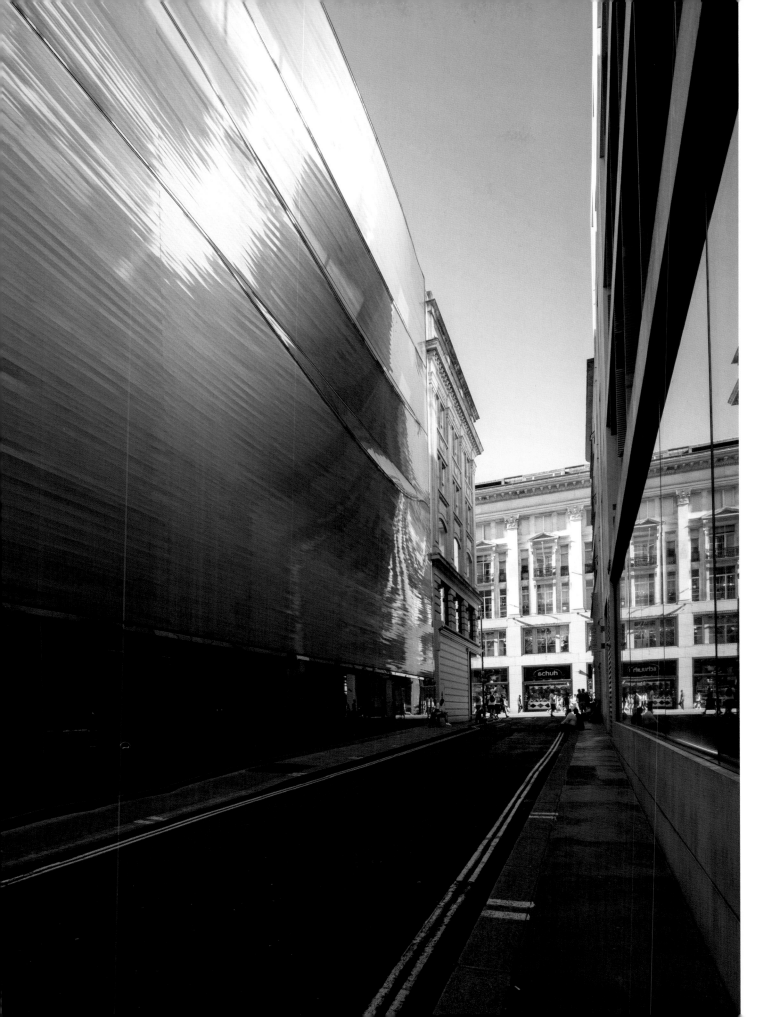

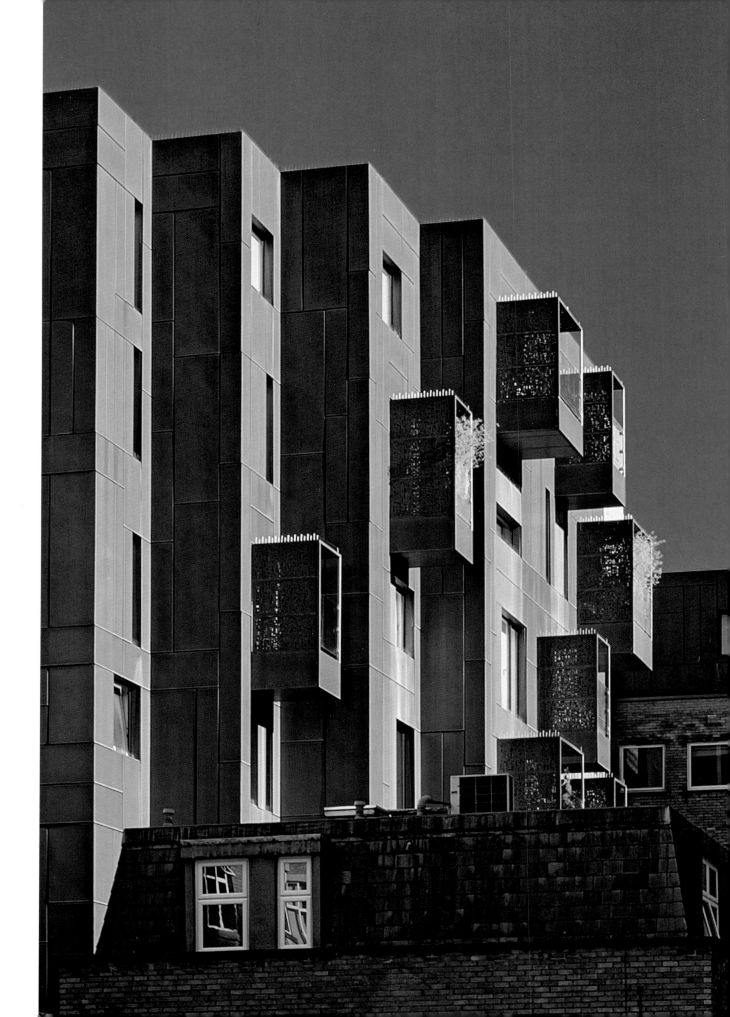

10 WEYMOUTH STREET

Make Architects
2009
10 Weymouth Street

On a drab street in Fitzrovia, Make Architects wrapped a brick apartment building in glistening brass that surges forward in a series of telescoping cubes, producing a structure that resembles a three-dimensional embodiment of a Georges Braque painting. Thanks to a newly extended rear elevation and additional top floor, 10 Weymouth Street contains twelve new luxury apartments and a ground-floor office space. An underground heat pump provides energy efficient heat and water, and each apartment features a balcony that affords sweeping views, a rarity in the neighborhood. The balconies are outfitted with brass screens laser-cut with geometric perforations that mimic the building's exterior and send dancing patterns of light onto the apartment floors. The trademark brass is designed to visually transform over time thanks to oxidization, ensuring that the building remains a captivating spectacle.

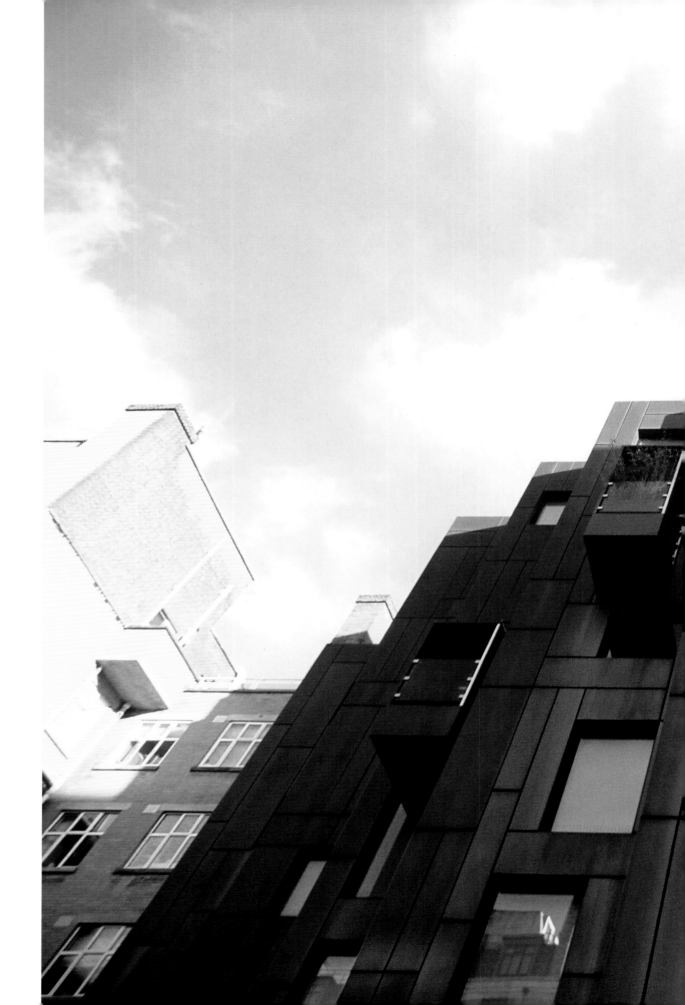

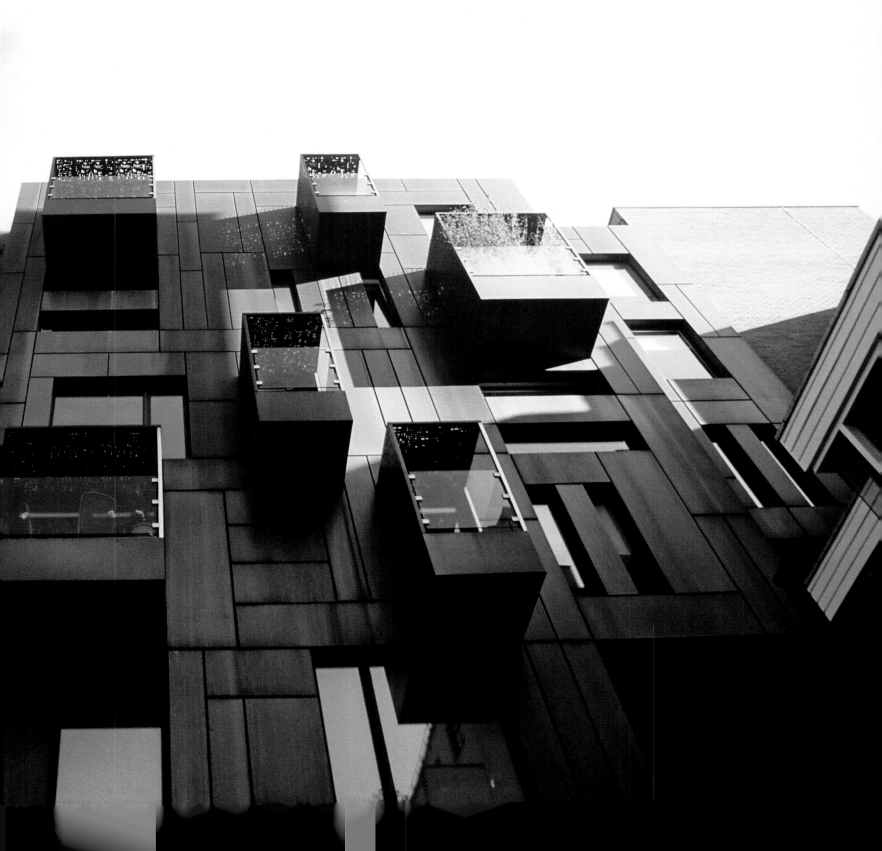

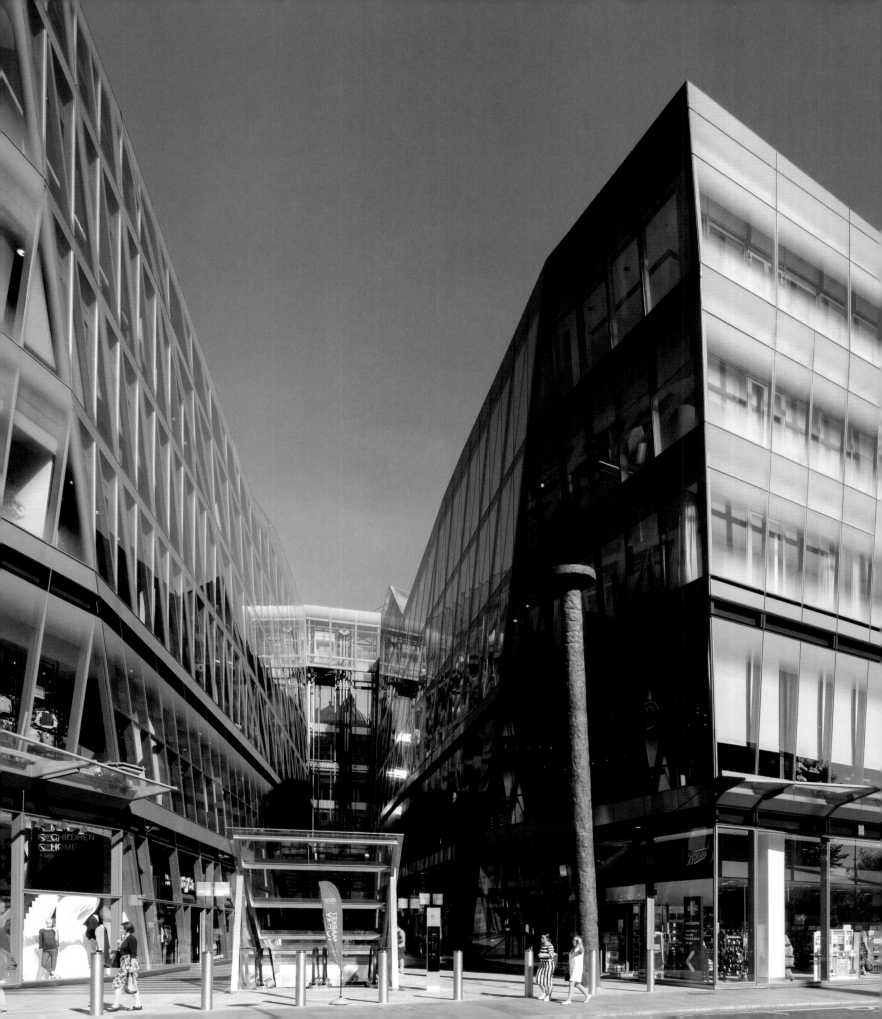

ONE NEW CHANGE

Ateliers Jean Nouvel
2010
1 New Change

Given its highly sensitive location alongside St Paul's Cathedral in the historic Cheapside market district, it is no surprise that many Londoners—including Prince Charles—were uncertain about One New Change, Ateliers Jean Nouvel's colossal retail and office development. But instead of ignoring its storied environs, "the stealth bomber" springs in concert with them, a glass block shaped by the constraints of context. Featuring three floors of shops and four of offices, the 554,340 square-foot (51,499 sq. m) space is split into two segments by one of its four canopied passageways, setting up a stunning telescopic view of St Paul's Cathedral. An elevator sits at the point where the twin steel-framed wings eventually reunite, carrying visitors to a rooftop terrace. The multi-planed exterior slopes west toward the cathedral, and is lined with 6,500 triple-glazed glass panels screen-printed with a panoply of patterns and colors designed to complement surrounding materials such as Portland stone and red brick.

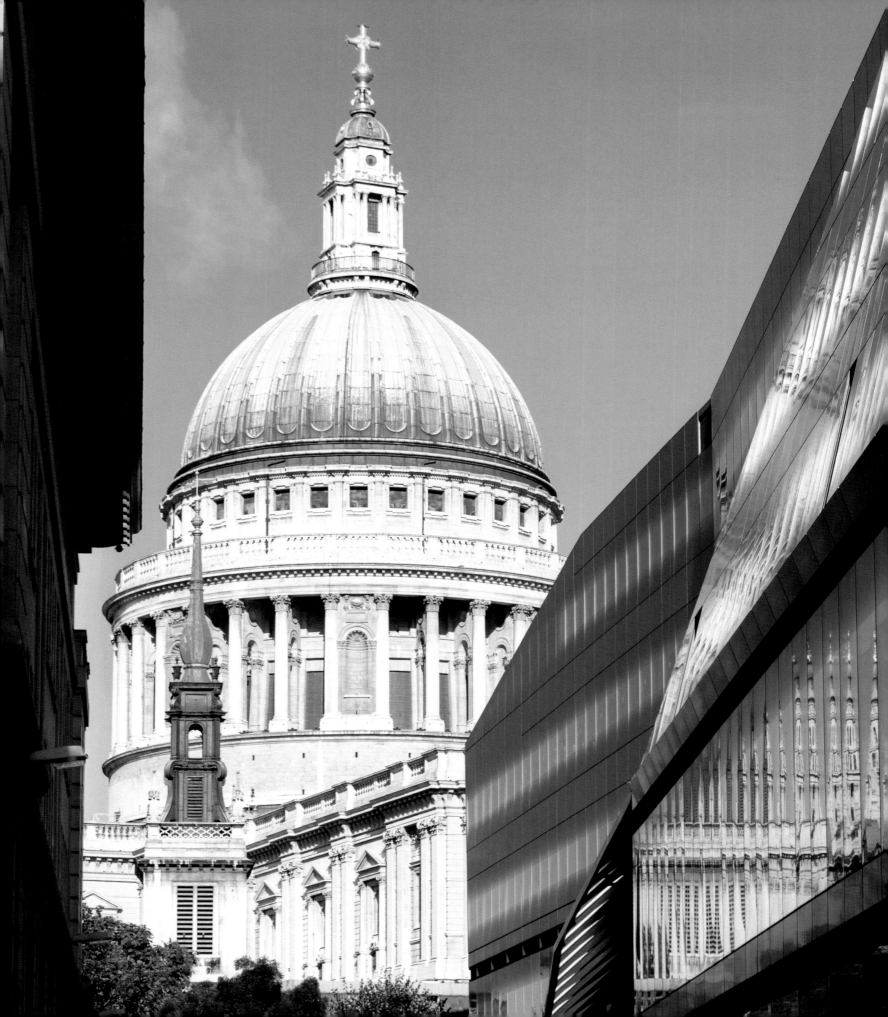

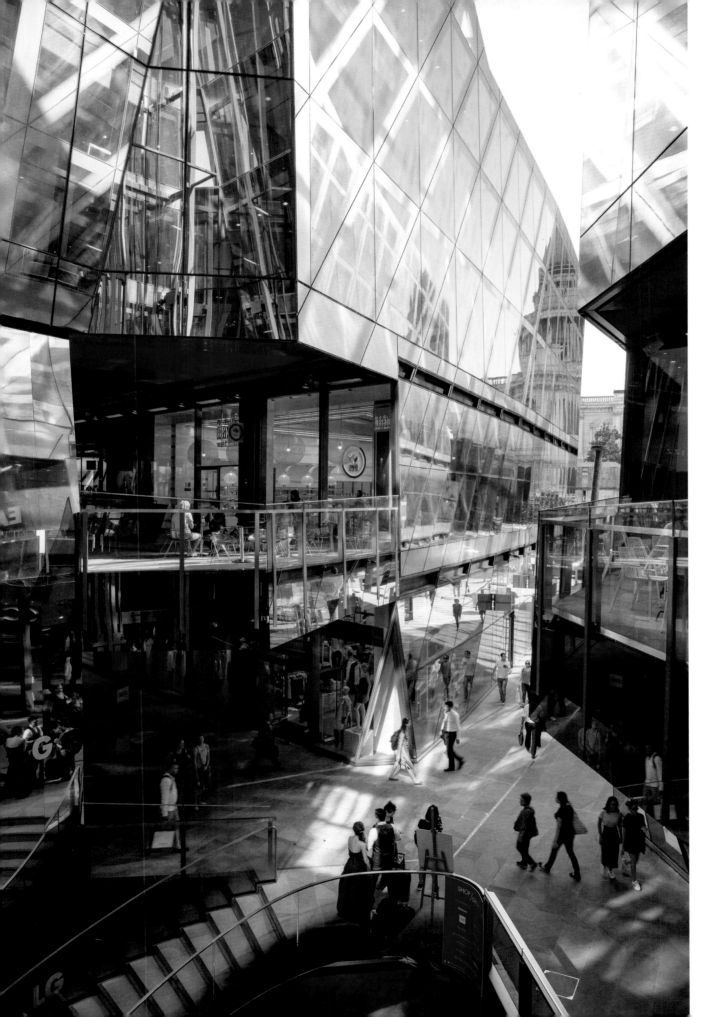

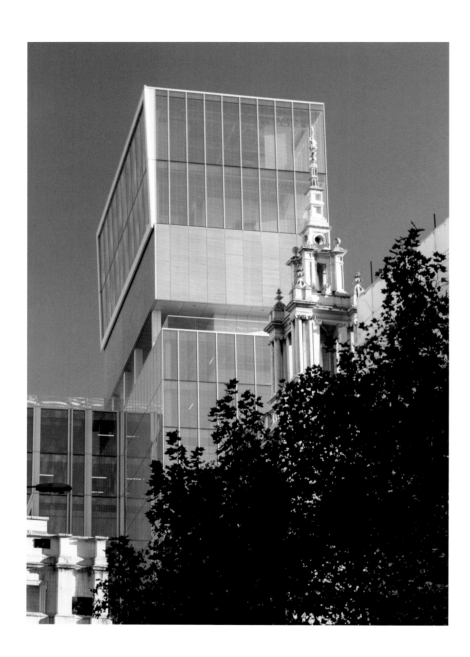

Office for Metropolitan Architecture
2011
New Court

Tucked away on a medieval alley, the New Court Rothschild Bank is custom-tailored for the city's historic financial district. The building, OMA's first in London, and the fourth iteration of Rothschild's headquarters, effectively displays the firm's trademark adaptability, nimbly juxtaposing contemporary features with traditional ones. A ten-story central glass cube with embedded steel columns contains open floor offices with unimpeded views of St Stephen Walbrook's dome next door. Both structures have towers of similar proportions, establishing a connection reinforced by a glassed-in lobby that opens onto the church green. Inside, ornately framed ancestral portraits are placed alongside embossed aluminum paneling and travertine ceilings. In an elegant final stroke, a landscaped roof garden with open air meeting areas is crowned with a double height Sky Pavilion that gazes out imperially on the city below.

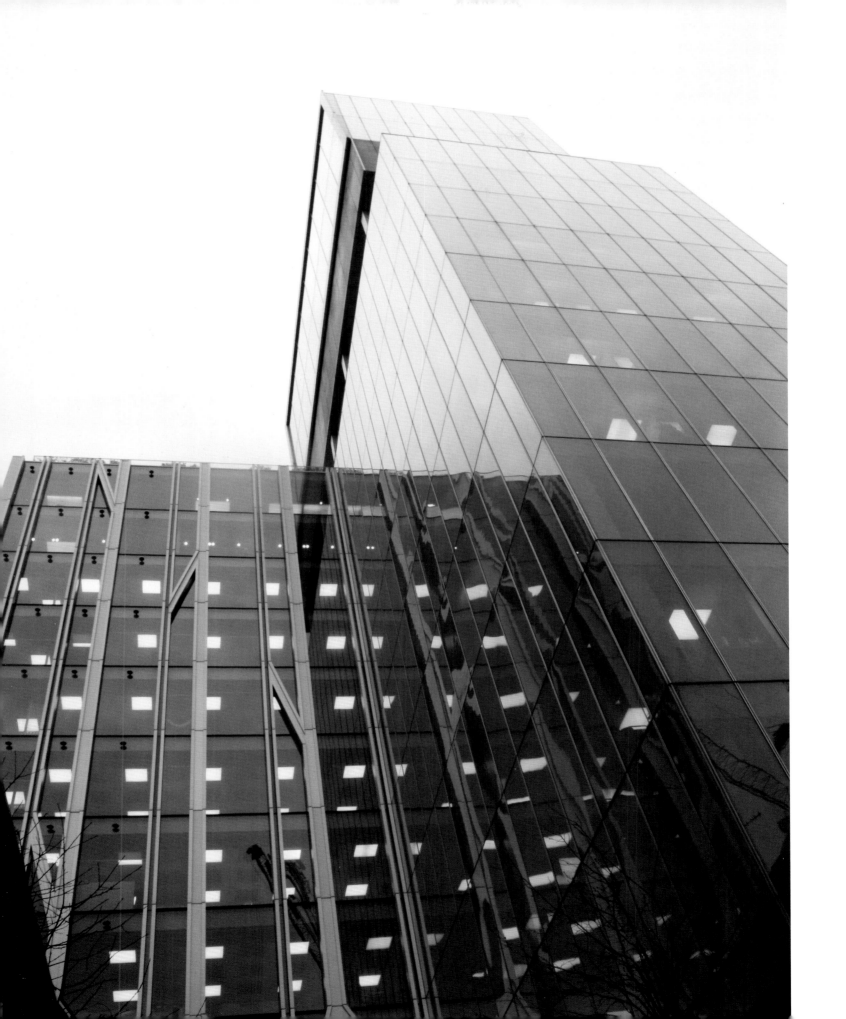

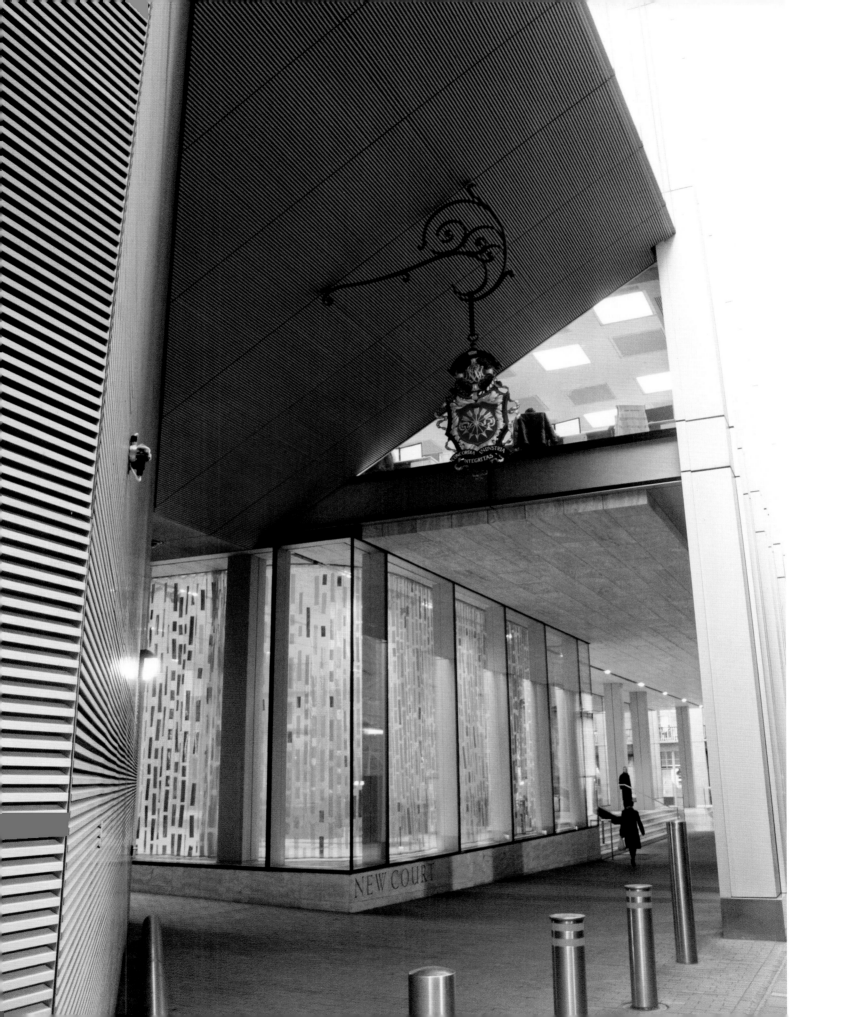

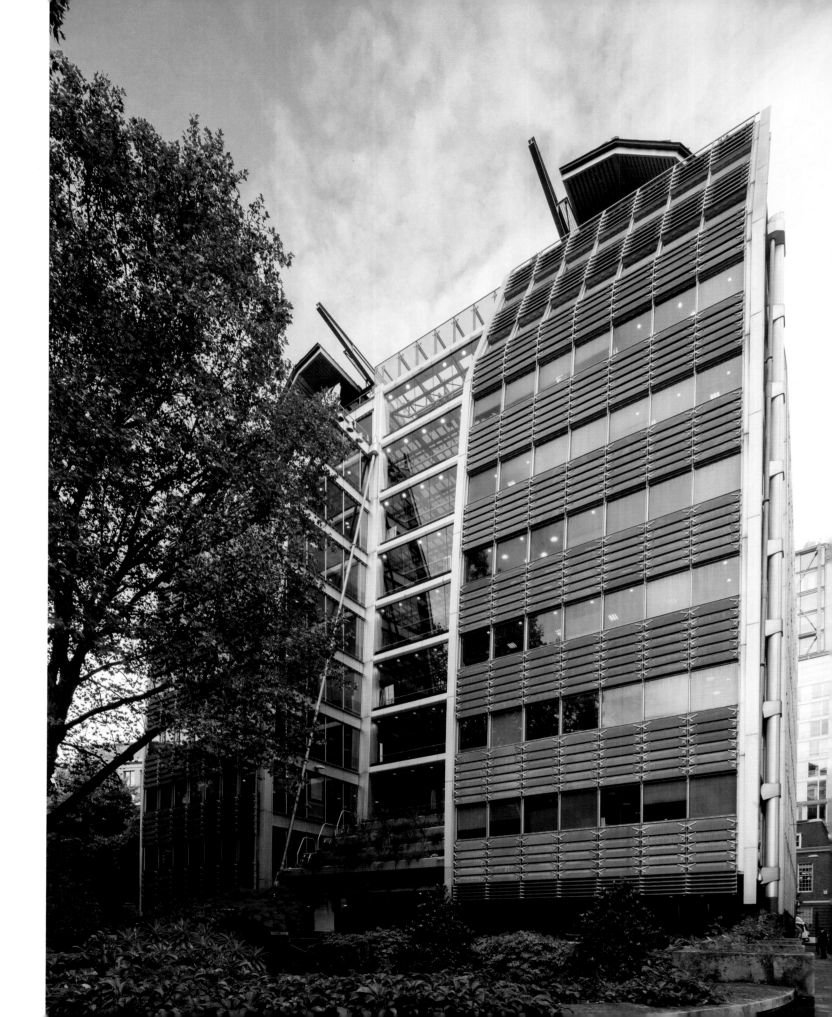

LLOYDS BANKING GROUP HEADQUARTERS

Grimshaw Architects
2002
25 Gresham Street

Adjacent to St John Zachary's Church, which was destroyed by the Great Fire of London in 1666, Nicholas Grimshaw's 25 Gresham Street opens onto its historic surroundings with a welcoming U shape. The building, headquarters for Lloyds Banking Group, furthers this gesture by protecting approaching visitors from the elements with overhanging upper floors that hover over the main entrance. Below, a stepped atrium incorporates the churchyard as a sunken garden and contains several sculpted natural terraces of its own. Four slanting cross-braces slice diagonally across the structure's alternating horizontal strips of slate and glazed glass, pinning themselves on the first floor to ensure that the building remains column free.

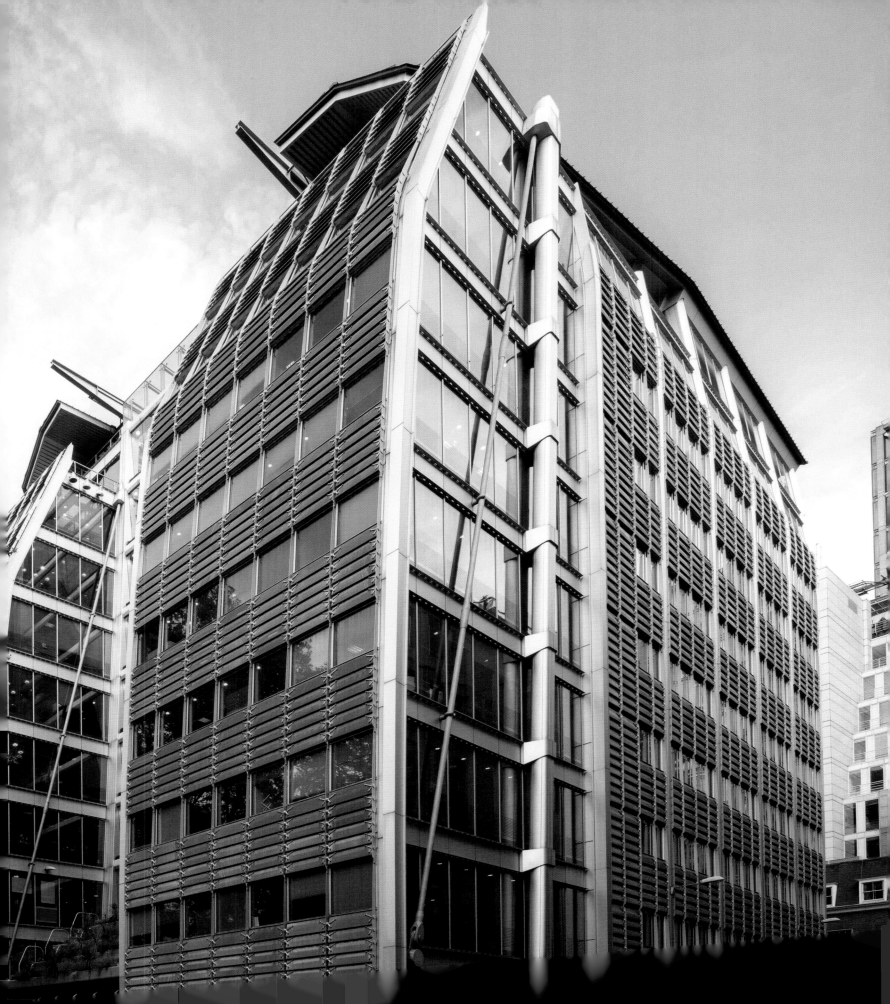

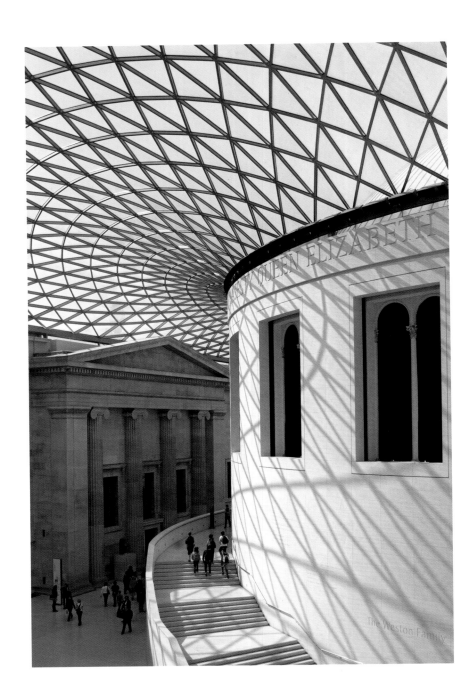

**Foster + Partners
2000
The British Museum, Great
Russell Street**

In 1857, the British Library built an ornately embellished domed room in the central courtyard of the British Museum. While the round Reading Room achieved instant renown, the surrounding two-acre courtyard became an underutilized dead space at the museum's core. Upon the British Library's relocation in 1997, the museum pegged Foster + Partners to create an alluring focal point out of one of London's great forgotten spaces. The resulting plaza, christened the Queen Elizabeth II Great Court, fuses innovative engineering with a timeless grandeur. Topped by an undulating tessellated roof made of triple-glazed glass and steel, the Great Court is an astonishingly massive space, reportedly the largest covered square in Europe. Enormous staircases wind along the now public Reading Room, eventually reaching temporary exhibition spaces and a terrace café. In addition to fluidly connecting the museum's multiple galleries, the Great Court also forms a bond with the city at large, linking up with a pedestrian route that stretches from Covent Garden to the South Bank.

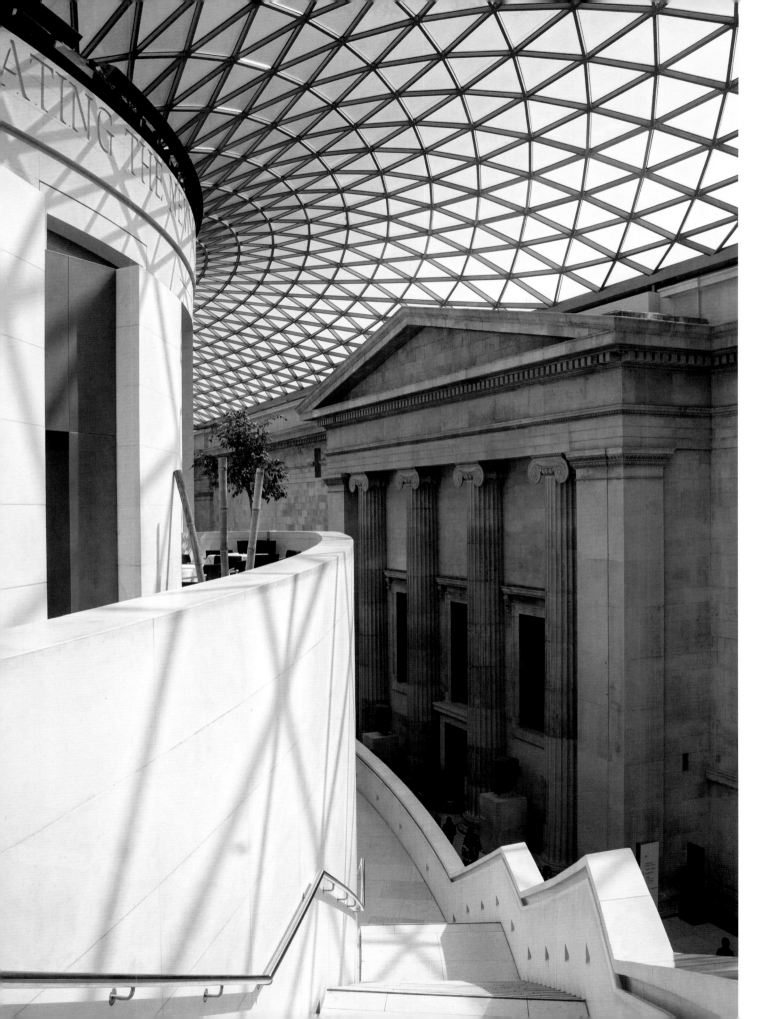

Studio Libeskind
2004
166–220 Holloway Road

Igniting like a metallic sunburst, Daniel Libeskind's London Metropolitan University Graduate Centre brings the architect's trademark geometric optimism to the school's campus on the nondescript Holloway Road. Three interlocking planar fragments clad in stainless steel produce a silhouette that evokes a reflective origami crane; inlaid with triangular contours, the exterior is ruptured by elongated windows that emerge like jagged cutouts. These openings splash the interior of the building—Libeskind's first in London—with dappled sunlight, and further the angular tension of its outward appearance. Inside, seminar rooms, staff offices, and a central lecture hall bend and slant in imitation of the greater volume.

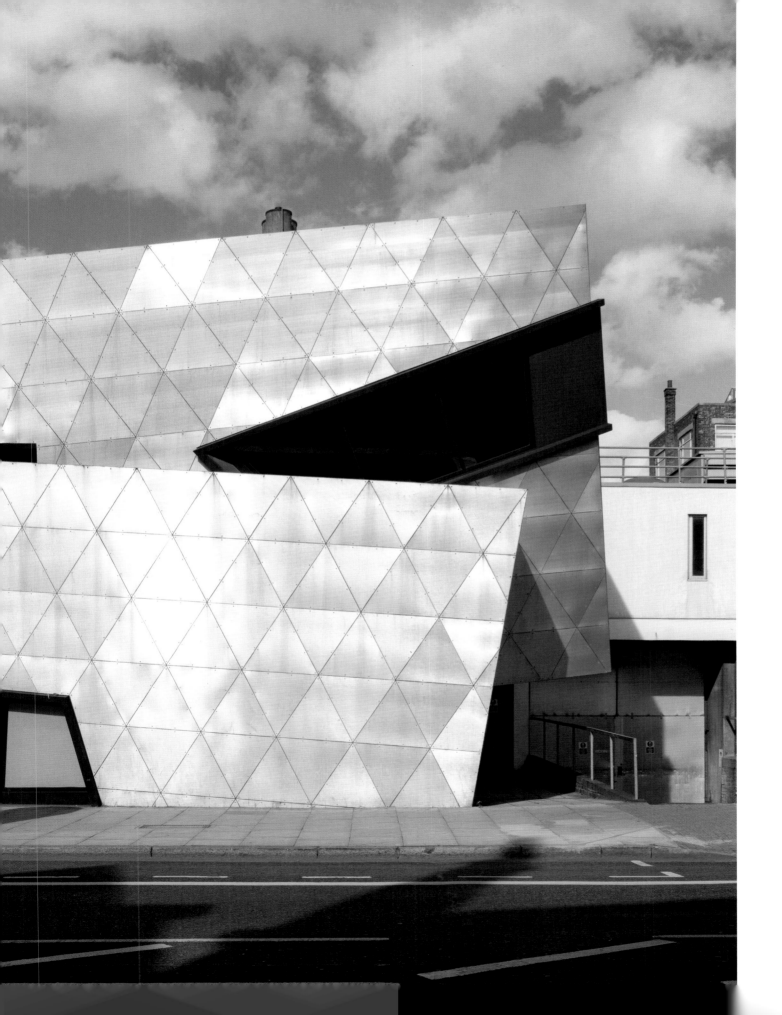

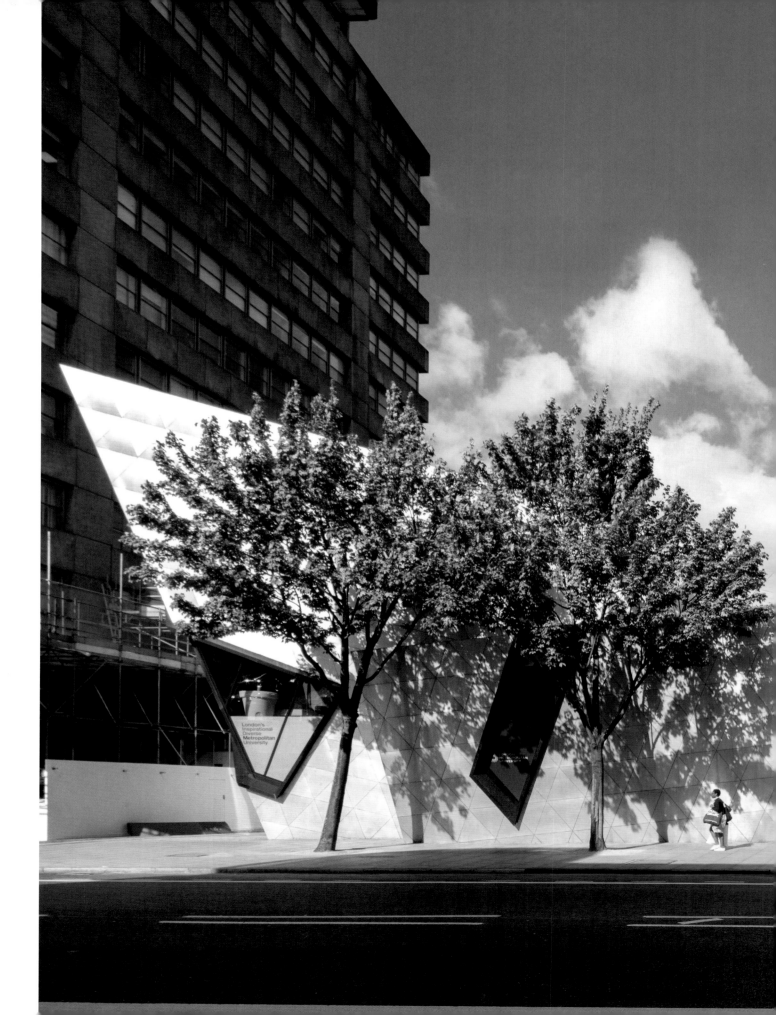

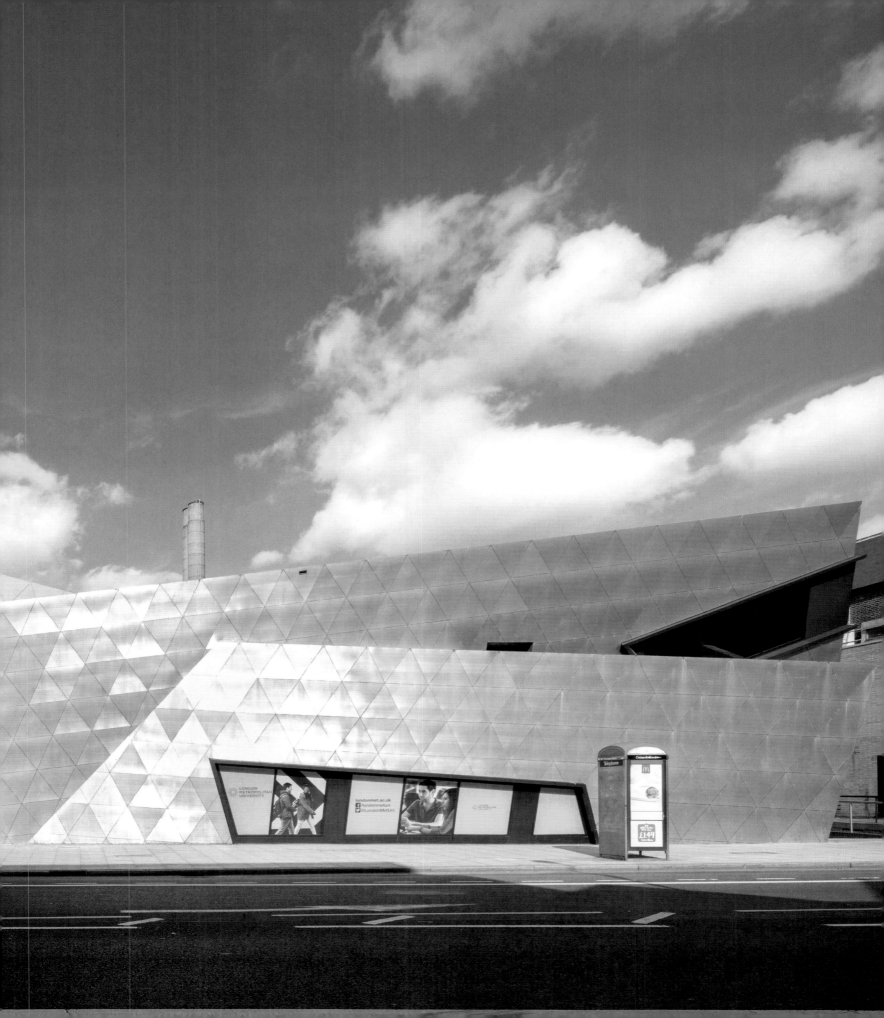

UNStudio
2015
257 City Road

Deliberately evoking Le Corbusier's vertical city, but presented in a more palatable— and less invasive—package, UNStudio's Canaletto brings promise of a new kind of urban living. Arcing, multilayered metal parentheses climb up the building's exterior in sets of three to five stories, offering expansive terrace views in all directions and creating multiple distinct "neighborhoods in the sky." The design moves the apartment tower away from monolithic blandness, and also marks something of an architectural renaissance in the northern periphery of London, as Foster + Partners and Skidmore, Owings & Merrill are also working on proposals for the area. In addition to its 190 distinct apartments, Canaletto offers a landscaped ground-floor garden, a private cinema, and a swimming pool.

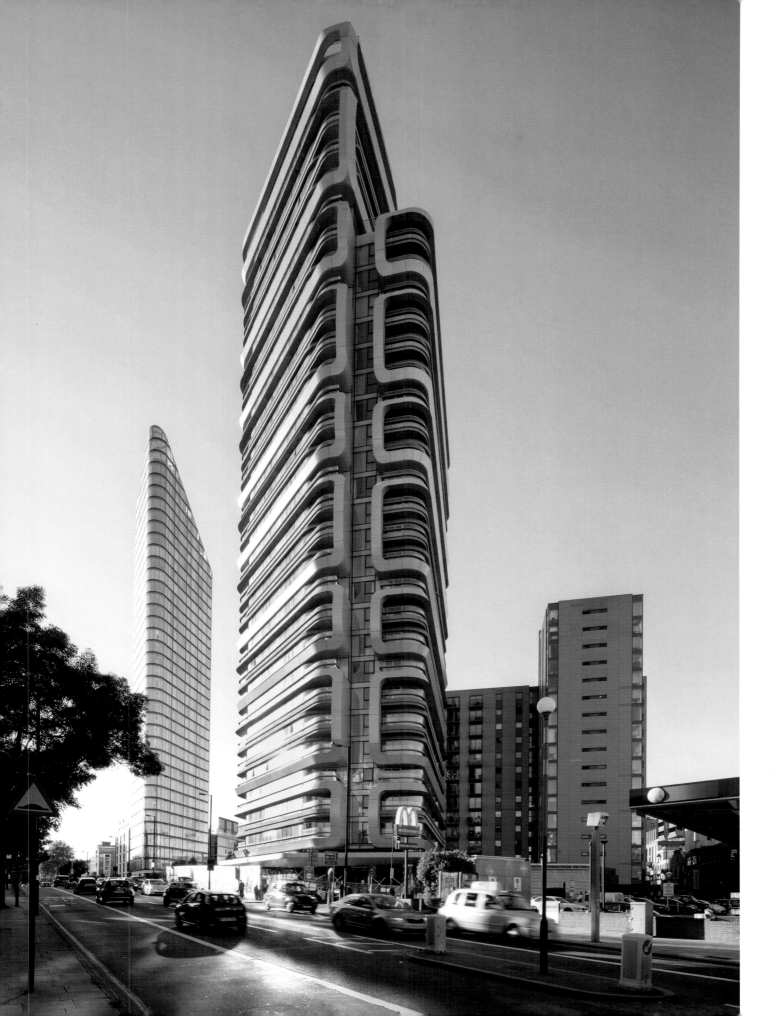

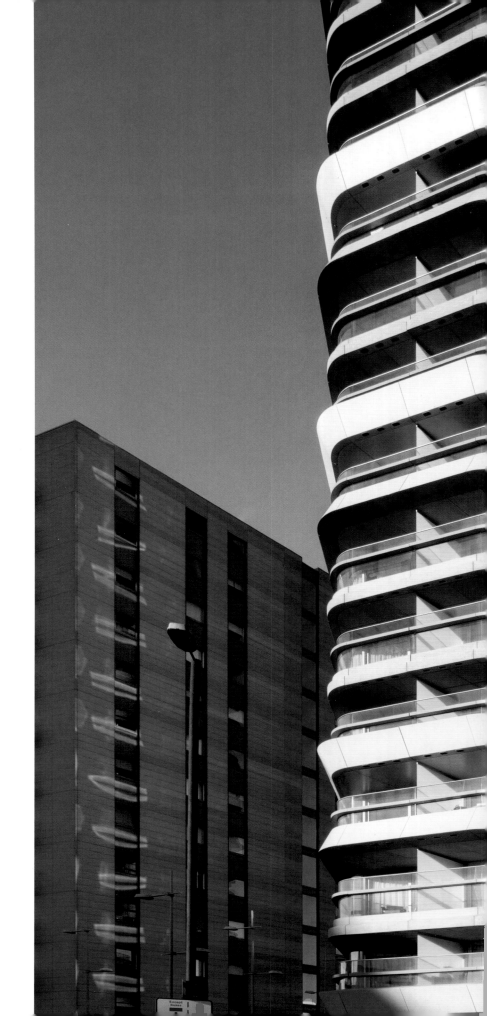

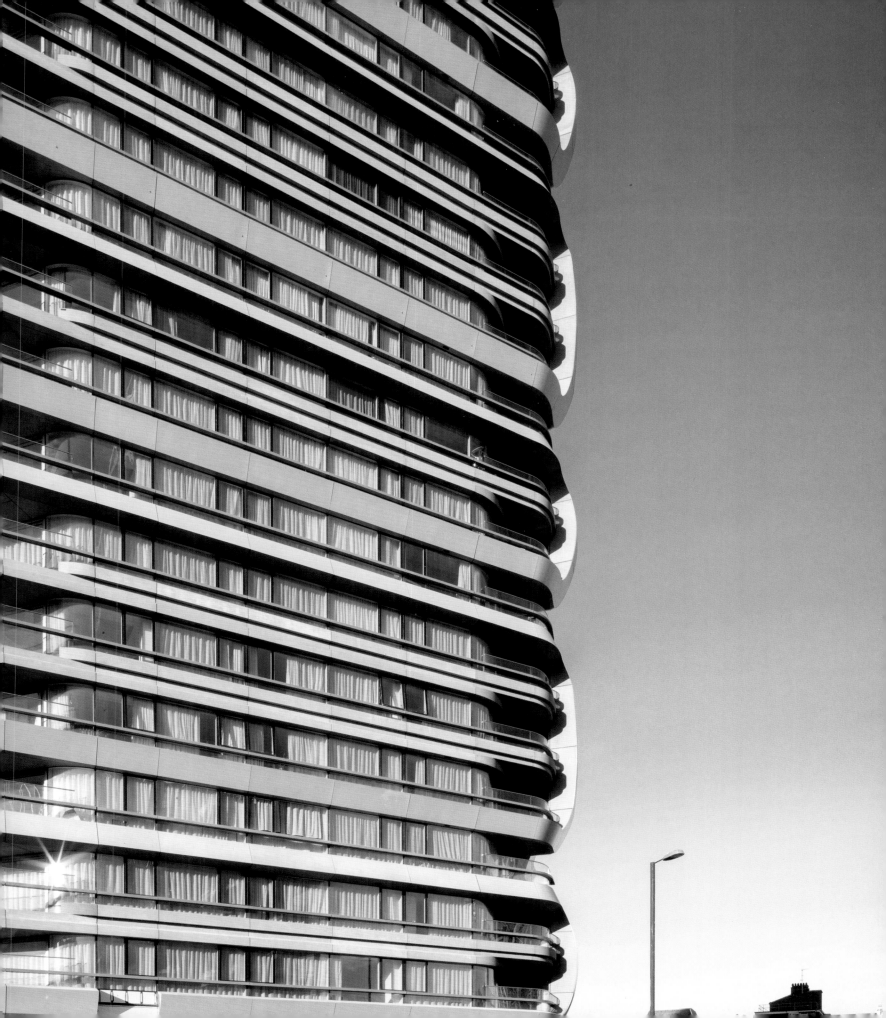

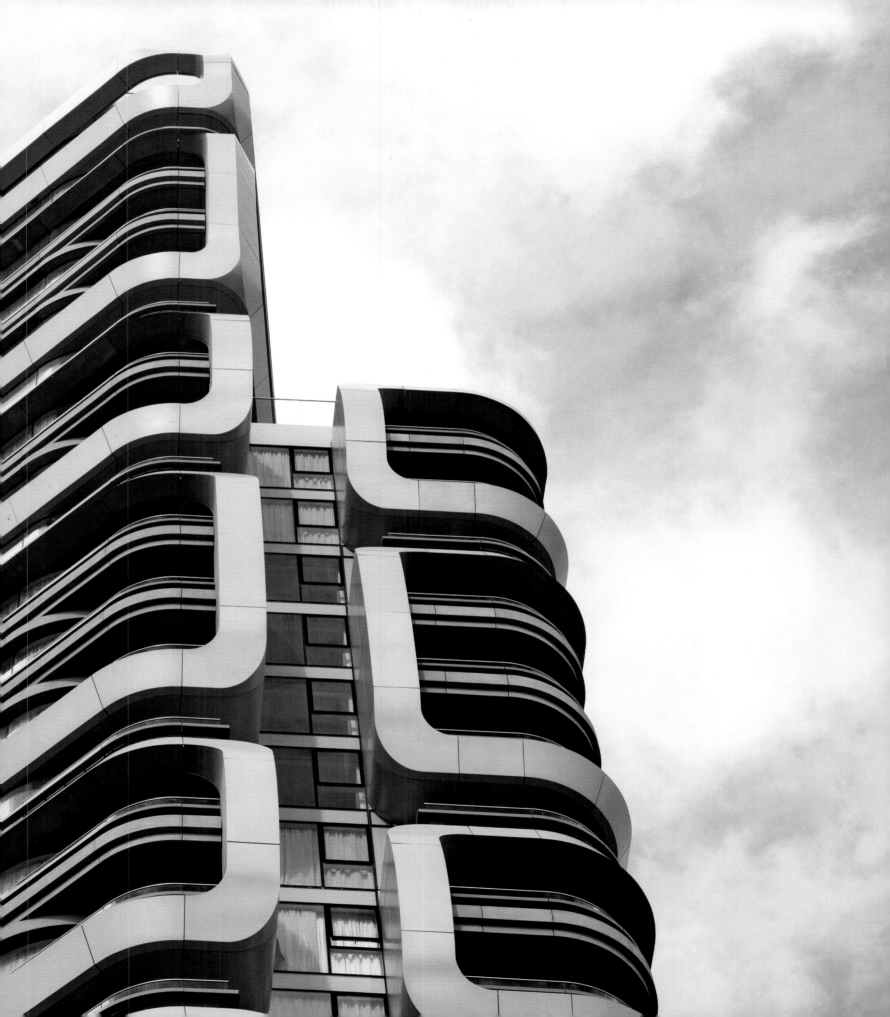

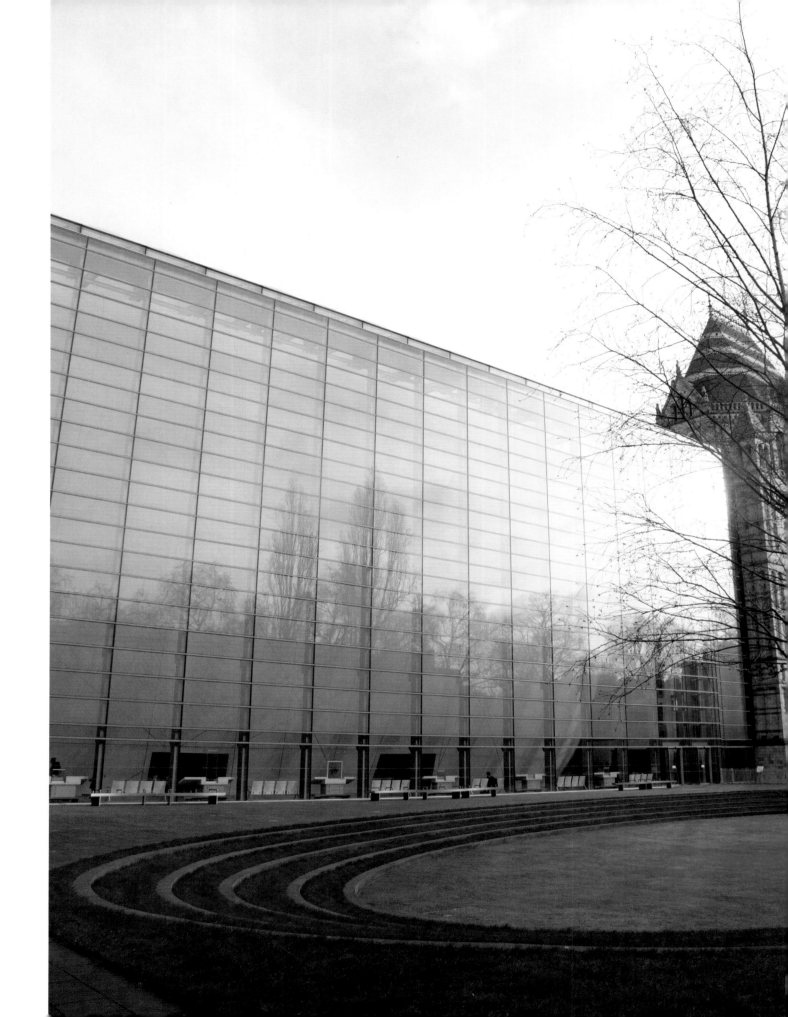

DARWIN CENTRE

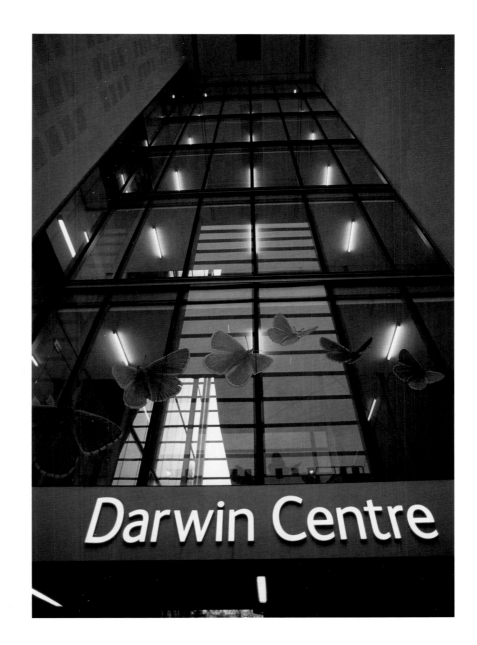

C. F. Møller
2009
Natural History Museum,
Cromwell Road

An extension of the hugely popular Natural History Museum, the Darwin Centre doubles as a pioneering research facility and tourist destination. Almost a decade after the centre's private work spaces were completed, C. F. Møller constructed a secondary addition containing an eight-story, plaster-covered mass that acts as an incubation site for millions of specimens from the museum's collection. The central "cocoon" is lined with bisecting expansion joints resembling silk threads and its egglike contours are enhanced by the cubed rigidity of the glass case in which it's enclosed. Though its glacial bulk cannot be seen fully from any angle, visitors can walk upward through it and peer down on researchers working far below.

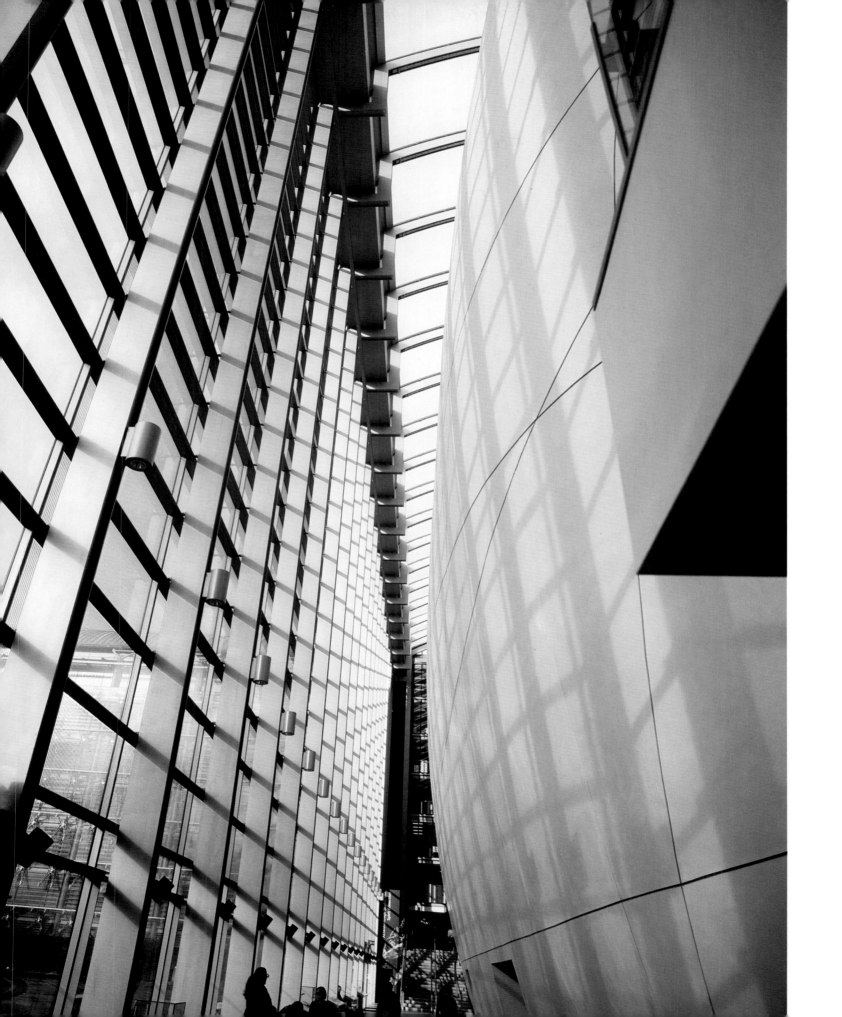

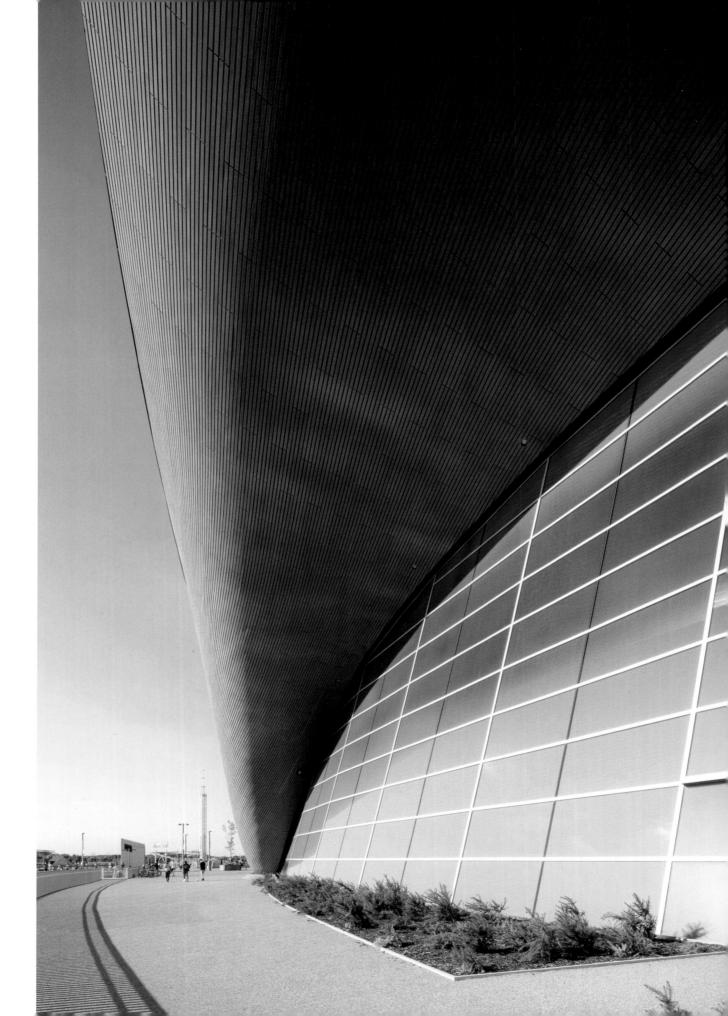

LONDON AQUATICS CENTRE

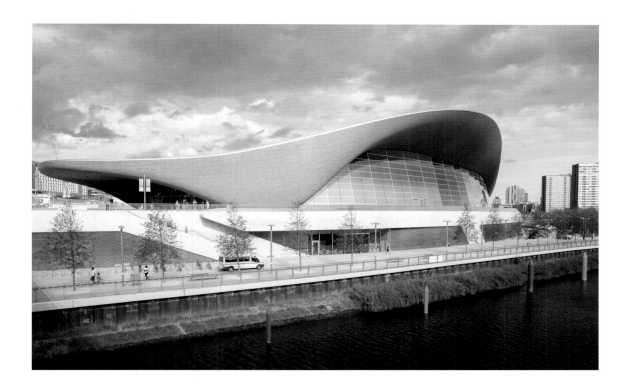

Zaha Hadid Architects
2011
Queen Elizabeth Olympic Park

Despite global scrutiny and a tricky site sandwiched between waterways, railroad tracks, and sprawling concourses, the London Aquatics Centre effortlessly unfurls itself in the graceful, undulating manner commonly associated with its architect. The building's iconic 11,200 square-foot (1,040 sq. m) steel roof is designed to mimic the sinuous contour of a wave, rising and falling to accommodate two massive glass walls that admit beams of natural light and grant views of Olympic Park beyond. The concrete-dominated interior features two 50m pools, including a cavelike training pool with a coffered ceiling containing skylights shaped like water droplets. The diving pool furthers the general theme of motion, as concrete diving boards arc over the surface like individual sculptures. All of the pools are outfitted with movable floors and sliding booms designed for easy adaptability.

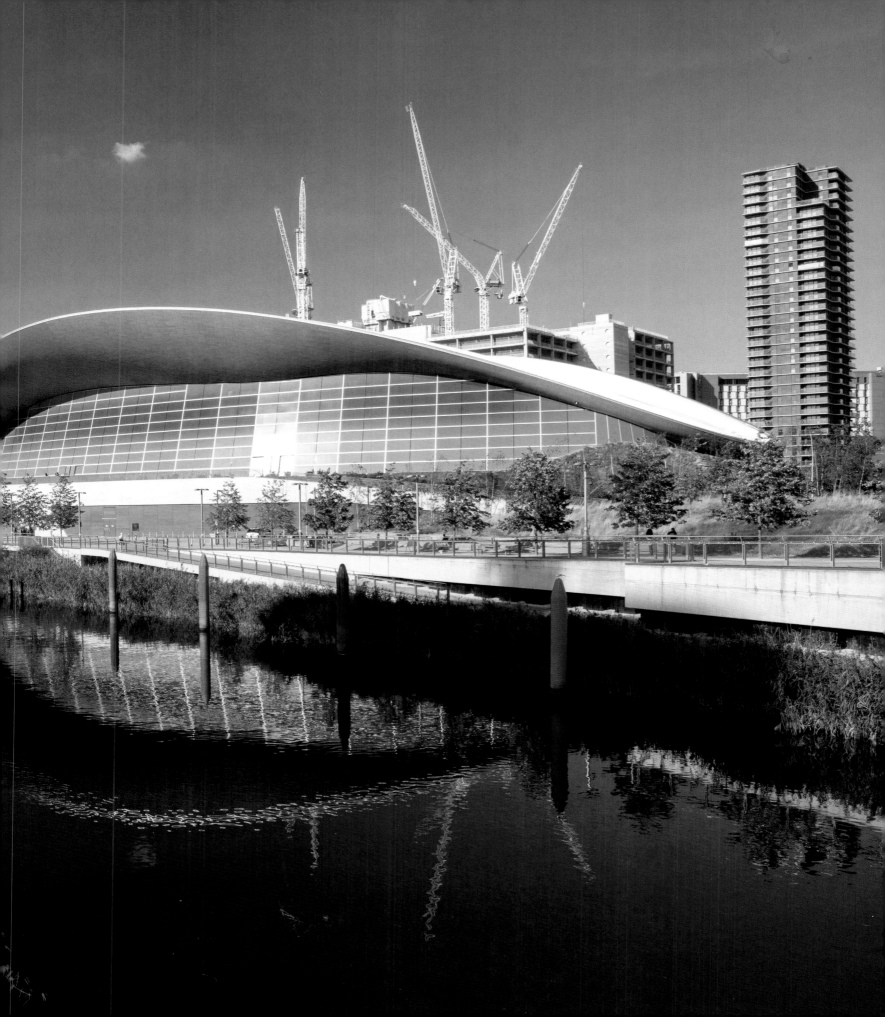

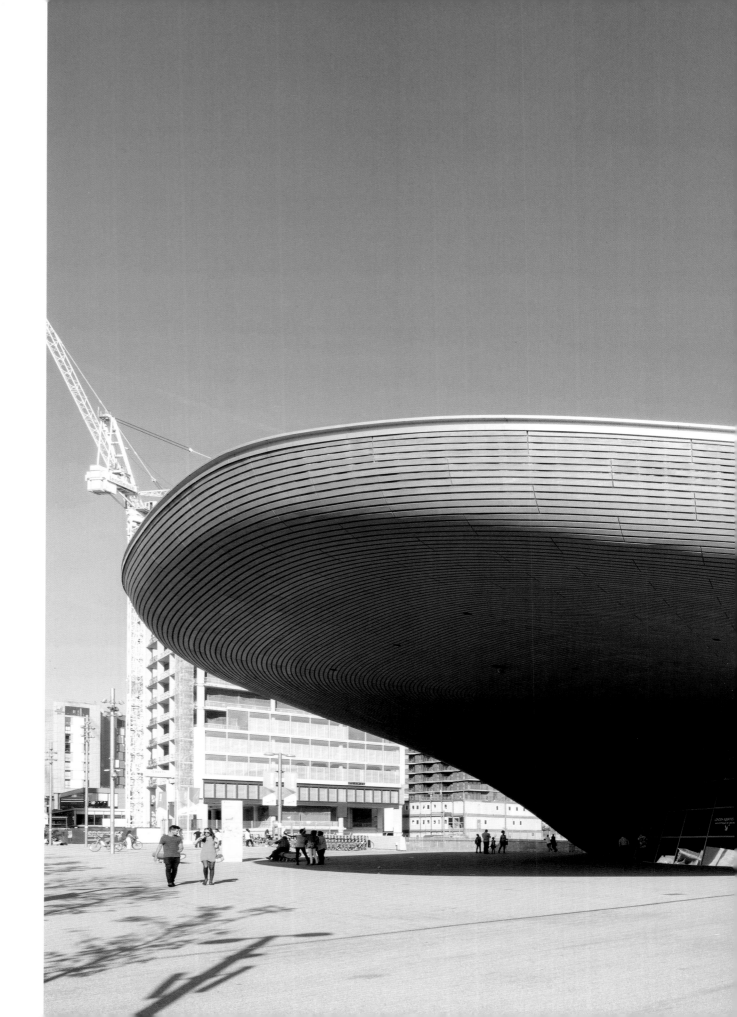

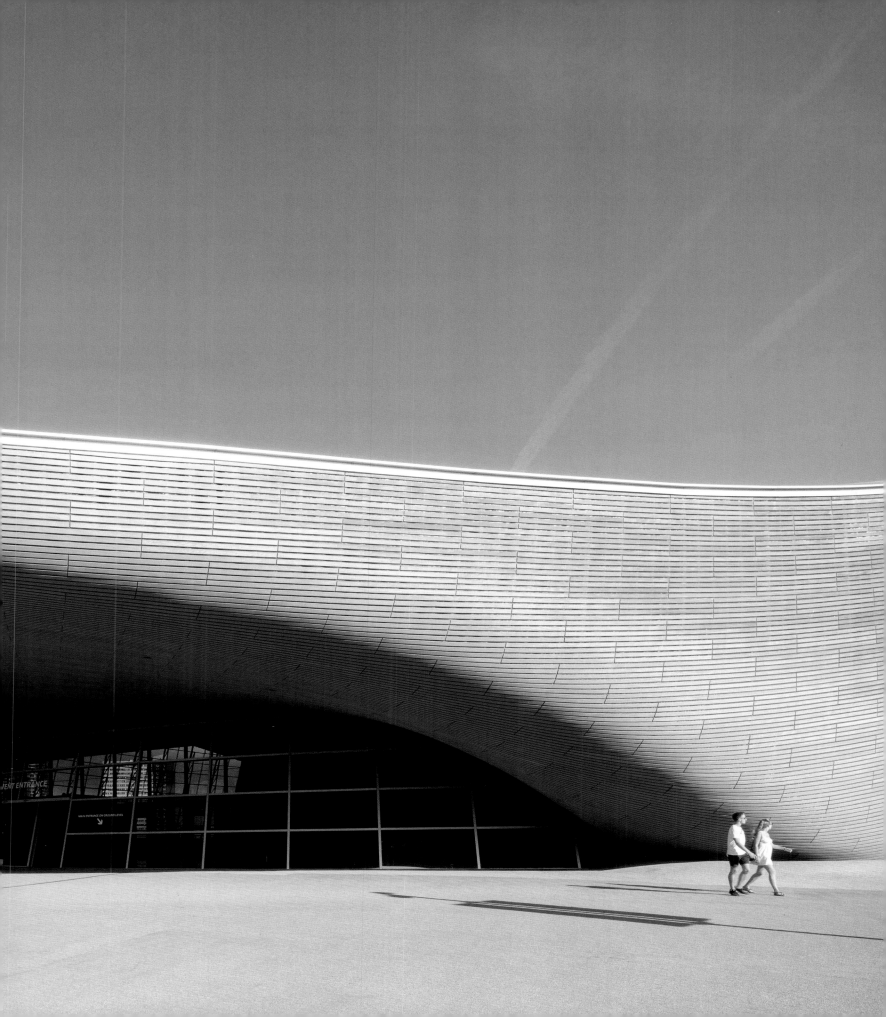

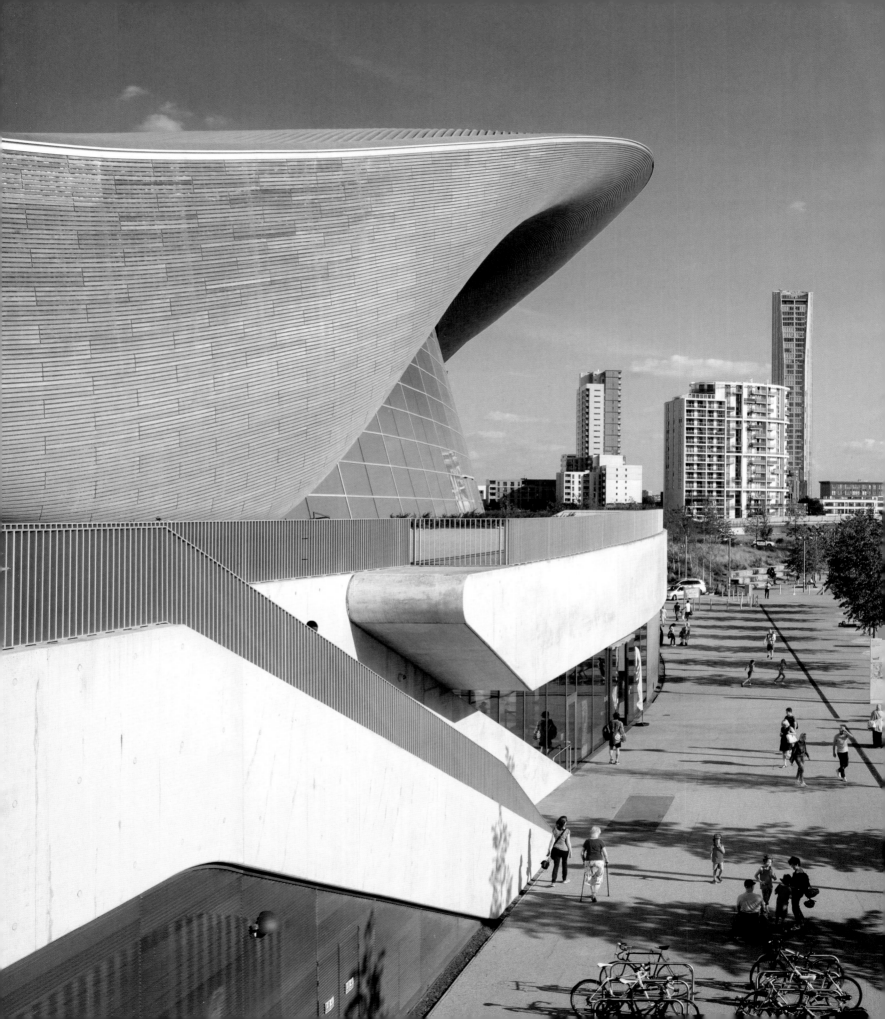

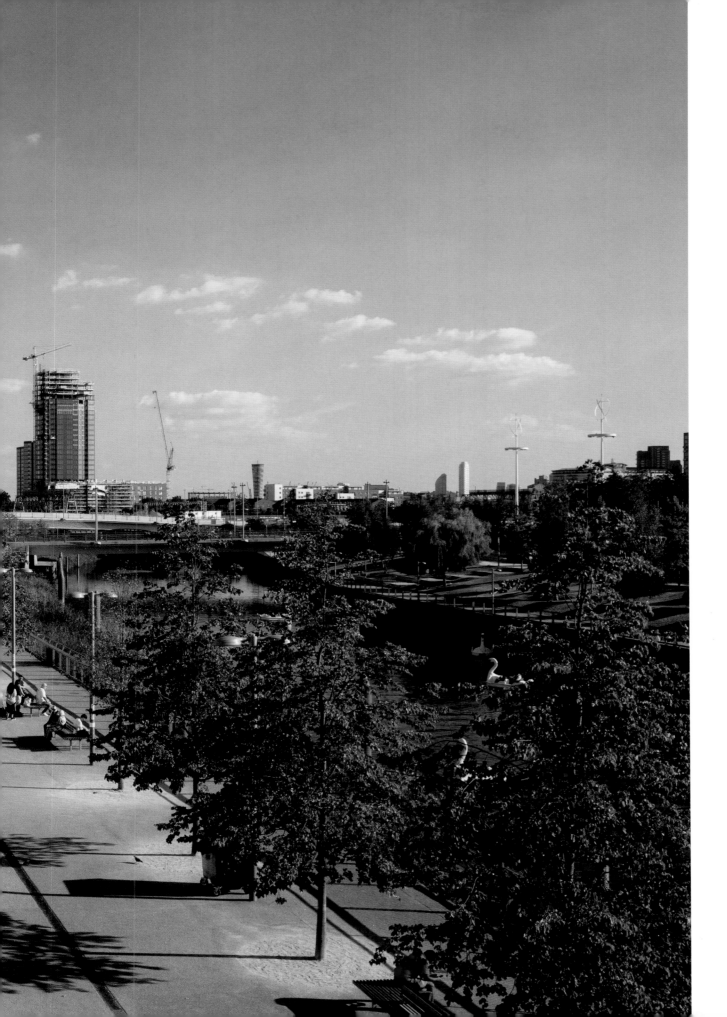

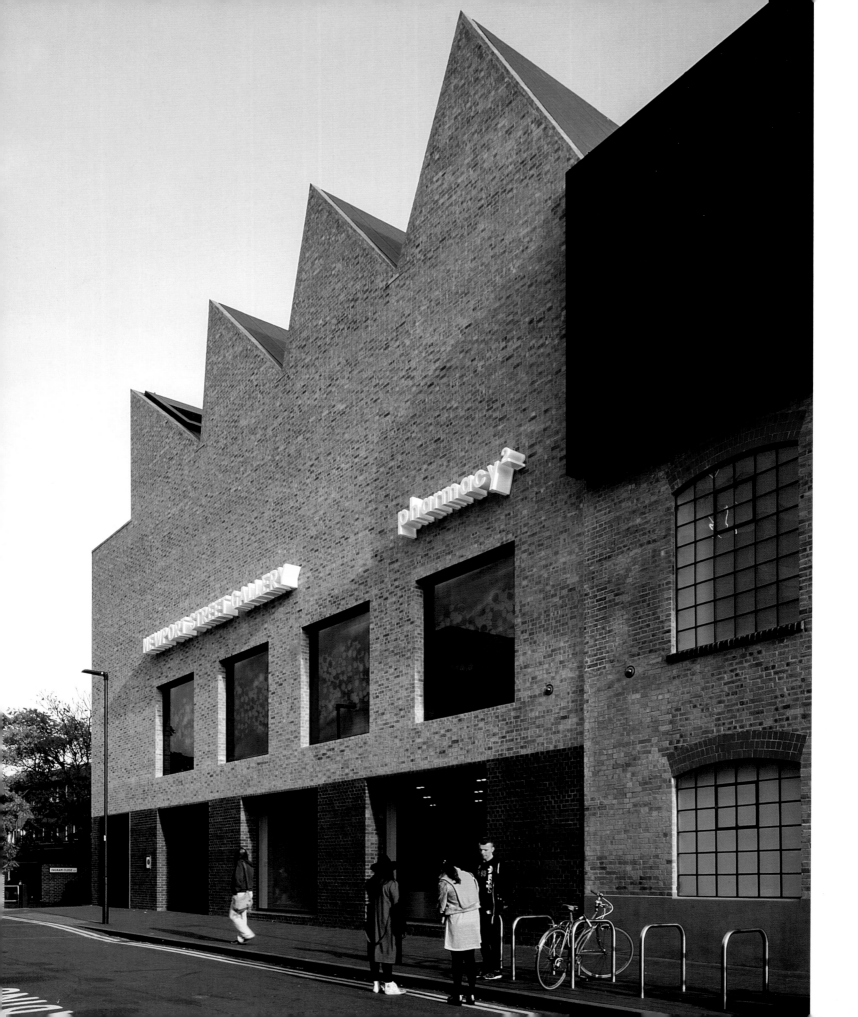

NEWPORT STREET GALLERY

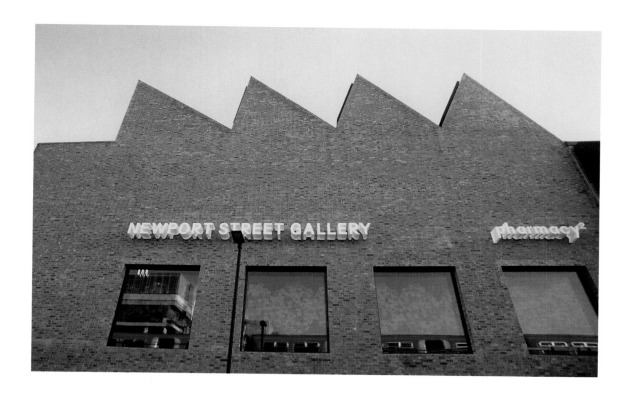

Caruso St John Architects
2015
Newport Street

Having built a reputation as the reigning provocateur of the contemporary art world, Damien Hirst seems to imagine his Newport Street Gallery—designed by the sovereigns of renovation, Caruso St John—as a demarcation of belatedly acquired maturity. Housing his extensive personal collection that includes works by contemporaries such as Tracey Emin and Jeff Koons, as well as predecessors like Francis Bacon and Pablo Picasso, Hirst's gallery extends its sawtooth figure along an entire railway-lined street in Vauxhall. The elongated brick structure is made up of three existing warehouses originally built for theater scenery production, as well as two newly constructed sections on either end. The architects removed several interior floors to create high-ceilinged galleries, and engineered three amoebalike stairwells lined in white brick that facilitate fluid progression and provide their own visual idiosyncrasies.

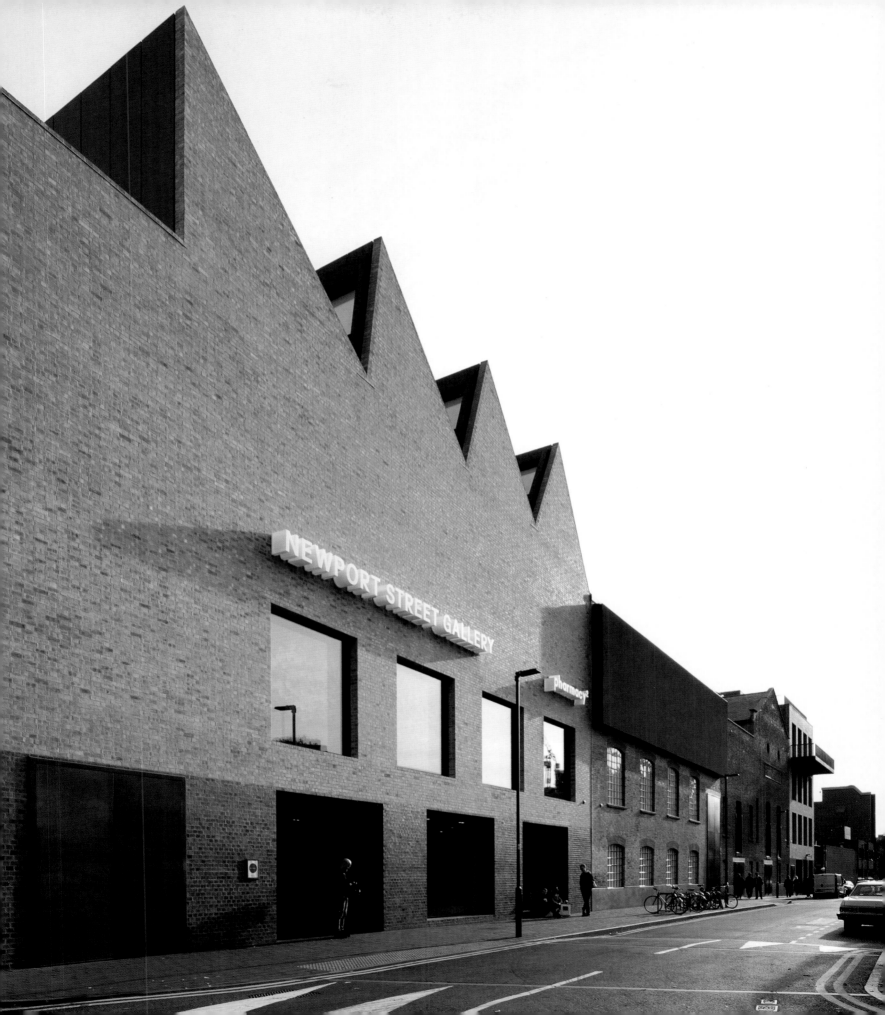

Eric Parry Architects
2009
50 New Bond Street

Eric Parry has made a career out of pinpointing exactly where and how urban planning can be improved. His specialty is office buildings, which so often have the misfortune of being both ill-conceived and very public. Parry's redesign of 50 New Bond Street, on a corner in Mayfair lined mostly with nineteenth-century offices, is as much repair as it is renovation. The western facade of the building is lined with six columns of oriel windows that are surrounded by sculptural, zig-zagging, green faience ribbing. The ornate, Edwardian corner remains completely untouched itself, and is bound on the east side by Eric Parry's 14 St George Street, with a cantilevered, black steel-and-glass facade that fills a gap that had previously marred the cohesive beauty of the block.

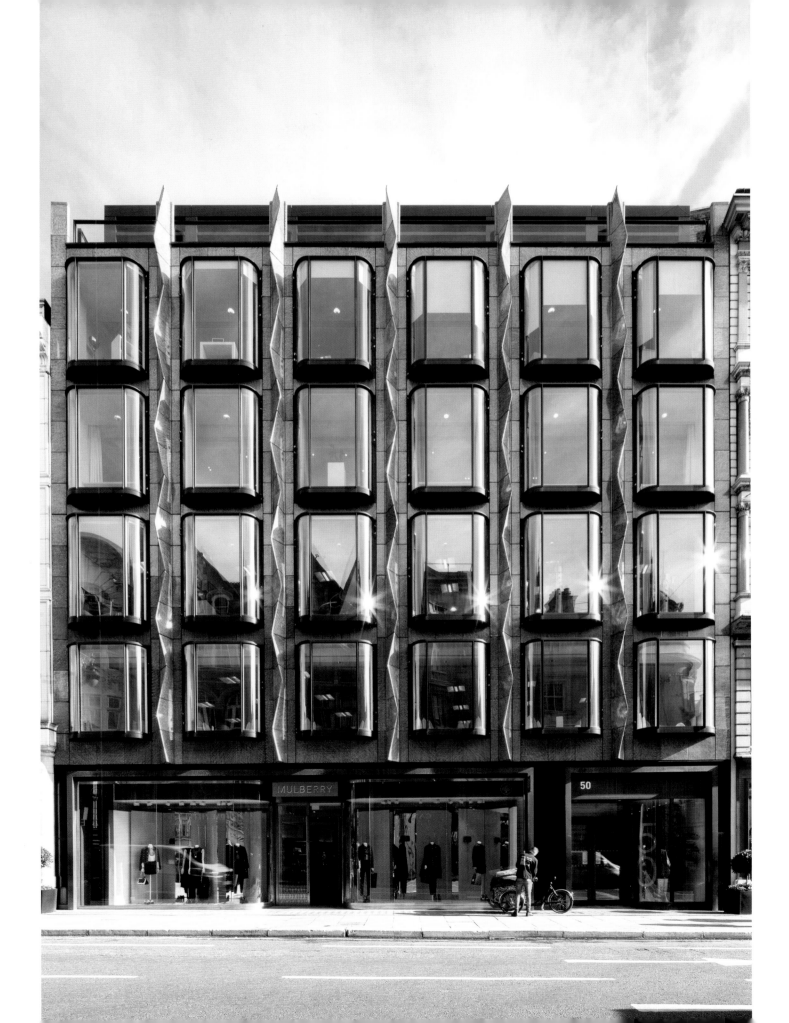

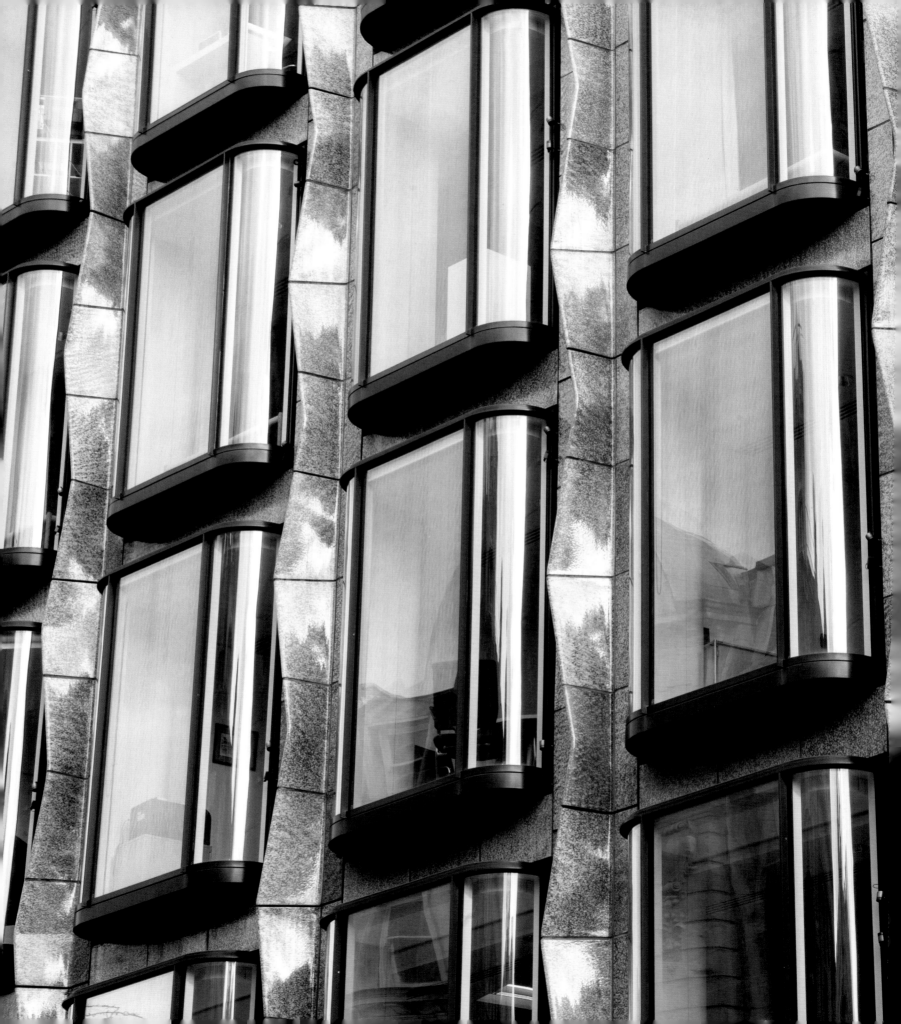

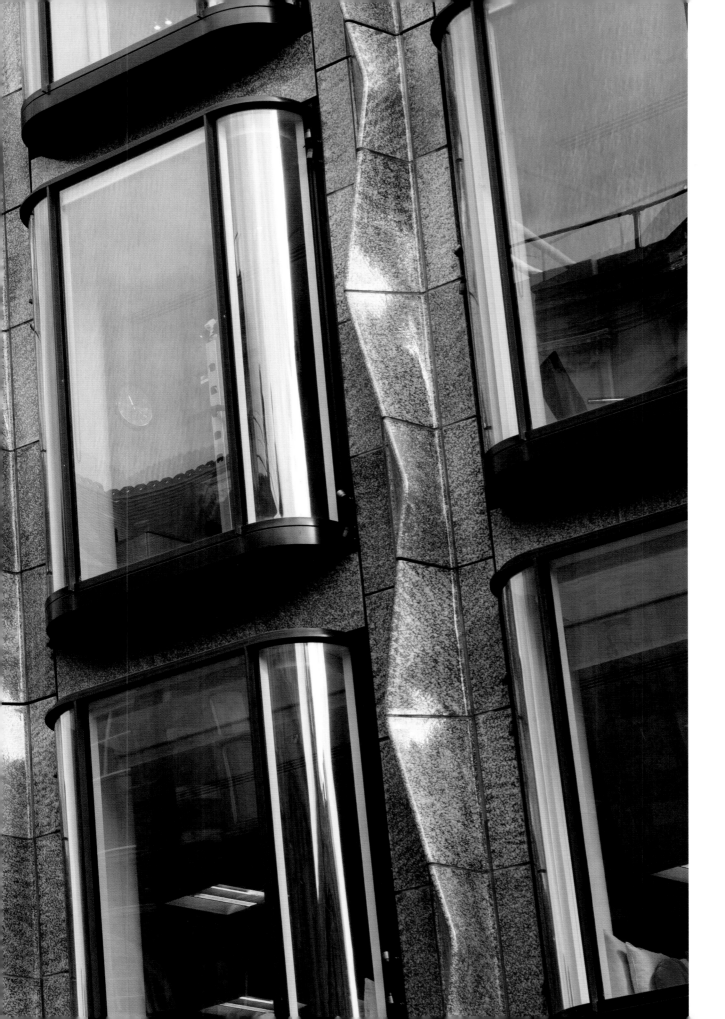

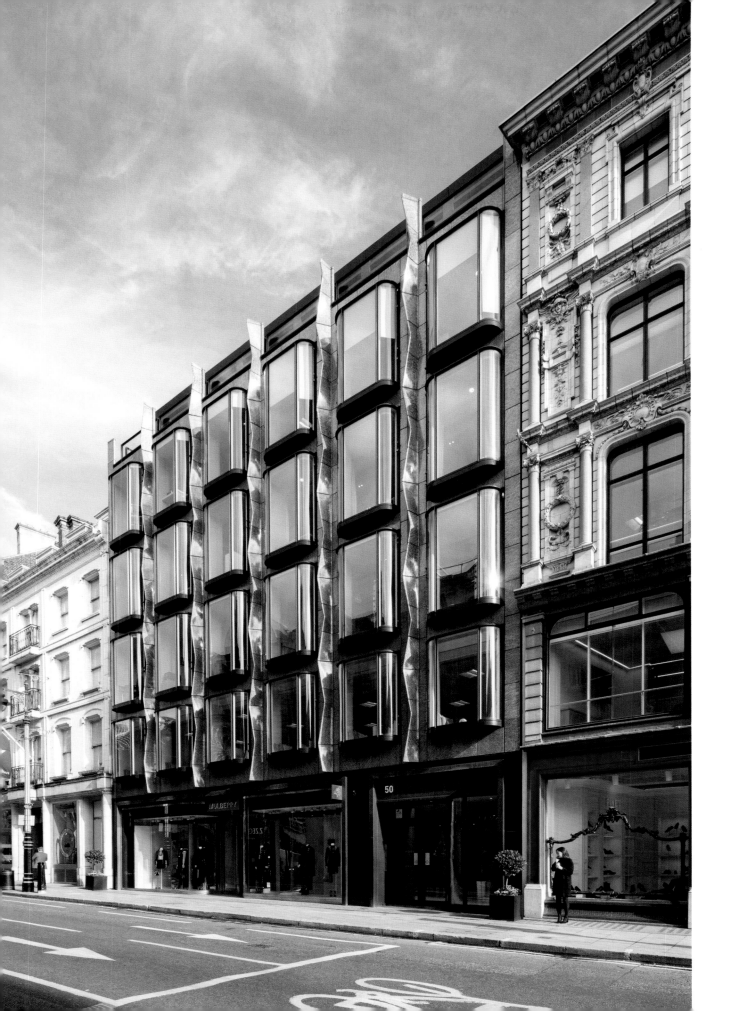

6a Architects
2013
9 Albemarle Street

At first glance, the patinated, cast iron facade of Paul Smith's new Mayfair location evokes London's aesthetic past: for centuries the city's lampposts, railings, and drainpipes have been cast using the same material. Yet while the siding's repeated curves generate an iconic Regency pattern, they also overlap to create an optical illusion engineered in drawings by Smith himself. 6a, the firm behind the project, used these sketches to digitally engineer a pattern that would transform with the changing angle of the sun; this approach also allowed the firm to cast three tiny illustrations of Smith's directly into the panels in subtle locations. As the eye pans upward, the layered patterning becomes increasingly pronounced before culminating at a perforated second-floor balustrade.

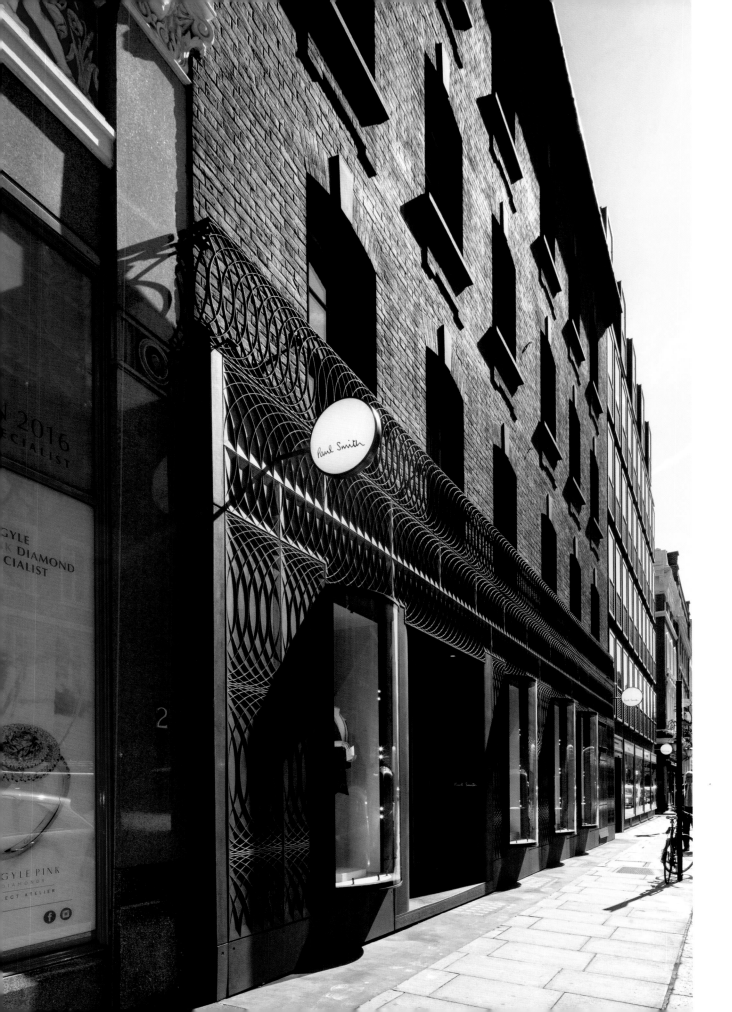

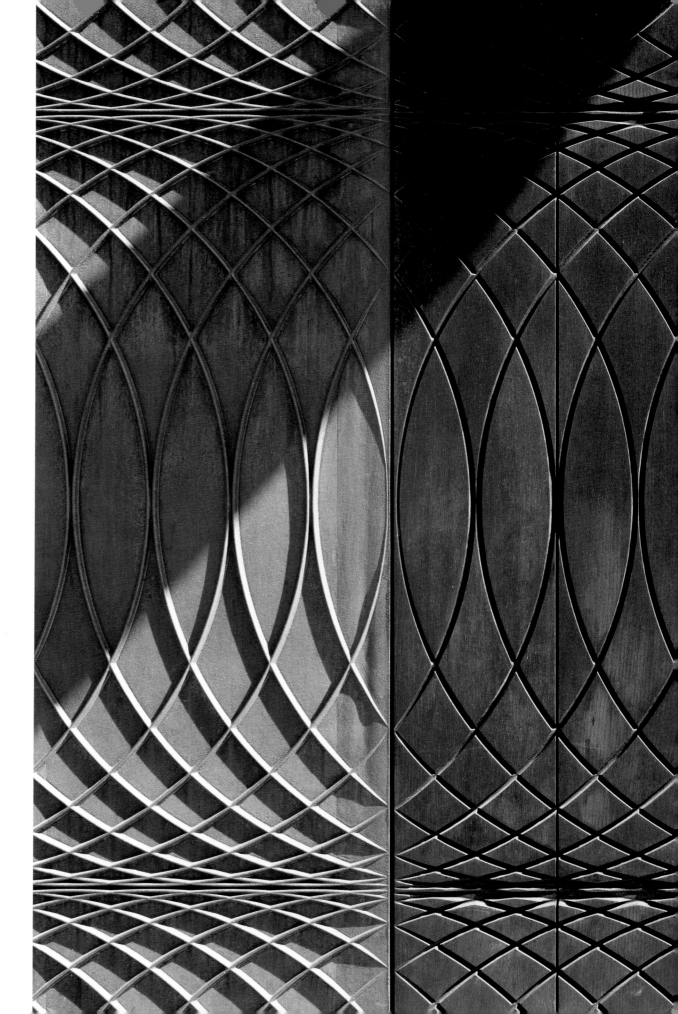

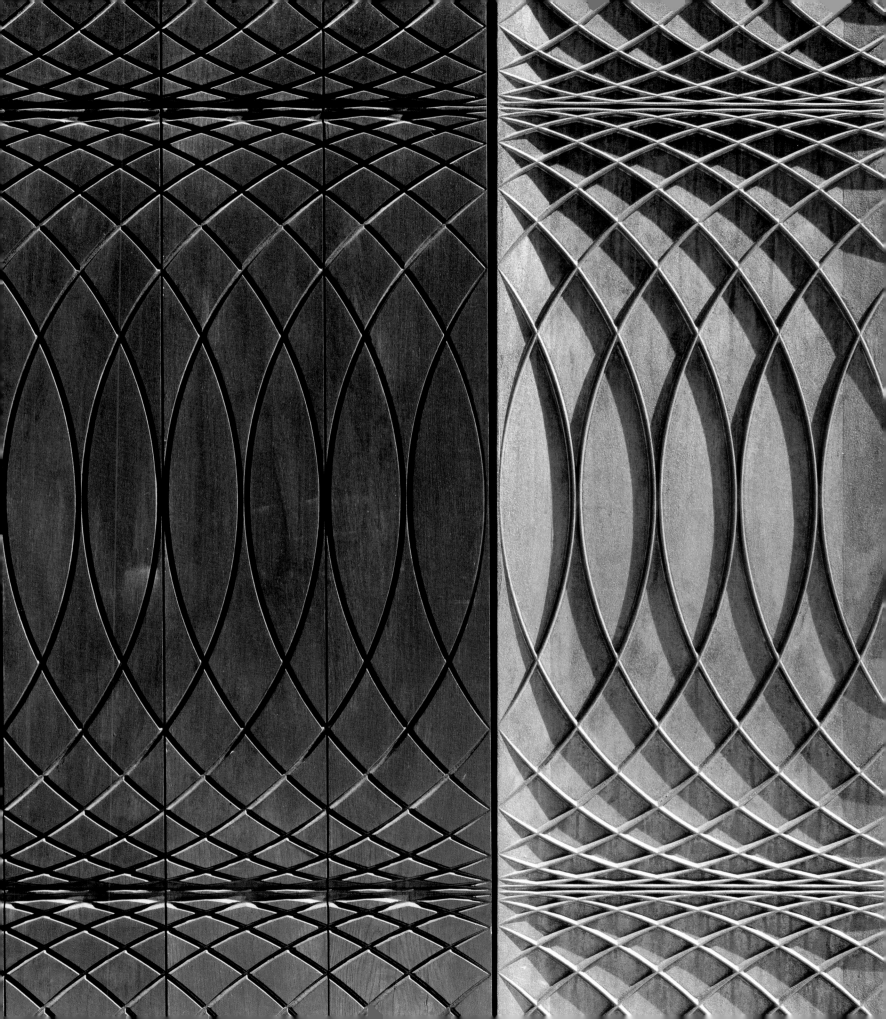

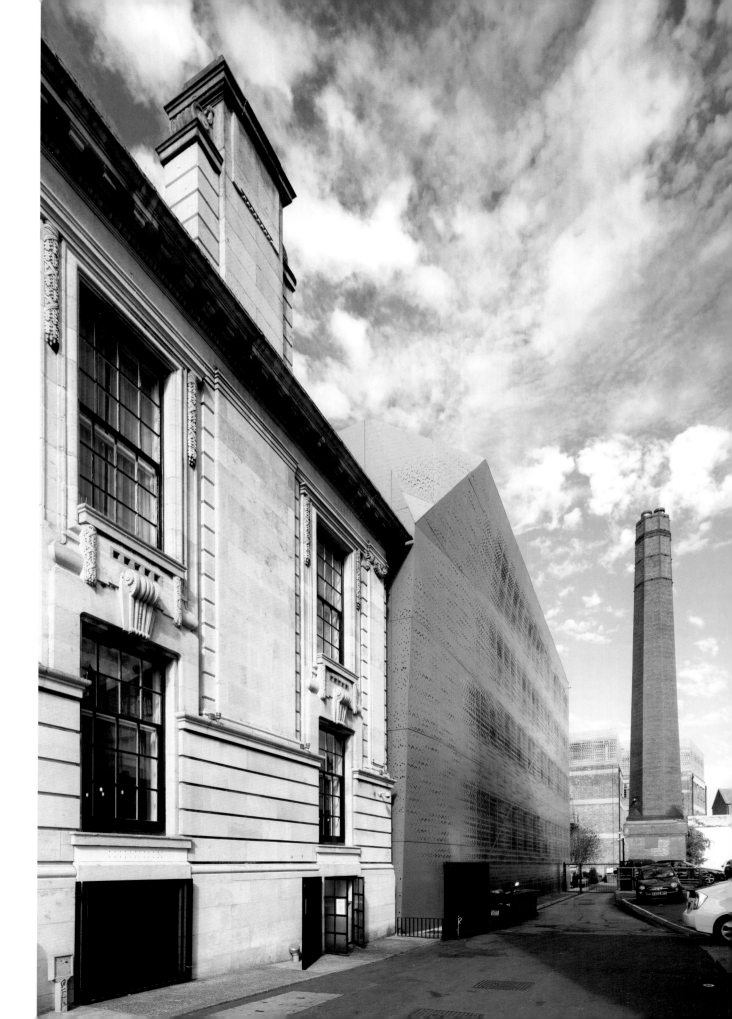

TOWN HALL HOTEL

RARE Architects
2010
Patriot Square

After housing London's municipal administration for decades, Bethnal Green Town Hall, a Grade II historically preserved structure, was subject to numerous, ill-advised modifications and eventually fell into decay. In 2007, the building was purchased by Singaporean hotelier Loh Lik Peng, who commissioned RARE to design a groundbreaking luxury hotel that would incorporate the Edwardian landmark. Along with restoring the molded ceilings and elaborate paneling in the original structure, the project included the addition of a secondary volume coated in an intricately patterned, powder-coated aluminum skin. Its gently sculpted, multi-planar form was dictated by the needs of its neighboring buildings, leading to an architectural dialogue that extends beyond the hotel itself.

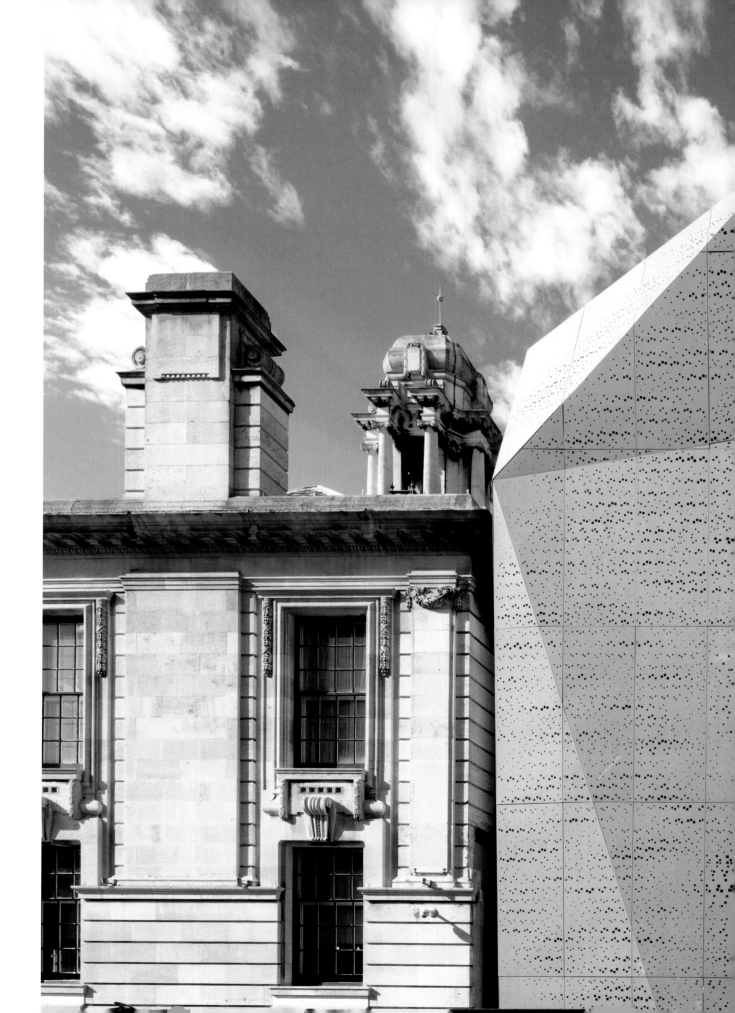

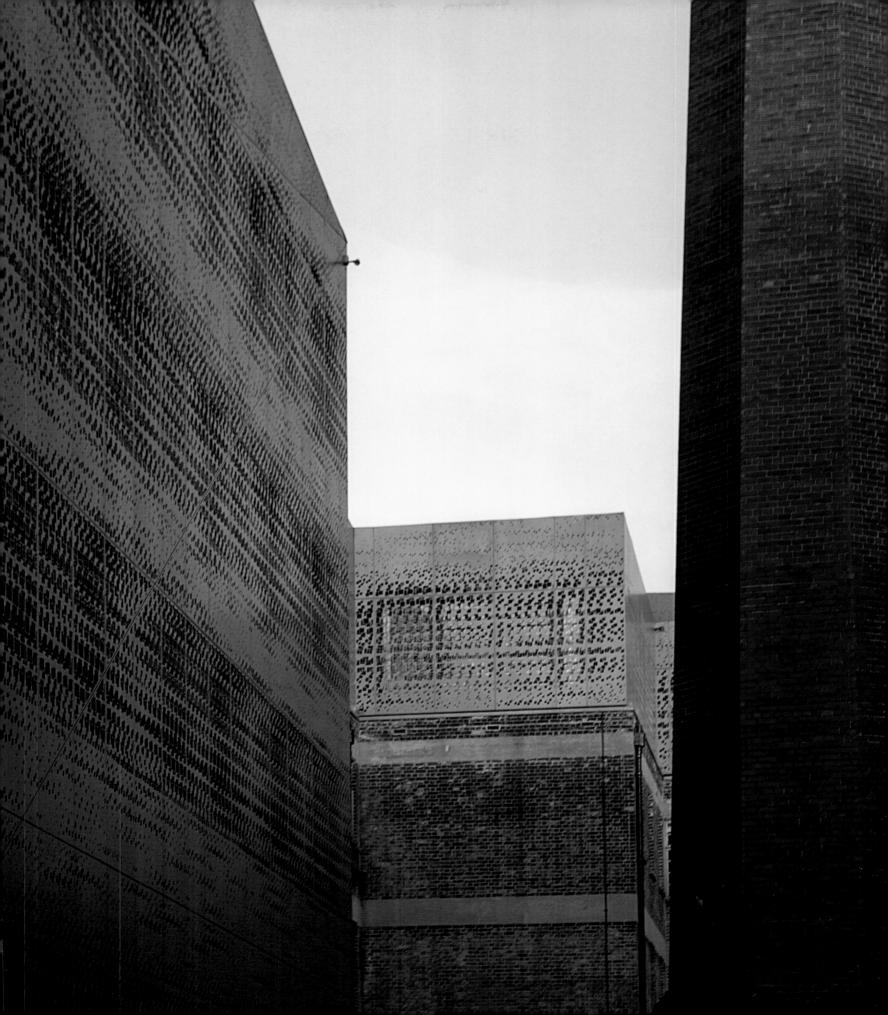

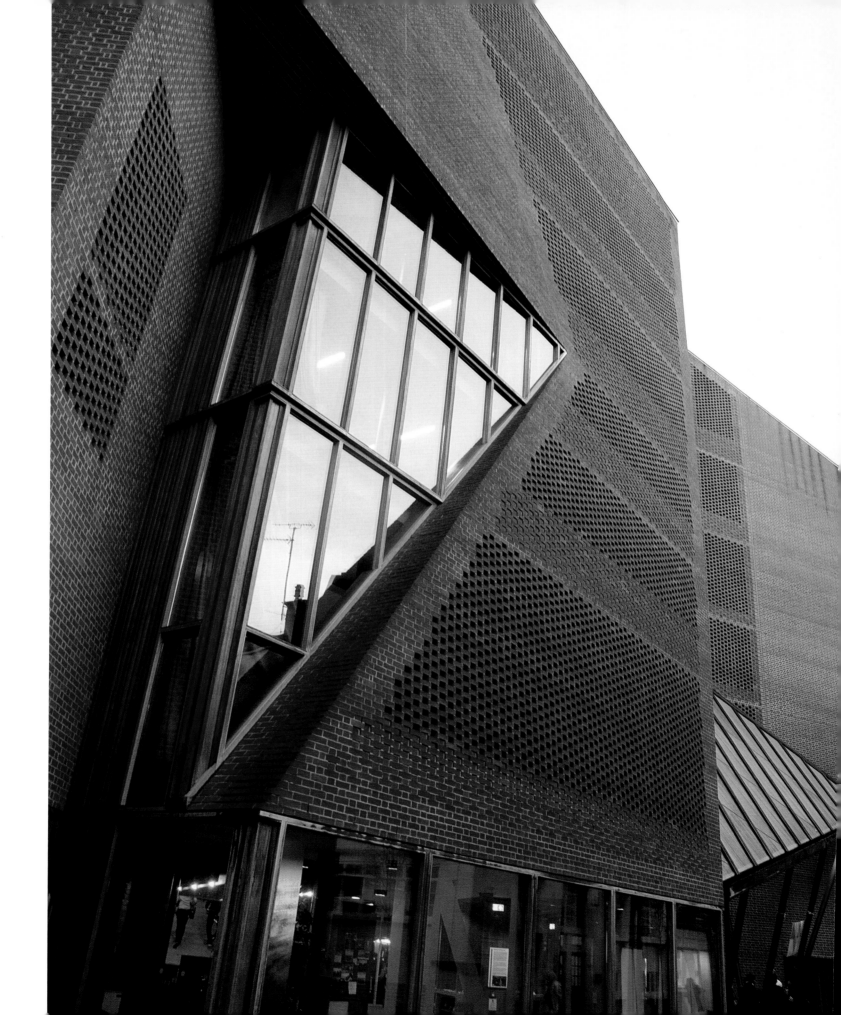

LSE SAW SWEE HOCK STUDENT CENTRE

O'Donnell + Tuomey
2013
1 Sheffield Street

Unfolding like a brick-clad Cubist mountain range, O'Donnell + Tuomey's LSE Saw Swee Hock Student Centre elegantly responds to its cramped triangular site and demanding brief. Holding a café, gym, career center, and media lab, as well as prayer rooms and a whole host of other social spaces, the structure brings cohesion to the London School of Economics while also supplying a burst of spontaneity. Winglike walls angle toward the main entrance, placed on axis with St Clement's Lane, the campus's primary thoroughfare. In several locations, the planar brick walls incorporate a perforated Flemish bond pattern that filters sunlight into the building during the day; at all hours, luminous geometric patterns are ghosted upon the floor. Inside, the quirky angles of the centre's facade are mirrored throughout the space, while a coiled concrete stairway near the entrance provides an aesthetic counterpoint.

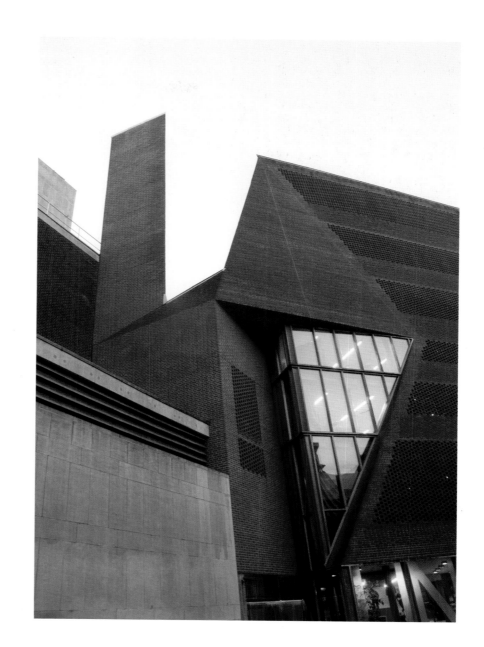

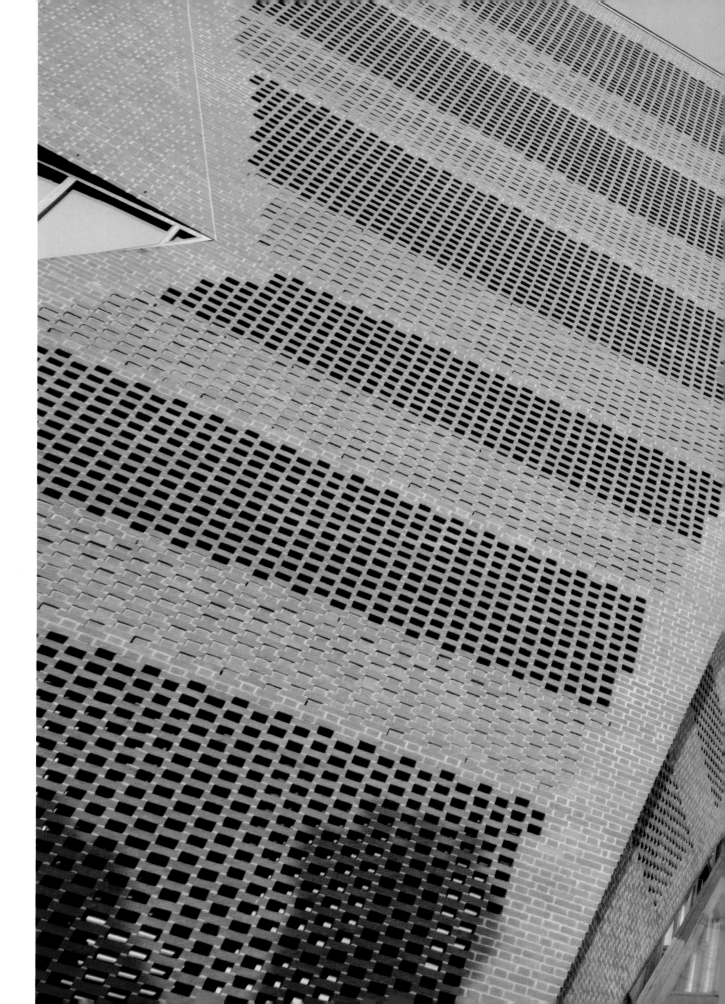

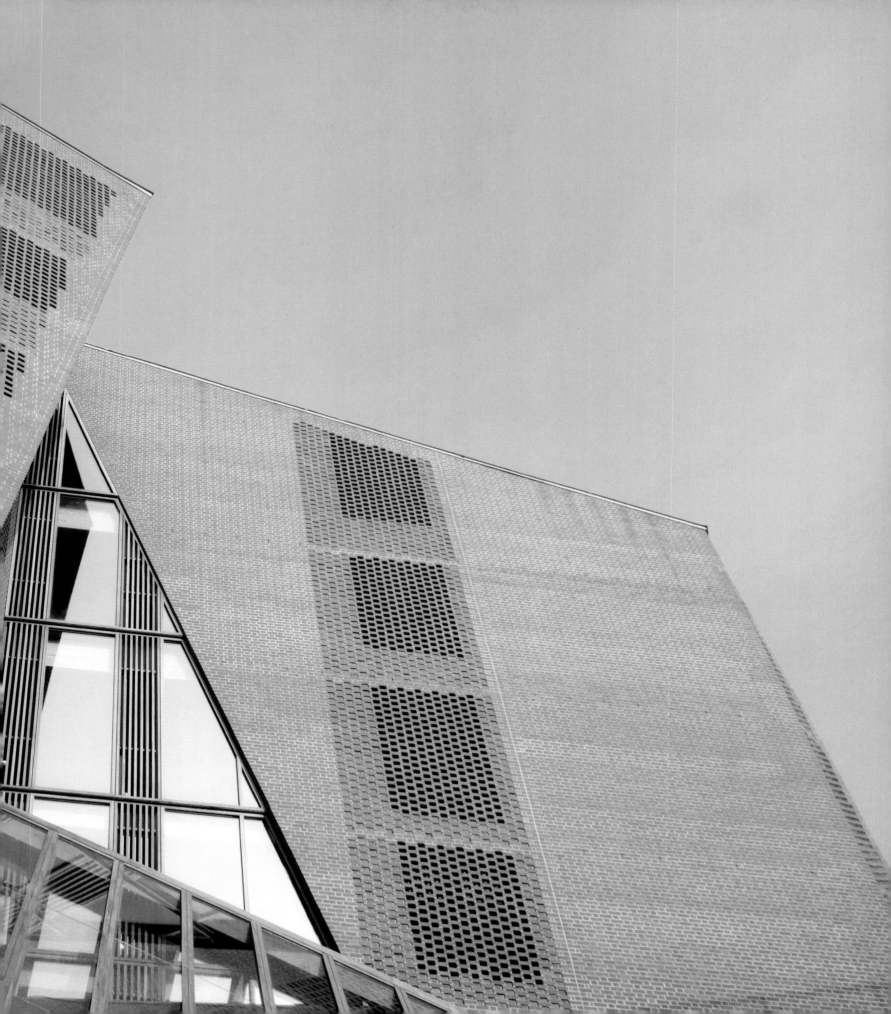

BLUE FIN BUILDING

**Allies and Morrison
2005
110 Southwark Street**

As part of the ongoing
"regeneration" of London's
Southwark borough, the firm
of Allies and Morrison was
brought in to design a mixed-use
development on a prime location
between the Tate Modern and
Southwark Street. At over one
million square feet (9,290 sq. m),
Bankside 123 is composed of
three structures devoted primarily
to office space, of which the Blue
Fin Building (originally Bankside
1) stands most strikingly, owing to
the 2,000 vertical aluminum fins
of varying blues attached to the
fully glazed facade. In addition
to providing solar shade to the
offices within, the fins alter the
building's appearance depending
on the angle of view. At grade
are retail outlets and restaurants,
public art installations to enliven
the public spaces, and pedestrian
thoroughfares that link the three
buildings together, as well as to
the surrounding community.

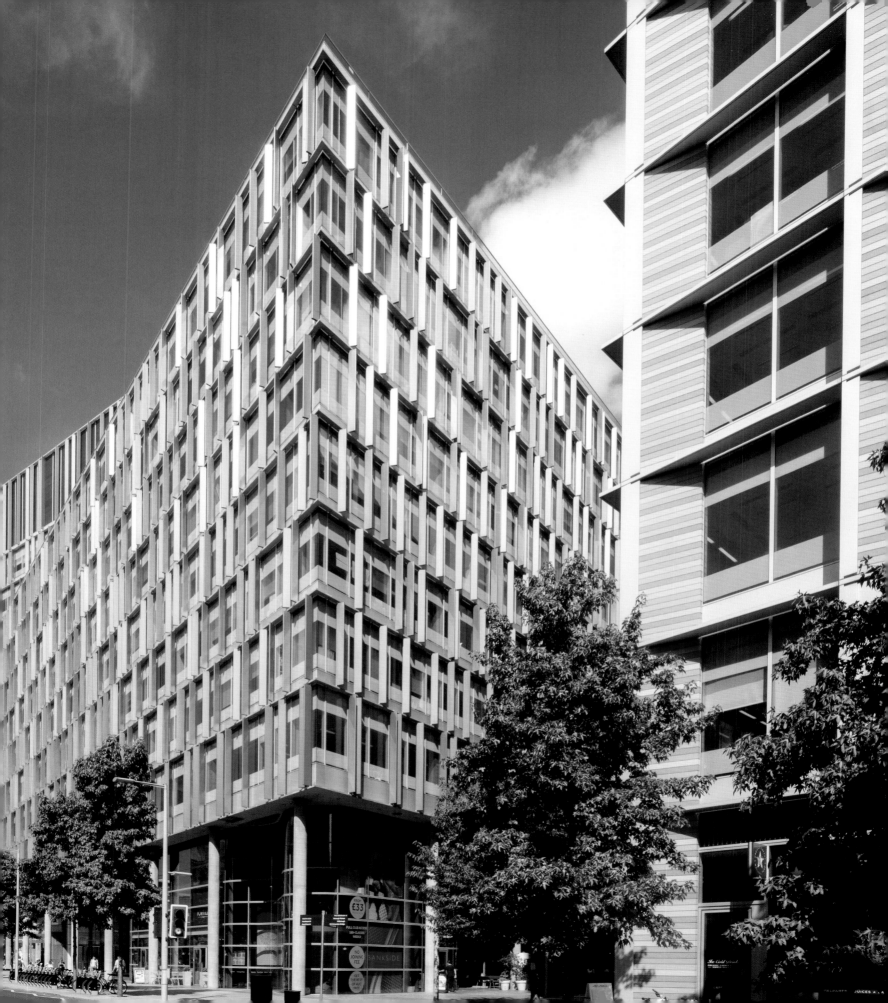

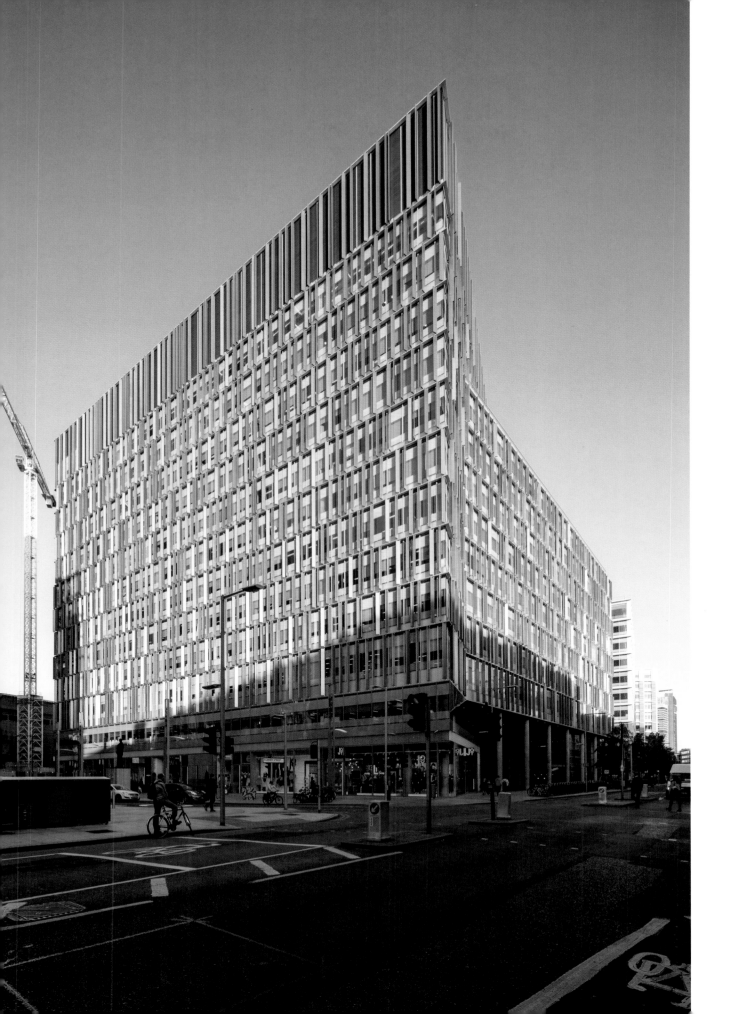

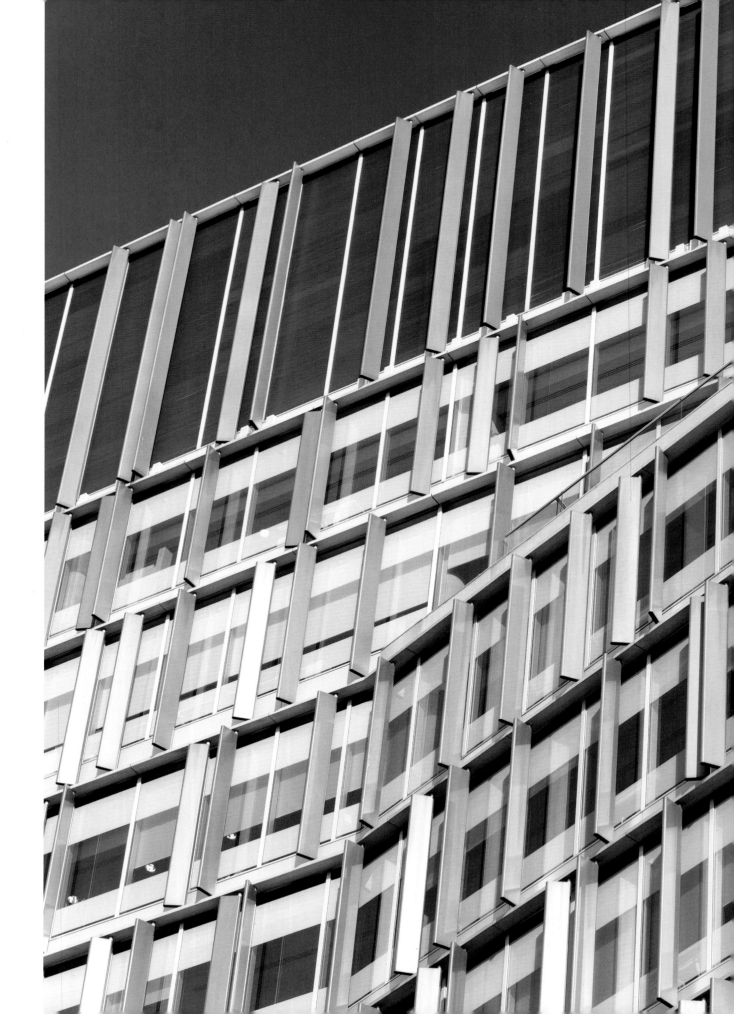

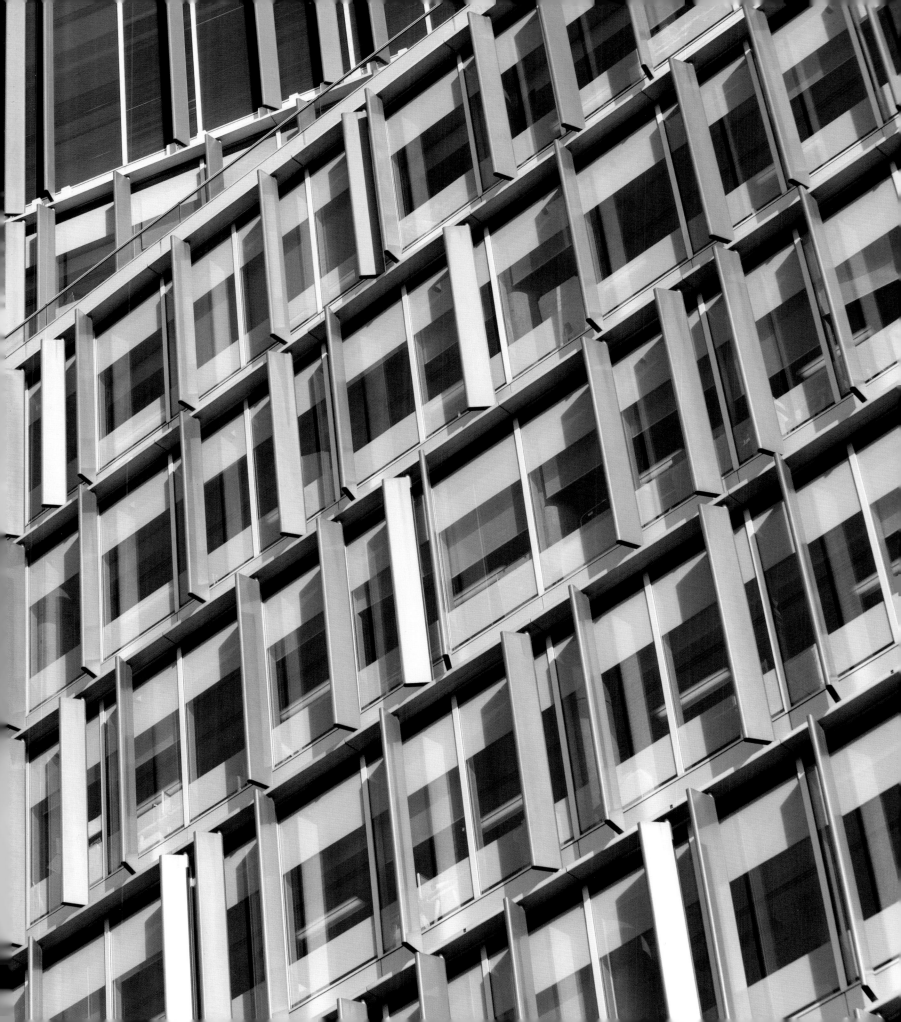

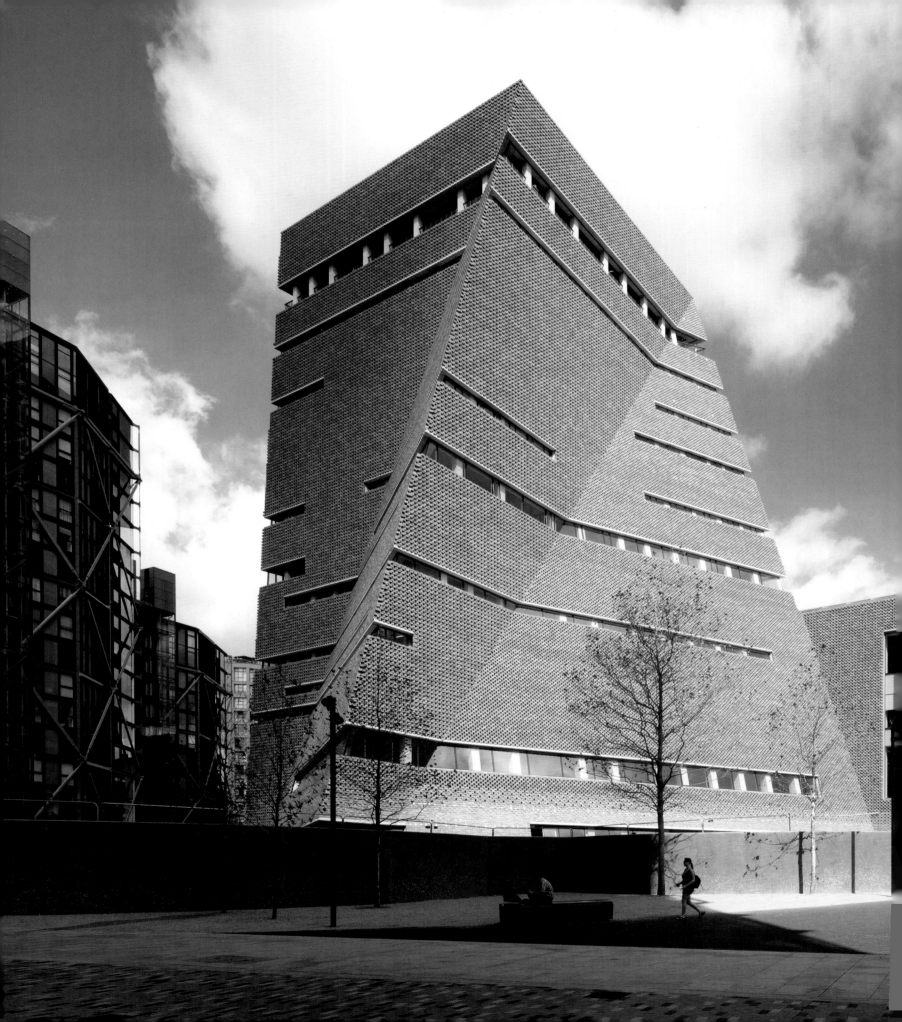

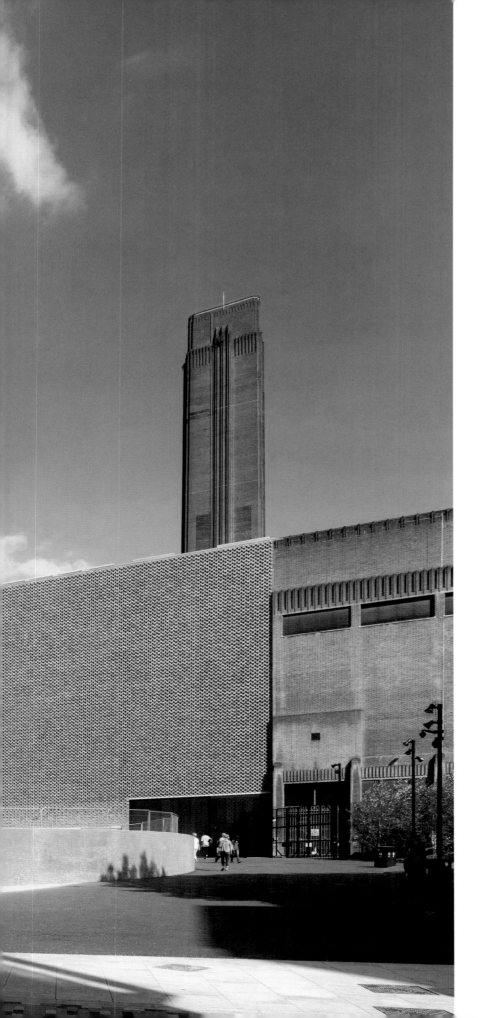

TATE MODERN SWITCH HOUSE

Herzog & de Meuron
2016
Bankside

Functioning as an encore to their hugely successful design for the Tate Modern, Herzog & de Meuron's recent eleven-story extension generates over 220,000 square feet (20,700 sq. m) of new exhibition space for the museum. Jutting from the hulking brick form of the gallery's converted Bankside power station, the addition resembles a contorted pyramid craning for a view of the Thames. Originally conceived as entirely glass, the creased volume is lined with brick to match the surface of the power station, and is inlaid with parallel strips of inset windows that create an abstract pattern. While the project's supplementary gallery spaces build on the museum's mission, its numerous performance spaces allow audiences to interact with modern art in an unprecedented manner.

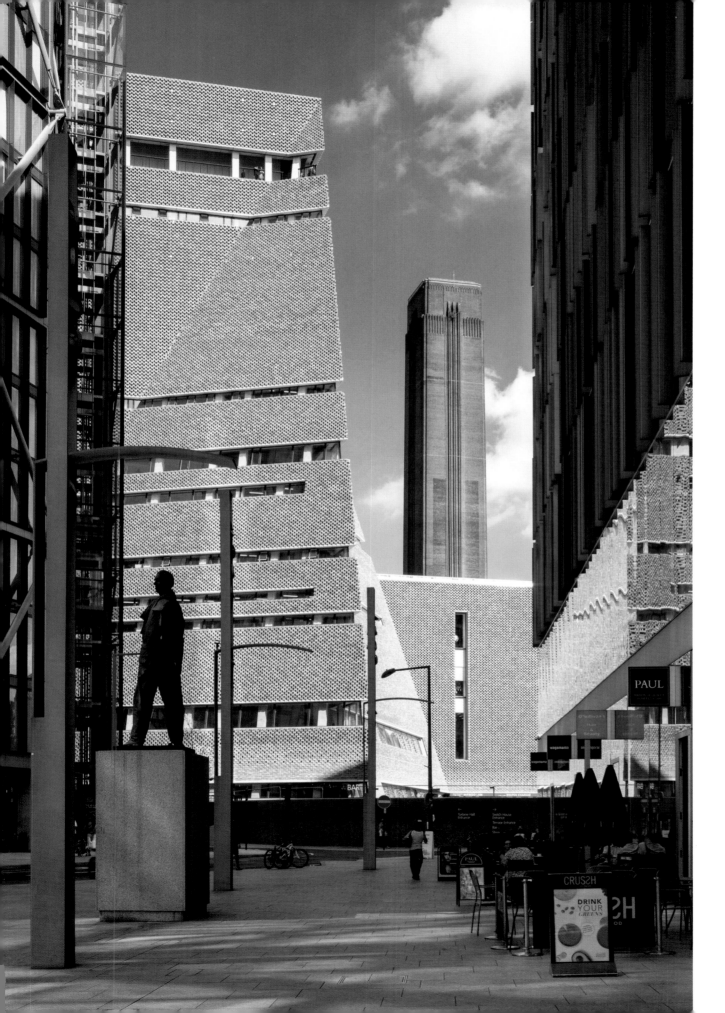

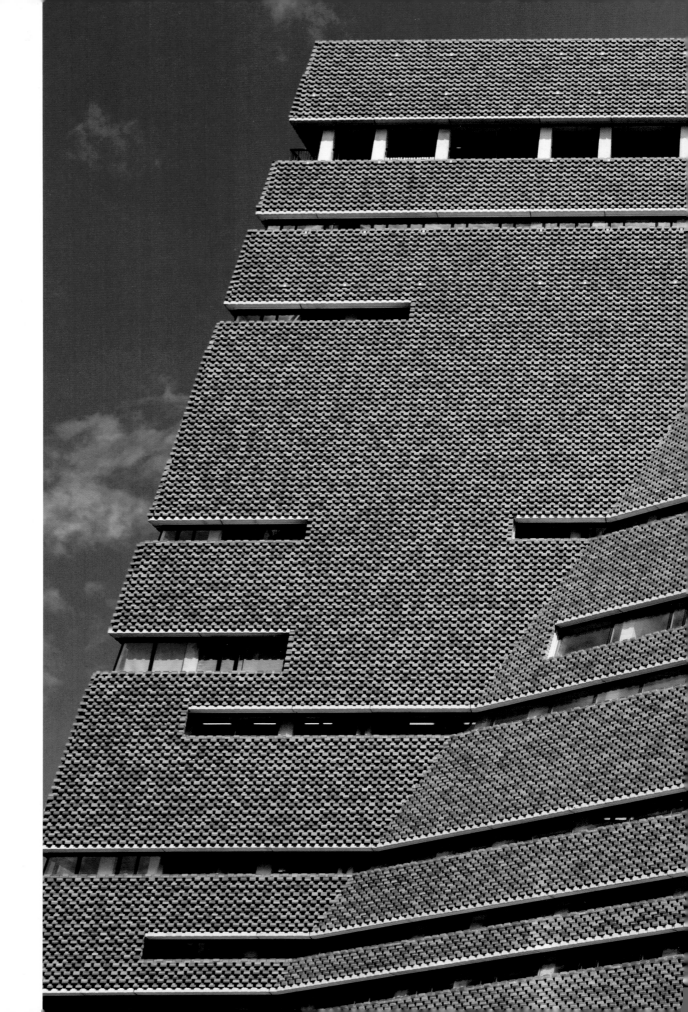

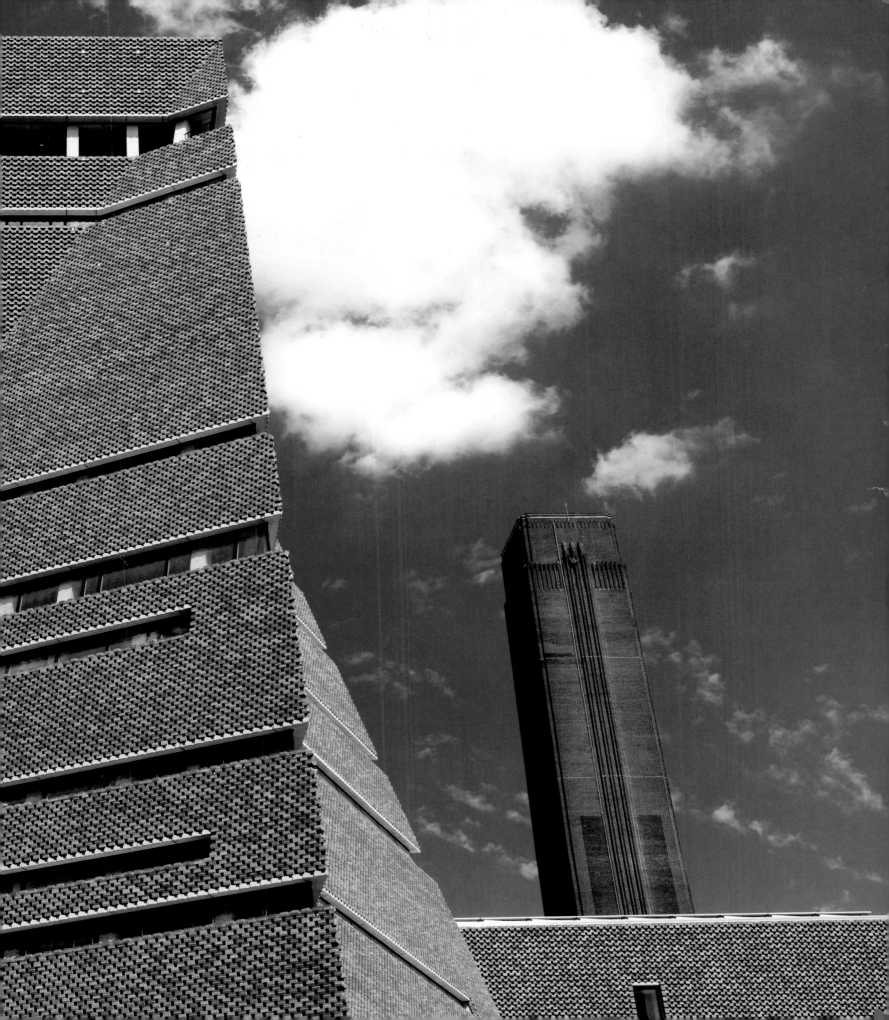